Diego Rivera
The Cubist Years

Guest Curator
Ramón Favela

Organized by
James K. Ballinger
Phoenix Art Museum

The exhibition, made possible by grants from the
IBM Corporation and the National Endowment for
the Arts, a federal agency, was organized by the
Phoenix Art Museum and Instituto Nacional de
Bellas Artes, México. An indemnity has been
provided by the Federal Council on the Arts and the
Humanities for the exhibition in Phoenix
and San Francisco.

i

Cover:
Catalogue No. 18
La mujer del pozo, 1913
(Woman at the Well)
oil on canvas
57⅛ x 49¼ (145.0 x 125.0 cm.)
Instituto Nacional de Bellas Artes, Museo Nacional de Arte
(verso of *Paisaje Zapatista*, Catalogue No. 40)

Frontispiece:
Catalogue No. 39
Still Life with Gray Bowl, 1915
(Naturaleza muerta con tazón gris)
oil on canvas
31¼ x 25¼ (79.4 x 63.8 cm.)
Lyndon Baines Johnson Library and Museum, Austin, Texas

Copyright © 1984 Phoenix Art Museum
Library of Congress Catalogue Card No. 84-60891
ISBN No. 0-910407-11-8

Phoenix Art Museum
March 10 to April 29, 1984

IBM Gallery of Science and Art, New York
June 13 to August 8, 1984

San Francisco Museum of Modern Art
September 27 to November 11, 1984

Museum of Modern Art, Mexico City
December 6, 1984 to February 11, 1985

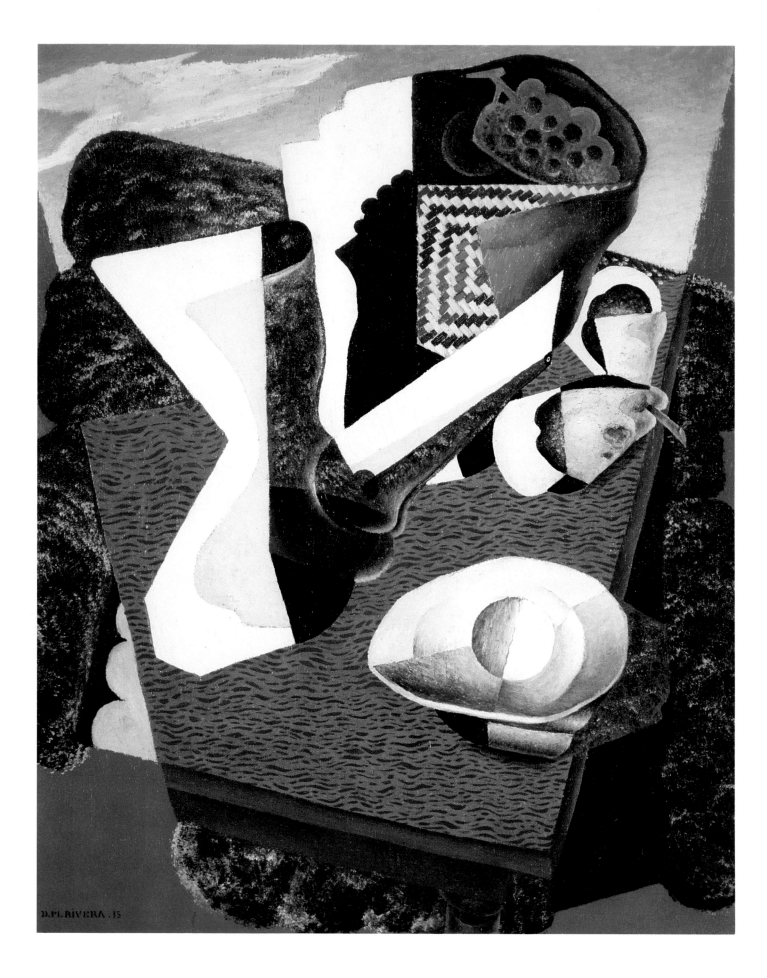

Table of Contents

Acknowledgements

It requires a long memory brought back from the labyrinths of historical meditation to write the litany of many thanks and appreciation that are due to all who made this study and exhibition a reality. It is hoped that mine does not falter on this occasion for thanks. Equally long would be the space needed to list all who contributed in the least but, at times, most significant way. It is hoped that the reader of this list of acknowledgements bears in mind the vast number of people, too many and whose names would fill a book, who are almost equals in what they contributed to the process that was involved in reconstructing this history of Diego Rivera's Cubist Years.

I am particularly grateful to Dr. Richard R. Brettell for his early encouragement in this endeavor and for his stimulating ideas and dialogue of a few years ago about the new art historical problems of artistic identities and the ideologies of images. At an opposite pole of intellectual refinement and historical orientation is Dr. Damián Carlos Bayón of Paris, whom I must thank for his equally untiring support in this investigation and for his unrelenting insistence on the purely visual qualities of art as well as the study of its human context. More recently, I am especially grateful to Dr. Linda D. Henderson for her own interests in "Cubism in context" and for guiding my way through the abstruse theories and thought of non-Euclidean geometry and early twentieth-century attempts at four-dimensional plastic and spatial actualization. Thanks is also due to Dr. Henderson for her assistance in the final preparation of my dissertation at the University of Texas at Austin from which this exhibition developed.

In my initial stages of research for this exhibition, I was fortunate to have met and recorded the personal recollections about those heroic Parisian years of the Cubist Rivera from his surviving mistress of those years, the Russian painter Marevna Vorobieva-Stebelska and his daughter Mme. Marika Rivera, both who now reside in London. Mme. Albert Gleizes and Sonia Delaunay, before their deaths, also provided important insight about Rivera during those years as did Mme. Jeanne Severini and Mme. Tora Garde, daughter of the Danish sculptor, Adam Fischer. They are to be sincerely thanked for making available to me the personal papers of their loved ones and allowing me to share in their most intimate, at times painful, recollections of the genial giant, Rivera.

Others who assisted in my research in an important way are: M. Olivier Debroise, who upon learning several years ago that we were working on the same subject graciously offered to share information and a lasting friendship; Mme. Arlette Albert-Birot, Dr. Nettie Lee Benson, Don José Bergamín, Don Pablo Beltrán de Heredia, John E. Bowlt, Juan Manuel Bonet, Prof. William A. Camfield, Sra. Vita Castro María Celis, Myroslava Ciszkewycz, Jean Cassou, Mrs. Jean and Mr. John Charlot, Eduoard Dermit, Christian Derouet, Clara Diament Sujo, Ing. Jorge Espinoza Ulloa, Ralph Fabacher, Mme. Faure-Sadoul, Jean-Louis Faure, Boris A. Filipoff, Matthew Frost, Edward Fry, Georges González-Gris, Malcolm Gee, Donald E. Gordon, Christopher Green, Don Guillermo Guzmán West and the late Sra. Ana West Vda. de Guzmán, Robert L. Herbert, Harry Holtzmann, Etienne-Alain Hubert, William B. Jordan, Luciano Joublanc, Miriam Kaiser, M. Jean Kisling, Carlton Lake, Giovanni Lista, Jean-Claude Marcadé, Mary-Anne Martin, Jean-Hubert Martin, Javier Martínez, Herlinda Martínez de Villegas, Yvette Moch, Lenin Molina, Agnes Mongan, the National Chicano Council on Higher Education, its Director Carlos Arce and

Ximena Poch and Marta Díaz of its staff, Andrei B. Nakov, Frances Naumann, Jean Osouf, Lisa Palmer, Mariana Pérez Amor, Alexandra Pregel, Mme. Solange Raynal, Alicia Reyes, Alain Riviére, Ione Robinson, Mme. André Salmon, Michel Seuphor, Carlos Silva, Prof. James F. Stephens, Carla Stellweg, Ana Vázquez de Parga, Jeanine Warnod, Robert P. Welsh, Roberto White, Ella Wolfe, Marcel Zahar, Grete Zahle, Rodrigo de Zayas, Mrs. Carl Zigrosser, Judith Zilczer, and Mtro. Tomás Zurián Ugarte, all to whom is extended my most profound appreciation.

Doctoral research grants from the Samuel H. Kress Foundation and the Ministére des Affaires Etrangéres of the French Government provided the important financial support for my research in Europe during 1979 and 1980.

Special thanks must go to Mr. James K. Ballinger, Director of the Phoenix Art Museum, for his enthusiastic interest in the project and his successful efforts to resuscitate it from previous failed attempts at organizing an exhibition. To his staff, in particular Ms. Barbara Gutiérrez who has followed the project all along; the Registrar Ms. Rosemary O'Neill, who for all practical purposes "wrapped up" the exhibition, brought it to Phoenix, and will see it on its way; Katherine Dee, Curator of Education who provided interpretative materials for the exhibition; and Mr. David Restad and his assistants who masterfully designed and installed the exhibition; I wish to extend a special thanks.

To the Director General of the Instituto Nacional de Bellas Artes, Lic. Javier Barros Valero and his Director of International Relations, Lic. Francisco Serrano, must also go a sincere word of appreciation for all they have done to coordinate the loans of the Mexican national collections and the private Mexican sector. To Lic. Serrano's assistant, Sra. Viviana Kochen and her diligent coordinator Lic. Lucía Alfaro, we are particularly indebted for their attention and assistance in the many minor and last minute details regarding the loans in Mexico. Likewise, our thanks to to their colleagues, Sr. Tomas Zurian, Jefe of the art conservation center; Sra. Teresa Del Conde, Director of Artes Plasticas and her technical Assistant Director, Adrian Villagomez.

My greatest debt of gratitude is owed to the Instituto Nacional de Bellas Artes and its staff through two administrations for their gracious assistance in my research and for placing their large collections at my disposal for the realization of this retrospective exhibition. This enormous debt of gratitude is also due to the many private collectors and dealers in Mexico, Europe, and the United States, who responded graciously for information and photographic documentation of works in their collections and who finally agreed to lend their "Cubist Riveras" to the exhibition; to those who wished to remain anonymous and to those whose names are listed on the following page. We are particularly grateful to Sr. Armando Colina, Director of the Galería Arvil of Mexico City and his associate Sr. Victor Acuña, for interceding on our behalf in various important loans. A special note of consideration to Sra. Dolores Olmedo is due for her decision to lend her much-requested works to this exhibition. We are also grateful to Arq. Manuel Reyero for his generous contribution of color plates and assistance with the photographic documentation for the catalogue. To Sr. Fernando Gamboa is extended a note of special thanks for his assistance in arranging the large loan from the collections of the Government of Veracruz and several private Mexican collectors.

Finally, both myself and the Phoenix Art Museum are deeply grateful to the IBM Corporation and the National Endowment for the Arts for their generous support in funding the exhibition.

Ramón Favela

Lenders To The Exhibition

The Art Institute of Chicago, Illinois
The Arkansas Art Center, Little Rock
Señor y Señora Rogelio y Lorenza Azcárraga
Bergen Billedgalleri, Norway
Capilla Alfonsina, Mexico City
Columbus Museum of Art, Ohio
Joan and Jaime Constantiner
Mr. and Mrs. Ferrand-Eynard
Fundación Amigos de Bellas Artes, Caracas, Venezuela
Señor Fernando Gamboa
Government of the State of Veracruz, Mexico
Instituto Nacional de Bellas Artes, Mexico City
Doctora Guadalupe Rivera de Iturbe
Lyndon Baines Johnson Library and Museum, Austin, Texas
Los Angeles County Museum of Art, California
The Metropolitan Museum of Art, New York
Museo de Monterrey, Mexico
Museum of Modern Art, New York
Señora Dolores Olmedo
Lennart Philipson
Phoenix Art Museum
Señora María Rodríguez de Reyero
Egil Nordahl Rolfsen and Kirsten Revold
Rijksmuseum Kröller-Müller, Otterlo, Netherlands
St. Louis Art Museum, Missouri
The Stedelijk Museum, Amsterdam
Arquitecto Don Jesús González Vaquero
Worcester Art Museum, Massachusetts
Eight anonymous private collectors

Introduction

The most significant showing to date of the Cubist and pre-Cubist works of Diego Rivera, without doubt one of the greatest creators of modern plastic arts, is being presented to the public as a result of the collaboration of the Instituto Nacional de Bellas Artes (National Institute of Fine Arts) of Mexico and the Phoenix Art Museum. The sponsorship of International Business Machines Corporation with additional help from agencies of the United States government is much appreciated.

These works – the majority completed during the painter's stay in Paris, between 1909 and 1921, when he met and was a friend of the most important exponents of the Cubist movement: Braque, Picasso, Juan Gris – proclaim Diego Rivera's excellence. Rivera's fame has been concentrated, with reason, on the magnificence of his mural work. Brilliant compositions in public buildings in Mexico, San Francisco, New York and Detroit testify to one of the most intense and fascinating aesthetic adventures of our century. Nevertheless, Rivera is also a great painter of easel works: portrait and landscape artist, undisputed master of drawing, he joins to the rotundity and perfection of line a very sensual knowledge of color. And these virtues are clearly visible in the paintings of the Cubist period.

From Cubism Rivera extracted not only its precise sense of the disposition of masses and bodies in space, but also that which some critic has called its powerful *materiality*. And it is not inexact to affirm that from the meticulous volumetrical analysis that characterizes, with precision, the Cubist experience, Diego Rivera learned the fundamental lessons of composition which he afterwards knew how to apply when he undertook his inspired reevaluation of the prehispanic aesthetic. Even though it has been little studied, Diego Rivera's Cubist period is essential for understanding the evolution of modern Mexican painting and, through it – another link not fully explored – one important current of recent North American painting.

Ramón Favela, who has functioned as curator of the exhibition, has produced an illuminating essay which is fundamental to the study of Rivera. The exhibition "Diego Rivera: The Cubist Years" constitutes a valuable contribution to the understanding and enjoyment of the work of a creator who knew, as did few others, how to mold in a splendid language of art the spirit of his age and people.

<div align="right">

Lic. Francisco Serrano
Director of International Relations
Instituto Nacional de Bellas Artes

</div>

Preface

One of the great joys of being involved in an art museum is the capability of examining new areas of importance in the history of art. Diego Rivera is certainly not an unknown entity in histories of twentieth century painting; nor is Cubism an overlooked style of this century. However, Rivera's affiliation with the development of Cubism is a subject which baffles me that it has not been previously explored, while at the same time delights me that we can present the first in-depth exhibition of these masterfully created works of art. Through this exhibition we hope to demonstrate that innovations in Cubism were not only in the realm of Picasso and Braque, and that Rivera's control of his mural style was influenced heavily by the avant-garde movements found in Paris during the second decade of this century. We certainly hope that "Diego Rivera: The Cubist Years" meets these goals while visually challenging the interested viewer.

The Phoenix Art Museum is proud of its continuing interest in the art of Mexico. Over the years we have presented one-person exhibitions on the work of Gunter Gerzo, Rufino Tamayo, José Luis Cuevas, Francisco Zuñiga and Frida Kahlo. In addition, we have brought to Phoenix several group exhibitions of emerging artists working in Mexico. This exhibition continues that tradition while at the same time meets yet another goal of our institution; organizing for national and international travel, exhibitions of great import. It is our pleasure to be sharing this project with the IBM Gallery of Science and Art in New York City, the San Francisco Museum of Modern Art and the Museum of Modern Art, Mexico City. To these institutions' Directors, I extend a thank you for sharing our visions.

This is a rare opportunity for the exhibition visitor because this group of works represents almost one-half of the known Cubist works by the painter and never before has the Instituto Nacional de Bellas Artes allowed its entire

holdings of any period of Rivera's works to travel outside of Mexico. To Sr. Javier Barros, Director, and Sr. Francisco Serrano, Director of International Relations at INBA we all owe a sincere gesture of gratitude. Our staffs have worked well together in order to bring about this difficult project.

"Diego Rivera: The Cubist Years" was the idea of Ramón Favela from the University of Texas, who has served admirably in the role of guest curator for this undertaking which began when my predesessor, Ronald Hickman, received a planning grant from the National Endowment for the Arts in 1978. Favela's diligent search for objects coupled with his desire not to be denied a successful completion of this project can serve as a model for anyone involved with a complex undertaking such as this.

National sponsorship for "Diego Rivera: The Cubist Years" has been provided by IBM Corporation; and I must say it has been delightful working with and receiving the support of Richard Berglund, Director of Special Programs and the many other people with whom we have worked at IBM. Finally, we received an indemnity from the Federal Council on the Arts and the Humanities for the exhibition in Phoenix and San Francisco. Alice Martin Whelihan, who stayed with us to the very day of the indemnity meetings, making last moment alterations because of the nature of this project, deserves a special note of thanks.

Seeing the works in this exhibition has given me an expanded understanding of Cubism, and had you asked me seven years ago to discuss Rivera's Cubist works, I would have thought you mad. My answer would have been that Rivera was the great Mexican muralist, the great social documentarian of the evolving Mexican nation and perhaps the greatest Mexican artist ever...but a Cubist? "Diego Rivera: The Cubist Years" proves the international importance of Diego Rivera while underscoring that the history of art never ceases to amaze even the most serious student of art.

James K. Ballinger
Director
Phoenix Art Museum

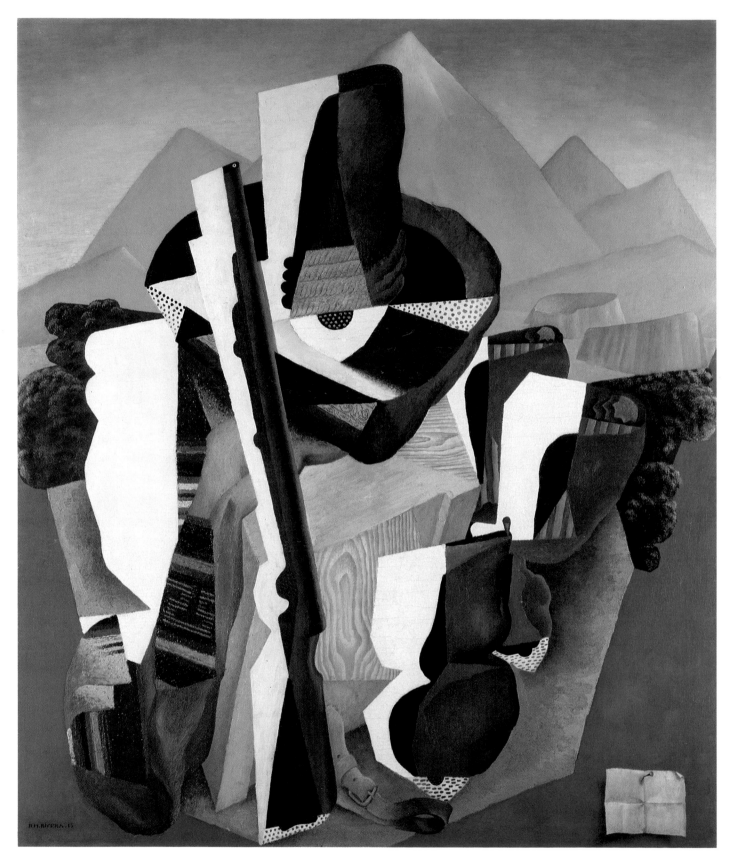

Paisaje Zapatista – El guerrillero, (Zapatista Landcape – The Guerrilla) 1915

Catalogue No. 40

Diego Rivera:
The Cubist Years, 1913-1917

Diego liked to talk of Mexico and his childhood. He had lived in Paris
for ten years ... he was friendly with Picasso, Modigliani and many
Frenchmen. But before his eyes there always rose the rust-colored
mountains covered with jagged cacti, the peasants in broad-brimmed
straw hats; the gold mines of Guanajuato, the incessant revolutions...

<div align="right">

Ilya Ehrenburg
People and Life, 1891-1921

</div>

In an homage to Diego Rivera in the year of his death in 1957, a fellow
Guanajuatense made a penetrating observation about "the clearest
relationship between Diego and Guanajuato." Armando Olivares wrote,

> Guanajuato is the most Cubist city in all of Mexico. In the
> (pedestrian's) approach to its neighborhoods, in the sharp balance
> between the ascent and fall of its lines, Guanajuato makes us live
> within a Cubism that has been projected vigorously upon its three
> dimensions. It is a Cubism of interwoven diagonals of lights and
> shadows, of broken planes and timbers, of plays of masses that reveal
> its popular (expedient) origins. It is a Cubism of the Mexican retablo
> (altarpiece) that more than a form of ordered urbanism resembles the
> (retablo's) superimposed outlines and planned diagrams requiring
> combined mental processes to experience its architecture.[1]

Little of the city's physiognomy has changed in almost one hundred years.
Diego María Rivera was born there in 1886.[2]

It is a long way from Guanajuato, Mexico to Paris, France. It is an even
longer journey from the artistic styles current in Mexico at the beginning of
the century to those that developed rapidly at the same time in the French
capital and comprised the foundations of that radical and difficult style,
Cubism. Nevertheless, twenty-seven years later Diego Rivera had established
himself in Paris and was in the throes of the Cubist revolution. He followed
that pictorial revolution, and in some tactical advances took the lead, before
certain events ended his Cubist career and propitious circumstances
developed for his return home in 1921 to become what he is most universally
known as, Mexico's greatest muralist.

In spite of the seemingly broad geographical and cultural distances
between Guanajuato, Mexico City, and Paris, Rivera traversed and reconciled
them well, first under official patronage, later independently. After a
prodigious artistic childhood and adolescence in Mexico, which included
seven long years of study at the National School of Fine Arts, Rivera went to
Europe in 1907. On a government pension to perfect his academic studies, he
spent two years in Spain followed by a brief tour of France, Belgium, and
London. He returned home in 1910 to inaugurate an exhibition of his
European works at the Academy of San Carlos in Mexico City, where, ironically,
his first one-man show opened on the very day that the Mexican Revolution
was declared, the 20th of November, 1910. The ensuing consequences and
events of this great social upheaval engendered prophetic changes in the
promising young artist's career. Rivera returned promptly to Europe at the
beginning of the following year. From his previous work as a successful
academic painter in the Zuloagan school of Spanish *modernismo*, Rivera set
out to re-invent the modernist artistic wheel, a venture that was to lead him to

the most abstruse theoretical confines of wartime Parisian Cubism. His Cubist period dates from 1913 until the end of 1917, and is roughly contemporary with the period of the First World War and the major activity of the Mexican Revolution (1910–1921). These latter two historical moments are inextricably bound up in iconography of some of Rivera's most important Cubist paintings in the present exhibition.

After a strong renunciation of his Cubist style by 1918 and a brief but resourceful trip to Italy in 1921, Rivera returned home for good that same year. In a classicizing reformulation and stylistic synthesis of Cézanne, Renoir, and "hidden constructive geometry," he set out to recreate in fresco the epic image of his fatherland on the walls of Mexico's cultural and political sanctuaries. His Cubist years in Paris and his formative years in Mexico receded into the forgotten past and became the stuff of fables, amusing anecdotes, and expiatory memoirs suffused with hindsight and ideological apologia. His total Cubist production between 1913 and 1917, of paintings alone, may have numbered two hundred, some one-hundred fifty of which have been located. After 1921, Rivera's Cubist works, widely dispersed in Europe and the United States and relatively unknown in Mexico, were closeted and for the most part forgotten by the artist. In the face of accumulating national, and nationalistic, fame and increasingly radical politicization accompanied by a dogmatic Marxist dialectical interpretation of everything, Rivera could conclude categorically by 1932 that "Cubism was a decadent art."[3] Although recognizing that "it was the most important single achievement in plastic art since the Renaissance," he wished to go on record that Cubism was "the art of a declining bourgeois society." "Rather than abandoning the principles of Cubism," he stated, and rightly so in his case, he was "as a matter of fact following the natural evolution of those principles into the final plastic stage."[4] Consequently, towards the end of his life, when asked by the Mexican poet Carlos Pellicer, "Why did you remain a Cubist painter for four years?" Rivera could answer, without hesitation, "Por pendejo!"[5]

Ironically, however, it was during the peak of his Cubist years in Paris that Rivera, in addition to discovering the inherent properties of his classicizing temperament, discovered the "native" of his native land. Despite his distance from Mexico, for the first time in his career he became surprisingly close in memory, spirit, and artistic form to the country he had left long ago. In the work that he produced during this period, this closeness manifested itself in a

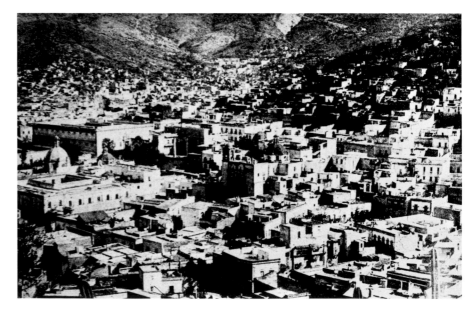

Figure No. 1 View of Guanajuato

uniquely qualitative manner. Among the few Mexican exiles from the Mexican Revolution who saw his strange new works in Paris, Rivera was said to have created a "Cubismo de Anáhuac" (the Náhuatl word signifying "that which is surrounded by water" and traditionally the ancient Aztec name for the Valley of Mexico — the Aztec center of the universe). Curiously, among his French counterparts of the Parisian avant-garde, according to Rivera, these same works produced such epithets as "exotic, barbarous, deviant, etc., etc." And the prominent critic, André Salmon, accused "the interesting Mexican insurgent, the abstract Courbet of the tropical plane," of "trying to confiscate Cubism for his own profit."[6]

Rivera's developing world view, his developing pictorial vision, and the identity that he projected in his Cubist works are the subject of this exhibition. It is a retrospective look at what a more sympathetic French critic, Guillaume Apollinaire, might have meant in 1914 when he stated about the young Mexican painter, early in his Cubist career: "Rivera is not at all negligible."[7]

There is yet to be published a scholarly and well-documented biography of Diego Rivera.[8] Most of the information regarding his early and formative years in the numerous monographs written on the artist and in his autobiographies is anecdotal and confused in chronology. Rivera's love of a good story, his concerted efforts to "épater le bourgeois," and his gargantuan imagination contributed considerably to the romanticized myths of his early years. An examination of some recently verified aspects of Rivera's "life before Cubism," so to speak, is of considerable importance for understanding the significance of his Cubist years and the sources for his own self-discovery within the conceptual geometry of Parisian Cubism. As Ilya Ehrenburg, the Russian émigré poet and close Parisian friend of Rivera, intimated, these sources began at birth.

Rivera's "Life Before Cubism"

The city of Guanajuato (Fig. 1), is situated in a narrow mountain gorge that rises majestically and prismatically out of the fertile Bajío of the Central Mexican plateau. Its structured surfaces appear sharp and tectonic on the mountain's incline. Planar facades of fortress-like houses flank the steep, narrow streets in which space is overwhelmingly compressed. The entire city winds and unfolds from the lofty hill known as the Bufa de Guanajuato downward and outward to the Cañon de Marfil, providing a striking view of a

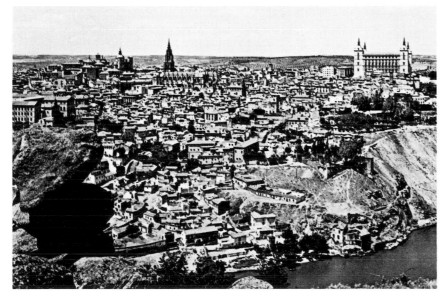

Figure No. 2 View of Toledo 3

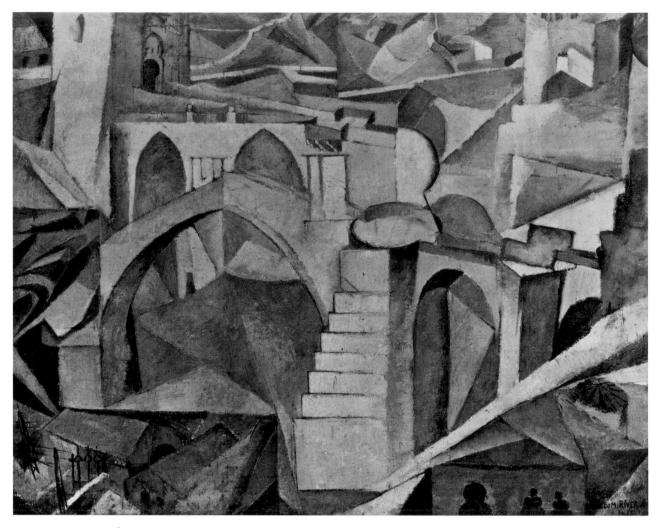

El Puente de San Martín, Toledo, (St. Martin's Bridge) 1913 Catalogue No. 17

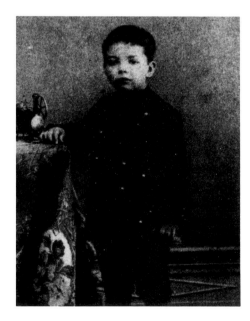

Figure No. 3
Diego Rivera at the age of five. Courtesy of INBA

highly faceted, random cityscape. Guanajuato and Toledo, Spain (Fig. 2) share these same visual characteristics, albeit on a larger scale, with the Catalonian town of Horta de San Juan (then known familiarly as Horta de Ebro) that was immortalized in Cubism by Picasso in 1909. It was a fitting parallel that just as a Paris-based Picasso in 1909 realized the potential of an early Cubist style in the little Spanish town of Horta, in 1913 a Paris-based Rivera also realized the beginnings of his own Cubist style in the locality of another, larger, and more well-known Spanish town, Toledo. In Toledo's similar landscape and its environs where Rivera painted periodically between 1912-1913, the young Mexican artist recalled the topography of his birthplace and focused on this aspect of visual reality in his new work.

Other aspects of the artist's childhood in the provincial capital weighed heavily on Rivera's future development. Guanajuato rests directly upon a once incredibly rich mother vein of gold and silver ores. Mined lucratively since the sixteenth century, the ores became difficult and costly to extract by the end of the nineteenth century — one of the reasons for the eventual move of Rivera's mine-owning family to Mexico City in 1892. Primitive and modern reduction works, winches, and mining paraphernalia dotted Guanajuato's precipitous hillsides during Rivera's youth, and the focal point of its silver-bearing trains was the Marfil station at the base of the gorge leading up to the city. Rivera's childhood memories abound with his fascination for locomotives, conductors, engineers, and machines. An early childhood photograph of a primly dressed Diego Rivera at the age of five shows him standing proudly by a small model of a locomotive engine (Fig. 3).

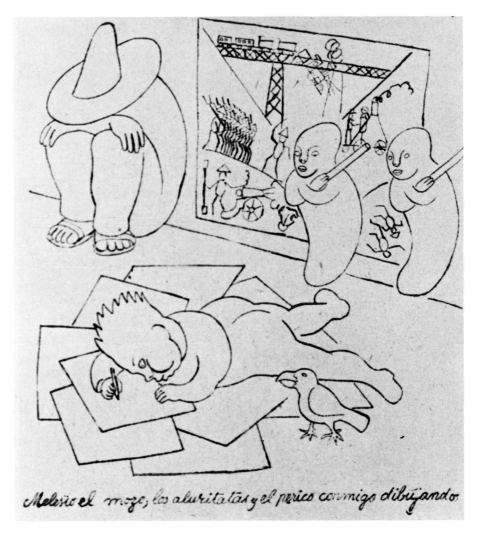

Melesio el mozo, los alavitatas y el perico conmigo dibujando.

Figure No. 4
Rivera, drawing. "How the painter Rivera recalls
his first Years," in Amadis De Gaula, "Los
primeros años de Diego Rivera," *Revista de
Revistas*, Mexico City, December 6, 1925, p. 17

The earliest surviving drawing by the artist, reportedly done at the age of
three, is a profile view of a train on its track and ironically prefigures his
interests in an important early Cubist painting, *The Viaduct (Landscape of
Meudon,* 1913). In this work, several trains are portrayed moving
simultaneously in different directions among smokestacks, clouds, and smoke
on disconnected shifting planes depicting the same motif, the train viaduct of
the Paris suburb, Meudon. The moving train in the background of his earlier
proto-Cubist *Portrait of Best Maugard* (Spring 1913, Cat. 5) rendered in
Futurist-like, chronophotographic static planes also attests to the
longstanding fascination with trains that Rivera took to Paris and to his
earliest Cubist experiments. His austere 1916 *Composition (Paisaje con
locomotora)* also includes a large ambiguous machine as its subject. Rivera's
interest in machines and science would, of course, have its most graphic and
successful manifestation in his Detroit Art Institute murals of 1933. However,
the thematic leitmotifs of science, technology and medicine can be observed
to run consistently throughout Rivera's oeuvre dating from his earliest years
(Fig. 4). His concerted interest in the study of perspective and optics while at
the Academy of San Carlos in Mexico City (1898-1906), as well as his peculiar
experiments with geometry, higher mathematics, and hyperspace during his

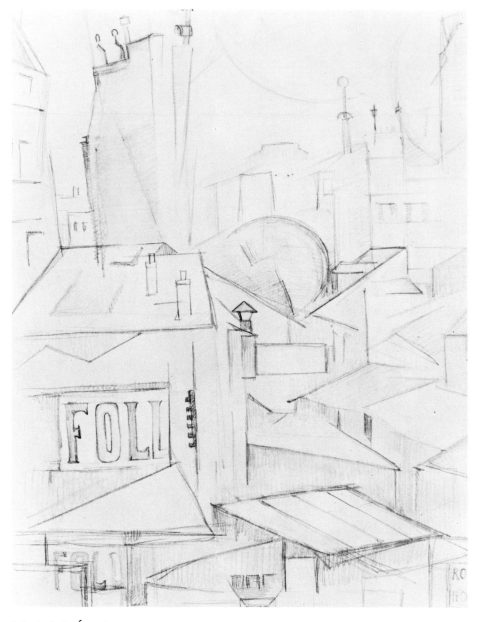

Paisaje de París – "Foll", (Paris Cityscape – "Foll") (n.d.) Catalogue No. 4

Cubist years in Paris (1913-1917), are graphic examples of this determinism.

In his numerous biographies and autobiographies, 'Wunderkind' (Wonderchild) and 'Ingeniero' (Engineer) were the telling appellatives that Rivera was most fond of using in recalling his childhood in Guanajuato. The epithets and especially the anecdotes that Rivera frequently recounted of his childhood and youth betray the *cientificismo* (scientism) that reigned over that period of his life. They also intimate the doting parents, both pedagogues, who were quick to indulge the precocious artistic talents, intellectual pursuits and whims of the young genius. The Rivera household was a privileged and educated one, where he was exposed to intellectual and scientific activity and to scientific texts at an early age. Both his parents were university educated and professional educators themselves. What is certain about his paternal background is that his father, Don Diego Rivera, was a fairly successful school teacher to judge by the preface to the Spanish grammar book that he wrote, entitled *Compendio de los elementos de la lengua castellana.*[9] In addition to tending the family's mining interests, Rivera's father was later employed by

the governor's office as a rural school inspector. Rivera's mother, María del Pilar de Barrientos, daughter of a Guanajuato store owner, was equally well-educated and a "profesora normalista titulada" (normal school teacher). By Rivera's own accounts, after the tragic death of his twin brother (who died at the age of one-and-a-half years), his mother studied medicine as therapy to overcome the tragedy. She went on to become one of the first female obstetricians to graduate from the state's school of medicine and to subsequently set up practice in Guanajuato.[10]

Coincidentally, it was also in Rivera's birthplace that a modified Comtian Positivism had first been officially introduced into Mexico as "a philosophy and educational system, and as a political weapon" by the Guanajuato physician and former student of August Comte, Gabino Barreda.[11] Significantly, throughout Rivera's childhood exclusively scientific education ("cientificismo") was fostered in Mexico and a consciousness about Comtian social evolution permeated the ideology of the Mexican Liberal upper classes and professionals.

By the time the Rivera family left Guanajuato for Mexico City, the young Rivera's attitudes toward learning and a peculiar form of scientism were well established. These were to have a definite impact on his future artistic orientation. His scientifically oriented childhood would also manifest itself later in Rivera's autobiographical diatribes surrounding the technical or scientific, as well as contribute to his notorious Parisian anecdotes of fantastic pseudo-scientific childhood exploits as his future mistress Marevna, Ilya Ehrenburg, Voloshin, and Dr. Elie Faure would all later relate.[12] Rivera's anecdotes included such "imaginative" childhood and adolescent recollections as operating a train locomotive at the age of six; eviscerating a live rat to find out how babies were born; plotting scientific battle plans for Porfirian generals (friends of his Jacobin father); archeological expeditions on Mexican construction sites; cannibalism (he reportedly "savored young women's brains in vinaigrette"); and other unmentionable experiments.

Paisaje con postes de telégrafo, (Landscape with Telegraph Poles) 1913 Catalogue No. 15

In 1892 when the Rivera family arrived in the Mexican capital, the physiognomy of Mexico City could be seen to have changed little from its colonial form and was only then beginning to reap the material benefits of Don Porfirio's "Order, Progress and Prosperity." It was the period of the *Paz Porfiriana*, the prosperous years of the dictatorship popularly known in Mexico as the "*Porfiriato.*"[13] Porfirian arbiters of taste were busily engaged in transforming the city's appearance into an architectural clone of Paris on the Mexican plateau. Nearly a decade and a half later as Rivera packed his bags for Europe, a leading elegant magazine of the Porfiriato could safely proclaim in a feature picture story on modern capitoline homes and buildings: "Modern Mexico City: The Paris of (South) America."[14] At the turn of the century, the physical scale and disposition of Mexico City circa 1892, situated on the ancient lake bed surrounded by volcanic cones, can best be appreciated in the views of the Valley of Mexico by José María Velasco painted during this period (Fig. 5). The landscape of his new home and the paintings of his future teacher produced a lasting visual impact on Rivera. The prominent volcanic cones and pristine sky so dear to Velasco reappear in much the same configuration in Rivera's most important Cubist painting executed in Paris, the *Paisaje zapatista (El guerrillero)* of 1915 (Cat. 40).

After several years and much relocation the Rivera family settled in a house on the Calle de la Merced, two blocks from the National Palace. The street was betwen the two central marketplaces of the city: the famous Mercado del Volador, the country's largest market offering every imaginable Mexican product and food, and the large produce and flower market of La Merced fed directly by flat-bottomed canoes from Xochimilco and the outskirts of the city. It is significant that there are no known works from Rivera's early period that depict any subject from this veritably rich source of popular imagery and motifs which literally served as his front and back yards. The visual impact of the color and exposure to national culture that the two

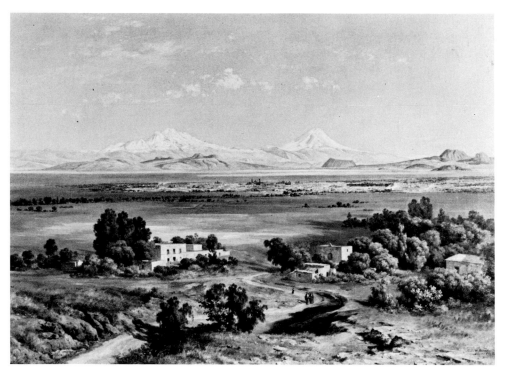

Figure No. 5
José María Velasco, *El Valle de México, 1905*
Oil on canvas
74 x 104 cm.
INBA, Museo Nacional de Arte

open-air marketplaces provided for the young artist are not evidenced in any of his known pre-European, and for that matter, pre-Cubist works. His early Mexican work consists primarily of academic figure studies, attenuated Impressionist and Post-Impressionist landscapes, and some Symbolist inspired drawings and pastels. Conspicuous in Rivera's student work — in light of the precocious social consciousness that he later professed — is a marked disinterest in social iconography when there was plenty from which to choose on the rural haciendas and streets of Porfirian Mexico. When his subjects were drawn from haciendas such as in *La era* of 1904, his subject is not so much the faceless Mexican peasant with plowshare as it is the calculated rendering of lights and shadows and one of the iconic volcanoes of the Valley of Mexico — a view of El Popocateptl seen from Amecameca. With a clearly positivist aesthetic Rivera's early works are based on the most neutral and demonstrable aspects of the physical sciences and visual data to the exclusion of extraneous concepts.

Ironically, it is not until his more advanced Cubist paintings done in Paris, such as the *Alarm Clock* (1914), the *Still Life with Gray Bowl* (1915), *Paisaje zapatista* (1915), and the *Portrait of Martín Luis Guzmán* (1915), that traces of conspicuously identifiable and colorful Mexican motifs (*sarapes, petates* (straw mats), an *equipal* (Mexican reed chair), *guajes* (peasant gourds), and sombreros) appear in his painting with charged iconographical meaning. In view of the development of his work, Rivera appears to have first discovered paradoxically his *mexicanidad* (Mexican identity) and the plastic qualities of his country and its *artesanía* (arts and crafts) in Paris. He would only fully "rediscover" them after his long absence from Mexico and his return in 1921. The "Neo-Primitivism" of some elements of the Russian avant-garde in Paris, with whose members Rivera maintained close ties, played no small role in awakening his consciousness about his native land and its popular art forms.

By 1898, Rivera's father had joined the ranks of the Porfirian middle bureaucracy. It is quite possible, as has generally been repeated by his biographers, that Rivera's father who had been "appointed an Inspector in the National Department of Public Health, and was required to travel all over the Republic" was instrumental in bringing his son to the attention of his future patron.[15] The generous and enlightened patron of the arts, and Porfirian governor of Veracruz, Don Teodoro A. Dehesa, eventually did become Rivera's patron, but Rivera obtained his European pension through more impartial and conventional means.

Before his departure for Europe in 1907, Rivera had already become an accomplished painter. After attending private schools in Mexico City, Rivera entered the Mexican Academy of San Carlos at the surprisingly early age of twelve. In addition to the National School of Fine Arts, the Academy included the School of Architecture, whose geometry and drawing classes Rivera claims to have attended. He is known to have studied at the Academy of San Carlos between 1898 and 1905, and was possibly still a student in 1906 when he last exhibited there.[16] Rivera exhibited 26 works in the 1906 "Exhibition of Mexican Artists Pensioned in Europe," at the Academy. As a result of the critical and financial success that he garnered in the exhibition, he was recommended by government officials and prominent critics to the governor of Veracruz for a European pension which he subsequently received.

At the Academy of San Carlos, Rivera had displayed a remarkable prowess and ability under the tutelage of Santiago Rebull, Felix Parra , José María Velasco, and towards the end of this training, under the imported Catalan academic painter Antonio Fabrés. The curriculum that Rivera followed during his seven years of study at the Academy was rigorously controlled and positivist in orientation.[17] Following the European academic tradition of hierarchical modes, but including such courses as descriptive geometry,

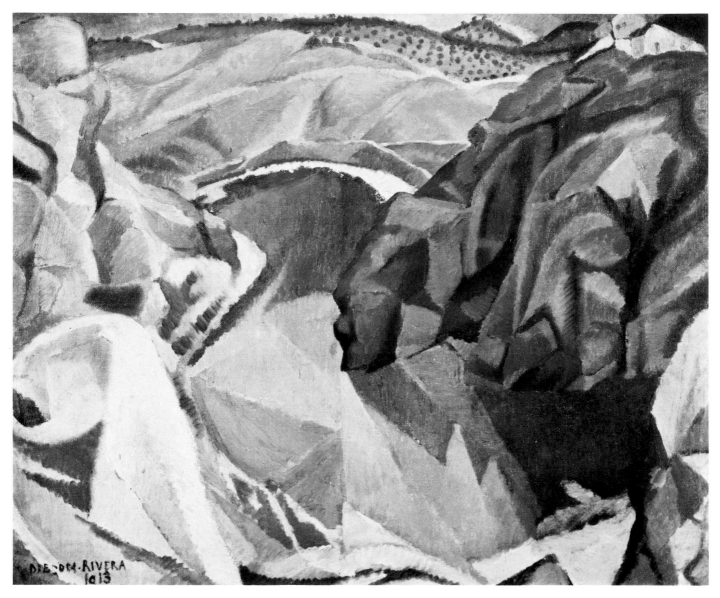

Paisaje de Toledo, (Landscape of Toledo) 1913 Catalogue No. 6

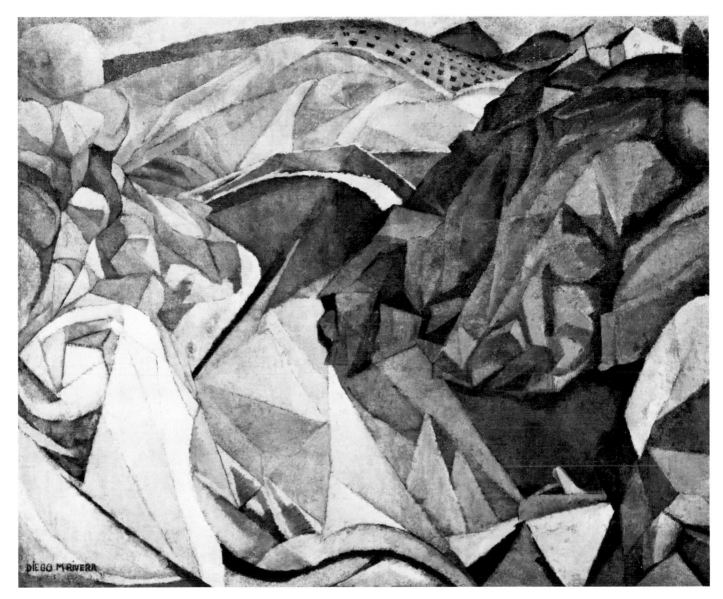

Paisaje españon, (Spanish Landscape, Toledo) 1913

Catalogue No. 8

mechanical drawing, and physical geography, Rivera undertook his training at San Carlos systematically with no short cut to painting.

There was a great emphasis on technical methods of expression that were deeply rooted in the Mexican Academy's eighteenth-century Enlightenment founding tradition, now amplified by a nineteenth-century positivist regard for nature and scientific analysis. The opening remarks from one of Rivera's textbooks used at the Academy, Eugenio Landesio's *La pintura general o del paisaje y la perspectiva en la Academia de San Carlos* (General Painting, or On Landscape (Painting) and Perspective at the Academy of San Carlos), are instructive.

Studies for the General Painter:
The young man who wishes to become a general (all around) painter should study mathematics, physics, chemistry, natural history, perspective, and the human figure…[18]

A more important text by Landesio, his *Cimientos…Compendio de perspectiva lineal y aerea, sombras, espejos y refracción con las nociones*

Figure No. 6
Plate 25 from Landesio's *Cimientos…
Compendio de perspectiva lineal y aerea,
sombras, espejos y refracción…*, 1866

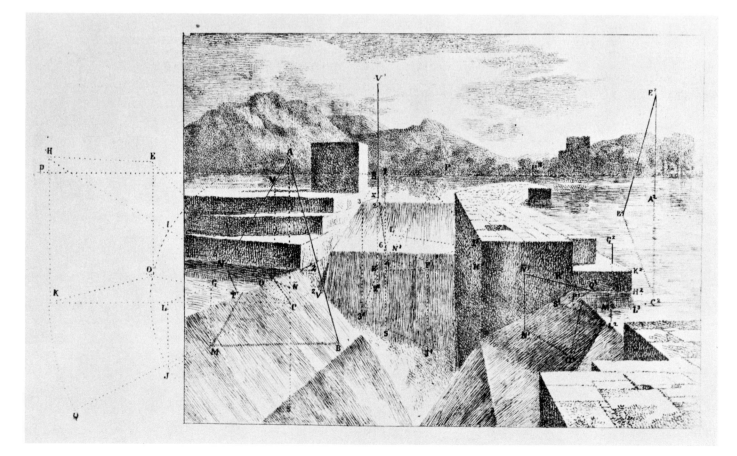

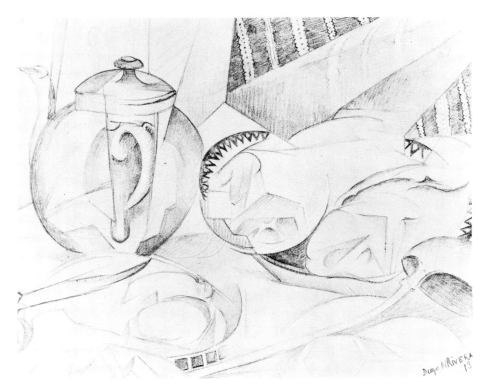

Naturaleza muerta con tetera, (Still Life with Teapot) 1913 Catalogue No. 16

necesarias de geometría (Foundations...Compendium of Linear and Aerial Perspective, Shadows, Reflections and Refractions with the Necessary Rudiments of Geometry), was the officially required text for Rivera in the Perspective Theory class taught by Velasco.[19] It was a crucial text, as were Velasco's rigorous instructions, for developing Rivera's scientific inclinations towards optical theory which would be the basis for his future Cubist experiments.

To Rivera, José María Velasco (1840-1912) was ''a completely scientific man, a student of geology, botany, natural history, meteorology, physics, and therefore, mathematics.'' About his teaching, Rivera recalled

> The body of knowledge that Don José María Velasco made available to me was based on the geometry and trigonometry of space, and not on pure speculation but rather on the immediate apprehension of the plastic construction that transposed values of three or more dimensions on surfaces that are not only flat, but also concave, convex, and multifaceted. Everything that architectonic forms and surfaces have to offer in the way of representable surfaces, and the transformation of volumes engendered upon those surfaces was always executed with a mathematical security.[20]

This statement, made by Rivera in the 1940s to his biographer, may appear suspect in its mention of geometric values of more than three dimensions alluding to *n*-dimensional geometry. It might also be construed as mere indiscriminate projection of the concept into his youth as a result of his

13

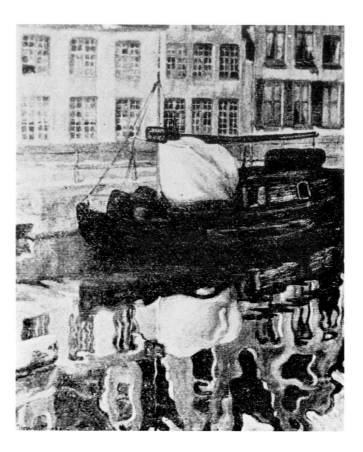

Figure No. 7
Rivera, *Reflejos (Reflections)*, 1909-10.
Dimensions and present whereabouts unknown.
Illustration from the *Revista Moderna de
México*, Mexico City, XV, No. 5 (January 1911),
p. 262

subsequent exposure to such geometries in his later Cubist experiments
(1915-1917) with "four-dimensional geometry." However, a closer
examination of the Landesio text might prove that this statement is not
entirely contrived, or at the very least that Rivera seriously had in mind or
recalled Velasco's instruction while later formulating his Cubist compositions
and theories.

Landesio's *Cimientos* begins with the essentials of descriptive geometry
that are utilized in the operations covered in the text. One important section
explains how shadows are drawn geometrically in a form of pseudo-
trigonometry. Another deals with reflections, e.g., in water and glass, and
refractions and their calculations, ending with a sixth section on aerial
perspective. All of these sections are accompanied by lithographic plates —
executed mostly by Velasco — with superimposed geometric diagrams (Fig. 6).
These explanatory plates are remarkably similar to the plates accompanying
David Sutter's *Esthétique générale et appliquée* (Paris, 1865), a text which
was important for the theoretical development of several modern
French painters.[21]

In his text, Landesio posits that there are two fundamental types of
drawing: 'geometric' and 'perspective.' He states that "The first (geometric
drawing) which is used for drawing the plans, profiles, and cross sections of
objects, and is required by all artists, is not subject to perspective diminution,
maintaining within itself its own true dimensions, as if we perceived those
dimensions not through our sense of seeing or eyes but through our sense of
touch." That is, that there is a geometric manner of rendering objects and
that we perceive, not necessarily visually, but tactilely. This notion of a
"tactile" awareness of a geometrically conceived space is interesting for its
basis in sense perception that can be viewed as an expressly positivist
approach to space and drawing. It is also significant for its similarity to the
concept of Ernst Mach and Henri Poincare's differentiation between geometric
space, which is continuous, infinite, and idealized (conceptual); and

perceptual (or physiological) space made up of the three component spaces which are: visual, tactile, and motor. The latter concept would have important implications for the early Cubist theoreticians, Gleizes and Metzinger and their theoretical tract, *On Cubism*.[22] By Rivera's familiarity with Landesio's text and Velasco's instruction, the Cubist concept of a subjective, perceptual pictorial space composed of tactile and motor sensations would later be easily apprehended by him.

The rendering of reflections, refractions and their calculations were also covered in great detail by Landesio. They were of special interest to Rivera and studies of water reflections appear frequently throughout his early work (Fig. 7). In more than one review of Rivera's 1910 exhibition of European works, his paintings were noted for their "very fine water effects, as have many of the pictures, for the artist seems to have a predilection for water reflection studies."[23] In Rivera's earliest Cubist paintings, such as the two *Landscapes near Toledo* (Cat. 6 and 8) of 1913 and the *Adoration of the Virgin and Child* (Cat. 7), abstracted forms of geometricized reflections in the waters of the Tagus river are conspicuous elements. In the 1917 version of the same subject, his geometric analysis of water reflections is clearer.

Rivera's compulsion to fix art within a technical rationalization based on scientific and pseudo-scientific optical research as manifest in the works and teachings of Velasco, was of paramount importance for the young artist. Some of Rivera's most extreme forms of synthetic and metaphysical Cubism, for example in the conceptual transposition of concave and convex planes and oblique views in his *Still Life with Bust* (1916, Cat. 53), the *Telegraph Pole* (1916, Cat. 57), and his 1917 series of austere still lifes for example, are based on similar rationalizations.

Among the collection of student drawings owned by the Academy, Jean Charlot saw a bearded bust of Homer copied from the round by Rivera under Rebull's tutelage. He commented that "With hindsight we can discover in the faceting of Homer's beard a seed of the preoccupation with geometric forms that characterize Rivera's Cubist period."[24]

The instructions of the 'born Ingrist,' Santiago Rebull, had no less an impact on Rivera than did the "ultramodern teachings of the completely scientific man, Velasco." The 78 year old Rebull, who corrected Rivera's life drawings at the Academy and offered him personal guidance, was to be a major influence on Rivera's Cubist aesthetic as well as on his highly refined Ingresque drawing technique. Rivera credits Rebull with confirming his own realizations about "a conception of forms in space that led me to draw the human figure taking the model's forms to their most essential geometric character in space."[25] Rivera's masterful Ingresque drawing style that he utilized in both his entrance and exit from Cubism, and which allowed for delicate and subtle graphic distortions in his work can be seen in his 1913 *Still Life with Teapot*, the 1918 *Still Life, Paris* (Cat. 76), and in his series of Ingresque portraits (1917-1918) of which the Portraits of Jean Cocteau, M. and Mme. Fischer, Chirokov (Cat. 71), and his own Self-Portrait of 1918

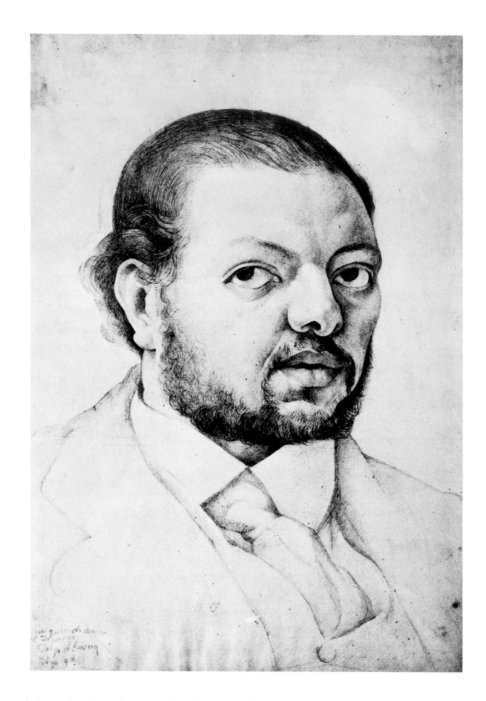

Figure No. 8
Rivera, *Self-Portrait*, 1918
Pencil drawing
Present whereabouts unknown. Photograph
courtesy of INBA

(whereabouts unknown, Fig. 8) are the finest examples.

Perhaps, the most remarkable of Rivera's hindsight recollections, establishing a significant link between his Parisian Cubist experience and his early training at San Carlos, is his statement that while tutoring him privately, Rebull quoted to him from Plato's "Socratic Dialogues," the famous passage that

> illustrates how in all great periods of art, the Masters have always sought to take geometric forms and colors to their utmost purity, thereby rendering them immortal:

>> I wish to teach you to love, not beautiful fruits and women because flowers and fruit wilt and women grow old. But rather, I wish to teach you to love the purest, permanent, and most imperishable forms, that is to say, the figures that architects draw and construct: the cylinder, the cone, and the sphere; and the pure colors that correspond to them such as red, yellow, and blue; as we see them in a rainbow.[26]

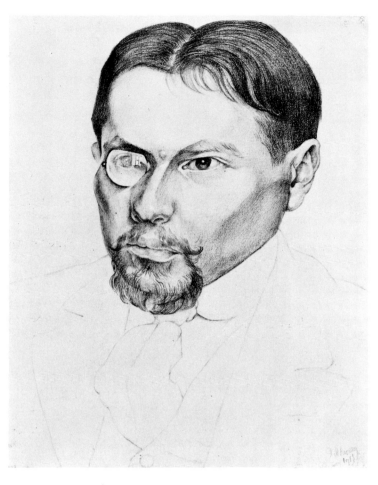

(Retrato de Chirokof) Portrait of Chirokof, 1917 Catalogue No. 71

The above quote is loosely paraphased from Plato's definition of pleasure derived from Beauty in the *Dialogue-Philebus.* The original quote was popular among the theorizing wartime Cubists in Paris, among them Rivera's dealer Leonce Rosenberg.[27] It was pronounced by them as an aesthetic postulate extolling the beauty of abstraction in art, and it provided a historical and philosophical justification for a modern aesthetic, of Cubism and geometric painting. In Paris in 1915, the Mexican writer Martín Luis Guzmán was taken by Rivera to Picasso's studio. He noted that

> Picasso with an admirable instinct about his work, recites pages from the *Philebus* as a commentary to his paintings. And the points are clarified in speaking with Rivera.[28]

Rivera's curious conflation of the quote from Plato's *Philebus* and the equally familiar and often seriously misunderstood passage from Cézanne's letter to Emile Bernard, in which Cézanne exhorts the latter to "Treat nature by means of the cylinder, the sphere, and the cone," is especially intriguing. The statement by Cézanne, which is so often cropped of its crucial ending, originally continued with the utterly conventional advice that "everything is directed towards a central point."[29] In spite of the obvious hindsight projection of Cézanne's dictum into his own past, Rivera ironically places this private conversation with Rebull in the context of an academic teacher's advice to his pupil, just as Cézanne's original statement to Emile Bernard was meant. As Theodore Reff has shown,[30] Cézanne was, for all practical purposes, giving Bernard the academic advice to work in the conventional academic manner of perspective tonal gradation and modeling in order to achieve the solidity of forms in a representationally true and convincing way. The idea of reducing "nature's diversity to simple geometric solids," as discussed in

Charles Blanc's *Grammaire des arts du dessin*, was "as conventional as that of rendering depth in perspective." Such conventional drawing was taught as a matter of course in most late nineteenth-century municipal drawing schools in France.

By 1903, a comparable academic practice was instituted in Mexico City at the Academy of San Carlos, stressing the "students' faculties of direct (empirical) observation."[31] Whereas before, classical busts and prints were used exclusively in drawing classes, students now used ordinary objects as drawing models, manipulating them manually into various positions in artificial light (which was also new). They thereby derived geometric figures from the models in order to grasp the essence of perspective. This "new scientific system for the teaching of drawing" was one of several French drawing systems developed by Jules-Jean Désire Pillet. Such empirically based early training may have predisposed Rivera toward his later perceptual rationalizations of Cubism.

In his memoirs, Rivera related his conversation with Rebull about Phileban solids and the purity of Platonic forms to Ingres. Rebull instructed him, in particular, in Ingres' "use of elliptical contours in his compositions to harmonically contain the Platonic essences of a figure at strategic junctures of the Golden Section."[32] Rivera recalled being entranced by the formal dynamic interplay and strategic placement of compositional details in a reproduction of an Ingres portrait that Rebull showed him. Rebull had him diagram, by the use of a compass and ruler, the Golden Section rectangles and triangles on a sheet of tracing paper placed over the Ingres reproduction. There is, however, no documentary reference to Ingres' intentionally employing the Golden Section on teaching this proportional system to his students.[33] However, before considering Rebull an "Ingriste," he was actually an acknowledged leader of the Mexican Nazarenes. He had been the closest disciple of the imported Catalan painter Pelegrín Clavé y Roquer who implanted the classicism of "the German Nazarenes," at the Academy of San Carlos after becoming its director of painting in 1846.[34] Rebull had also frequented Overbeck's studio while he was a pensioner studying in Rome.

The Golden Section appears to have formed a part of Nazarene artistic education. It played a major role in the development of another artist who like Rivera emigrated to Paris and became a major figure in the mystical theoretical branch of avant-garde painting, Frantisek Kupka.[35] Rebull's emphasis on "mathematically quantitative compositions with humanly qualitative aesthetics," according to Rivera, provided him with a basis for his art and personal aesthetics that were and always have been inherently classicizing. It would be difficult to encounter Golden Section constructions in Rivera's Impressionist and Symbolist paintings of 1905-06, which are primarily romantic and Whistlerian in nature, but in earlier academic works such as *La era* (1904), systematically structured compositions possibly based on the Golden Section can be detected.

What is most significant about Rivera's dwelling, in his memoirs, on his purported early indoctrination in the universally valid laws of formal relationships and the Golden Section ratio is his claim to have used objective mathematical properties and fixed modules in the composition of his most complex Cubist works. However, when

explaining in great detail how Juan Gris constructed the entire surface of his Cubist canvases "into harmonically proportional and proportioned spaces…using a special Golden Section triangle constructed out of paper," Rivera provided no hint of how he (Rivera) actually applied the Golden section to his own Cubist works.[36] In the absence of Rivera's papers and notebooks and any studies or underdrawings displaying the use of a consistent Golden Section system among his Cubist works, this remains to be seen.

Mean and extreme proportional divisions can be approximately plotted on any number of Rivera's Cubist paintings where he has a tendency to divide the composition along the vertical or horizontal edge at points dividing linear or spatial segments into Golden Section ratios. This occurs, for example, where the rim of the hat breaks the edge in the 1914 *Young Man with a Stylograph (Portrait of Best Maugard)* (Cat. 24) or where the tilted yellow plane, if extended, in the *Portrait of Voloshin* (1916, Cat. 46), meets the right vertical edge of the canvas. Whether these divisions and junctures were intuitive and second-nature in Rivera's well-grounded compositional technique, or were calculated with a specific Golden Section controlling "grid" in mind is difficult to discern.

Rivera's statement that "Gris reintroduced the long forgotten concept of the Golden Section to the studios of the Cubist painters," and that Gris used a special Golden section triangle constructed out of paper might mean that he too adopted Gris' methods at that time. André Lhote, an intimate friend of Rivera during his Cubist period, also later recalled that "special Golden Section compasses could be purchased in color merchants' shops in Montparnasse and could be used to divide surfaces rhythmically."[37]

In any event, the underdrawing of one of Rivera's early transitional Cubist paintings, the *At the Fountain near Toledo* of 1913 (designated here as *Woman at the Fountain, Toledo II*, Cat. 3) illustrates that Rivera did work from preconceived ideas of well-defined arcs and elliptical curves (drawn possibly with a string-type compass) and calculations dividing his compositions by rhythmic geometric proportions. His unfinished *Still Life* of 1918 (Cat. 72) and the *Construction Drawing* (Cat. 75) for the *Mathematician* (Cat. 74) of the same year, although not Cubist, show that in leaving Cubism, if not also during his Cubist period, Rivera was engaged in a critical analysis of his work using the lessons of his teacher Rebull.

Santiago Rebull's encouragement of Rivera's "Ingresque" drawing technique and his valuable lessons on proportion and pictorial construction coupled with Velasco's theories were the most important aspects of his academic training at San Carlos for his future Cubist years. Minimized in Rivera's memoirs was the importance to his early work of the "fresh, and modern Academic"[38] — two inherent but telling contradictions — approach to painting imported into Mexico by the Catalan painter Don Antonio Fabrés Costa (1854-1936). Fabrés was Rivera's painting instructor from 1903 until 1906. Rivera gleaned what he could from Fabrés' Spanish naturalism which placed him in good stead with his future Spanish teachers. His fidelity to the Spanish academic approach between 1907-1912 is indicative of Rivera's early conservatism in matters of art, which delayed his entry into Cubism once in Europe.

An important point that requires clarification about Rivera's early training and formative years in Mexico as it related to his Parisian period is the myth that Rivera studied with the popular printmaker, José Guadalupe Posada. For example, Rivera's principle biographer, Bertram D. Wolfe, stated,

> The greatest of Diego's 'instructors' was not on the faculty of the Academy of San Carlos: his real master, if the boy may be said to have had one, was the popular engraver of illustrations for broadsheet ballads, José Guadalupe Posada.[39]

This was simply not true. The fact that Rivera ignored the engravings of Posada, at least in the style and appearance of his own work at the beginning of the century, has been little discussed in the literature on the artist. This stems from the later romantic popularization of Posada in the sources on Mexican art, which obscure the historical facts about Posada's actual "discovery" by the Mexican Revolutionary mural painters.

Rivera conspicuously remained silent about this "greatest" of instructors, in contemporary biographical accounts, interviews, and in his own writings where he often mentioned others (e.g., Rebull, Velasco, Antonio Ríos, Félix Parra), but not Posada, until 1928. Rivera first mentioned Posada in his autobiography, *Das Werk des Malers Diego Rivera*. This was three years after the immigrant French artist, Jean Charlot, first brought Posada's prints and metal plates which he had originally discovered, to the attention of his fellow Mexican Muralists. Posada's style and images were not actually to be quoted or popularized in their works until the latter part of the 1920s, after the very first article on Posada was published by Charlot, his "Un precursor del movimiento de arte mexicano: El grabador Posadas (sic)."[40] Recently arrived in the country with a Parisian formalist bias, Charlot had keenly perceived the work of Posada as exemplifying Mexico as "a pictorially plastic country *par excellence...* an essentially plastic, tragic, and supernatural land..." These qualities were alien, as recognizable in these terms, to the artists of the Porfiriato, such as Rivera, who when depicting Mexican Indians, contemporary or historical, were competing stylistically with European heroic formal renditions of indigenous figures as Classical ephebes and noble savages, or capturing the human and topographical landscapes of Mexico in the color and picturesque formats of Spanish *costumbrista* painting. Among the artists of the Porfiriato, the subject matter of Posada and his fellow manual workers in the arts were not considered worthy of inclusion in the realm of official Academic art or official "modern" art. Nor was it then conceivable for such popular art to be elevated to the rank of "arte nacional," least of all by the fledgling Mexican avant-garde with their eyes riveted on Europe.

This clarification of the actual context of Rivera's pre-Cubist years is important to bear in mind as a foil for the significance of the appearance in his work of specifically Mexican motifs — no less, in an archetypically modern European art form, Cubism. It is also important to bear in mind that even then, in 1914-1915, when Rivera decorated the walls of his Parisian studio (Fig. 9) it was not with *corridos* and *calaveras* by Posada, but with chromolithographic reproductions of El Greco's paintings, Russian balalaikas, Mexican colored *petates* and sarapes (of interest for their formalist qualities), and photographs of Picasso's recent Cubist constructions.

Contrary to the myth of Rivera as a young renegade artist who left the Academy in 1902 at the age of sixteen, he was, by all contemporary accounts, a model student at the Academy of San Carlos and a promising young artist of the Porfirian period.[41] He was a student totally immersed in the study of historical techniques and theory in painting. Rivera's work progressed from a superb technical fidelity to the Ingresque drawing technique of the "Mexican Nazarenes," Rebull and Parra, as seen in his Neo-Classical student drawings of the period to the naturalism of Fabrés and Velasco's late Impressionism. There was also an unofficial side to the young artist's formative years in Mexico. By

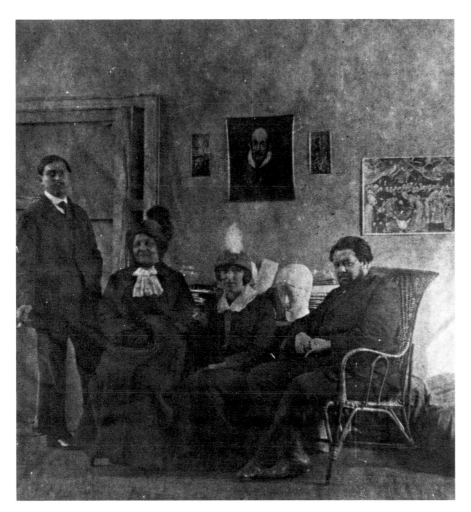

Figure No. 9
Diego Rivera, Angeline Beloff, Angel Zárraga, and Rivera's mother in Rivera's Parisian studio, c. 1915.
Photograph courtesy of INBA
A copy of an El Greco portrait, traditionally thought to be El Greco's *Self-Portrait,* and a reproduction of El Greco's *Burial of the Count of Orgaz* are hanging on the background wall along with two other smaller El Greco reproductions.

1906, Rivera had through his associations at the Academy of San Carlos fallen into living 'una bohemia mexicanísima' (a "distinctively Mexican bohemia").[42] It was a bohemia of the sophisticated *peintres maudits,* young architects, law students and intellectuals, and the Neo-Symbolist *literatos* of the *Savia Moderna* group — the seedlings of the future *Ateneo de la Juventud.* Among Rivera's closest friends in the group were architect Jesús Acevedo and writers Pedro Henríquez Ureña, Alfonso Reyes, and Martín Luis Guzmán. All four were to join him at one time or another in Paris and Madrid during World War I. Among the artists and writers of the short-lived *Savia Moderna* review (1906), Rivera cultivated a Symbolist aesthetic and taste for the works of Whistler, Carrière, Besnard, Rodin, the early Kupka, and German *Gedankenmalerei* ("thought-painting"), which were reproduced in the journal. Encouraged by Gerardo Murillo ("Dr. Atl"), who was then still known by his Christian name, Rivera and the *Savia Moderna* artists experimented in an eclectic modernism comprised of variations on an attenuated Whistlerian Impressionism, Neo-Impressionism, and Nabi-like Symbolism.

After his successful participation in the year-end exhibition at the Academy, Rivera left Mexico for Europe in January 1907 with a pension from the Porfirian governor of Veracruz, Don Teodoro A. Dehesa. At the age of twenty he traveled to Spain to study painting under the direction of a reputable Spanish master, Eduardo Chicharro, and to "find" himself and his personal style. Contrary to Rivera's later romanticized recollections, neither Paris nor intentions to study with Cézanne formed part of his immediate plans. Cézanne had died the previous year and even then the radical late work of the Master from Aix was largely unknown even in France and influential to only a limited Parisian circle.[43] In letters home over the next few years, Rivera

discussed plans to travel to Italy (Rome) to further his studies and to remain there an extended period before traveling through Europe. Rivera's plans to travel to what he then considered the artist's Mecca, Italy, and not Paris, also says much about his then conservative and academic orientation that would gradually be changed in Spain.

One of the most salient features of Rivera's early period in Spain was his immersion in the bohemian life of Madrid among the Spanish literary and artistic avant-garde. His social and literary contact in the Madrilenian *vanguardia* with such people as Ramón Gómez de la Serna, the Baroja brothers, Don Ramón del Valle-Inclán, Maria Gutiérrez Blanchard, Solana, and Viladrich, were more important than his academic ones for his future involvement with more progressive artistic forms in Paris. Most influential for Rivera's subsequent development was the writer and then art critic, Valle-Inclán, whose classicizing and idealistic aesthetic was at the core speculative and metaphysical.[44] His Spanish contacts would also be critical for Rivera's subsequent economic survival in Europe during the First World War when he spent seven months in Madrid.

Rivera remained in Spain from 1907 until the spring of 1909. His exposure to the master works in the Prado Museum and the technique-oriented teachings of Chicharro, figured in the development of Rivera's later Cubist technique. Rivera spent many hours copying at the Prado where he was naturally drawn by the works of Goya, Velázquez, and El Greco. He was also especially attracted by the cool, glazed palette of emerald and viridian greens, pinks, sienas, and rich umbers of the Dutch and Flemish Primitives. Their lacquered tones appear in numerous works from Rivera's early Spanish and Parisian periods, and in the delicate enamel-like palette of the *At the Fountain of Toledo I (Women at the Fountain*, Cat.2) and the *Tree and Walls, Toledo* (Cat. 12) of 1913. There are also elements of Rivera's "museum-derived" palette, evoking the especially rich metallic contrasts of El Greco, in his *Adoration of the Virgin and Child (Composition, peinture à la cire)* and *Woman at the Well* (Cat. 18) of 1913. Several years later in 1914, when Rivera was "marching at the head of the Cubist line," the Mexican writer, Roberto Barrios who visited the artist in Paris noted his tendency to

> always select the greatest and most valuable impulses from the past, and the most daring from the present. And thus, being sometimes ultramodern and at others archaic, his art exists in a luminous progression.[45]

Eduardo Chicharro, who had a significant impact on Rivera's pre-Cubist painting, was an accomplished colorist and fashionable portraitist. It is interesting to note that Rivera chose to study in Madrid with an academic artist who labored on large, Realist *costumbrista* paintings for the Venice Biennale and other international competitions, and who also displayed a sympathy for Symbolist or subjectivist qualities in painting. These two distinct tendencies were also paradoxically the ones Rivera followed simultaneously for the next five years before his entry into Cubism.

Paris and Rivera of Montparnasse "Avant Vivant" ("Before it was Lively")

> About his first arrival in Paris, Rivera later stated
>
> Paris had been my goal. My roving now ended, I set to work and soon fell
> into the usual routine of the art student…working in the free academies
> of Montparnasse… At night I joined groups of fellow students in the cafés
> in warm discussions of art and politics. Among these students were
> several Russians who had suffered exile and lived among professional
> revolutionaries… In my painting, I sought a way to incorporate my
> increasing knowledge and deepening emotions concerning
> social problems.[46]

Rivera got consistently ahead of himself in his memoirs regarding his Parisian
years and his meetings with Russian revolutionary émigrés, most of which
occurred only after 1913 and his friendship with Ehrenburg. In 1909 when
Rivera arrived in Montparnasse, the celebrated bohemian and avant-garde
artistic quarter was only beginning its "mutation." Citing an impressive list of
prominent professors from the Ecole des Beaux-Arts who inhabited the
quarter, its historian, Jean-Paul Crespelle, surprisingly noted that "at the
beginning of the century, the 'pompiers' (academic) painters formed the most
important artists' colony in Montparnasse,"[47] Although the café-tabac known
as the Dôme was already open when Rivera settled there in 1909, and the
Closerie des Lilas had long been catering to an exclusively literary crowd, the
notorious Rotonde café did not open its doors until 1911. In the eyes of
another contemporary observer, the critic Apollinaire, the artistic activity of
Montparnasse did not replace that of Montmartre until well into 1914.[48]

During Rivera's first stay in Paris, the wilder aspects of Murger's "la
bohème" were out of his realm of experience, even for this bohemian of
Madrid — a situation that would change considerably upon his return to Paris
in 1911. As the few letters which have surfaced from this period
reveal, Rivera was still a serious student of painting who worked and
studied tirelessly.

Rivera first arrived in Paris without much fanfare in the summer of 1909.
Accompanied there by his close friend, the eccentric Catalan painter of
gypsies and monks, Miguel Viladrich, he at first had no intention of staying. To
Rivera, Paris was at the time only the first stop on the express train to
Belgium, Munich, Rome and the great international art exhibitions.
Nevertheless, he settled in a small hotel on the "Boul Mich," in the Latin
Quarter and immediately set out to study museum collections, attend
exhibitions, and lectures. He also engaged in open-air painting along the
picturesque Seine River during which he produced his most exemplary work of
subjectivist Impressionism, the *Notre Dame Cathedral Behind the Fog.*

Not long after arriving in France, Rivera made a long-awaited pilgrimage to Belgium and to the archetypally Symbolist city of Bruges, where he painted a number of Symbolist-inspired works. In Bruges he also met his future female companion for the duration of his long Parisian stay, the Russian painter and printmaker, Angeline Beloff. Beloff was in the company of the Spanish female painter, María Gutiérrez Blanchard, whom Rivera had known earlier in Madrid. Their friendship was to become a very close one and the three artists would share a studio together on various occasions during the next ten years. Before his return to Paris in the winter of 1909, Rivera made a brief trip across the Channel to London which provided him the opportunity to visit more museums and deepen his relationship with Angeline Beloff.

For the remainder of the year that Rivera spent in France, his work vacillated on the edge between modernism and the academic tradition. His careful studies of the masters in the Louvre hindered his progression towards the new. While María Blanchard and Angeline Beloff worked at the Montmartre *atelier* of the Catalan *modernista* Anglada Camarasa, Rivera studied with the obscure academic painter, Victor-Octave Guillonet whose studio was also on the Right Bank. Participation in the Parisian Salons followed. Rivera's first Parisian Salon was the 1910 Salon des Indépendants that he entered for the simple price of an entry fee. He contributed six oil paintings to the spring Salon including the *House on the Bridge* (1909-1910). Before the Salon des Indépendants closed, Rivera rushed to withdraw what he considered his most important painting up to then, the *House on the Bridge,* and submitted it, and possibly other works, to the jury of the Salon de la Société des Artistes Francais. It was Rivera's only work accepted by the jury. He returned home to Mexico that fall to arrange an exhibition of his recent works apparently impervious to Cézanne and the earliest Cubist manifestations in the 1910 Salon des Indépendants.

In spite of the fact that Rivera's one-man exhibition in Mexico City opened on the day on which the Mexican Revolution began, its opening was celebrated with great pomp and enthusiasm. The president's wife inaugurated the exhibition at the Academy of San Carlos where it was installed from November 20 until December 20, 1910. It was well-received and won rave reviews.

According to news items, his brief return to Mexico was for the sole purpose of visiting his parents and friends, having an exhibition, and hopefully securing an extension of his European pension from the governor of Veracruz. To the Porfirian aristocracy that flocked to his exhibition and purchased almost all his works, Rivera and his show were an unqualified success. With a substantial sum in hand from the sale of his paintings[49] and possibly a renewed government pension from the state of Veracruz, the young Rivera soon returned to Europe.

Rivera later claimed to his biographers that after his "qualifiedly" successful exhibition closed, he "went to the south where he joined Zapata's peasant partisans in the state of Morelos." He stated that "at the end of six months as an active rebel, he received a warning from his friend in the capital,

Naturaleza muerta con botella, (Still Life with Carafe) 1914 Catalogue No. 23

26 *Naturaleza muerta española, (Spanish Still Life)* 1914 Catalogue No. 20

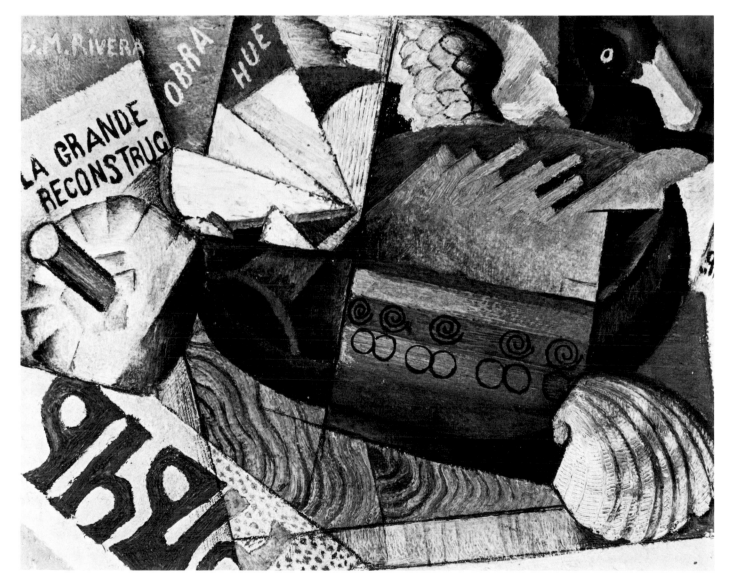

La Grande Reconstruction, (The Great Reconstruction) 1915

Catalogue No. 34

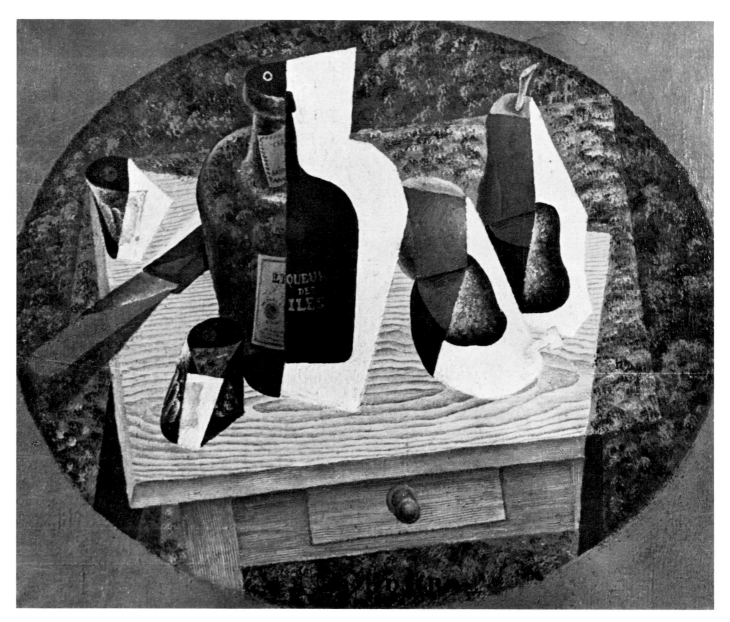

Still Life, (Naturaleza muerta) 1915

Catalogue No. 37

Don Antonio Rivas Mercado (still the Director of the Academy of San Carlos) that he must leave the country or be arrested and shot!"[50] Contrary to this heroic ending to his Mexican stay, of which there are several no less suspenseful variations, at the close of Rivera's exhibition at San Carlos, the capitoline newspapers announced that the artist would leave Mexico City on the 3rd of January 1911 for Madrid, where he was to continue his studies in painting.

Due to the cataclysmic circumstances in his own country, namely, the outbreak of the Mexican Revolution and the ensuing chaos, and in the absence of access to the artist's papers, there is very little information in Mexican, Spanish, and French sources that has come to light regarding the period in Rivera's life from the time he returns to Paris in 1911 and his first Cubist works in 1913. Aside from a line or two in Parisian Salon reviews, catalogues from the Independents and Autumn Parisian Salons, and the works themselves — many of which are undated — there is little documentary material to accurately reconstruct the crucial years between 1911 and 1913. The important decisions that Rivera made regarding both his life and his art during this period (i.e., to remain in Paris and not return to Mexico and to launch himself on a stylistic trajectory that would lead him to Cubism) will have to remain, for the present, speculative.

Rivera's later conflicting and contradictory accounts about his activities in Mexico as a "revolutionary fighter" and the date of his return to Paris, ranging anywhere from July to the end of 1911,[51] apparently have no basis in fact. The most preposterous reason Rivera has given in his highy romanticized memoirs as to why he returned to Paris in 1911 was to complete a pre-ordained Revolutionary mission. After his trip to Mexico in 1910 he was to report personally to Lenin the details of the Mexican situation and provide him with copies of political documents of the Mexican Revolution. The clandestine meeting, according to Rivera, took place in a little *brasserie* (beer-salon) near the Rotonde Café in Montparnasse. Equally preposterous was the reason Rivera advanced for remaining in Paris until 1921 and not immediately returning to Mexico in 1911 "to take his place among his fellow revolutionaries." Lenin, according to the artist, had found deficiencies in his agrarian and "pro-anarcho-syndicalist" views about Revolution and instructed him to remain and study among his Russian comrades in Paris to properly develop his knowledge of Marxist-Leninist ideology.[52]

After returning to Europe and Spain in 1911, Rivera made his way to Paris to establish himself in the artists' quarter of Montparnasse. He settled in a small studio with Angeline Beloff at 52, avenue du Maine, immediately next-door to the recently founded Académie Russe. In his new Parisian studio, Rivera completed two large canvases from studies begun in Mexico, which he entered in the 1911 Salon d'Automne. The two works, two views of the Mexican volcano, Iztaccíhuatl, drew no notices from the major Parisian critics in their reviews of the Salon. They were, however, discussed by Ulrico Brendel in an extensive Spanish-language review covering the Hispanic artists exhibiting in the 1911 "Salón de Otono" in *Mundial Magazine*.[53]

Brendel's review of the 1911 Salon d'Automne is important for setting the artistic stage to which Rivera returned from Mexico via Spain in the early fall of 1911. By spending the first part of 1911 in Spain, as seems to be the case, he missed the first public manifestation of the Cubist painters, excluding Picasso and Braque, in the notorious *Salle 41* of the Salon des Indépendants.[54] In the 1911 Indépendants, the early Cubist works of Gleizes, Metzinger, Le Fauconnier, Delaunay, Léger, and the more conventional paintings of Marie Laurencin had been grouped together in a single room. In a nearby room were the less "cubified" works of Lhote, La Fresnaye, and Segonzac. The paintings of the "Salon Cubists" in Salle 41 consisted of a highly diversified "style" of Cubism derived from varying combinations of Nabi planarity and curvilinearity, formal devices to be found in the late works of Cézanne, such as geometrication, *passage,* and multiple views; and Fauvist conceptions of arbitrary and expressive color. As well, there were signs of a recent familiarity with the Cubist innovations of Braque and Picasso, on the part of the exhibitors. Their diverse and radical works had two things in common in the eyes of the outraged public and most critics: excessive and extreme distortion and illegibility ("illisibilité"). The 1911 Indépendants exhibition of Cubism, which had heretofore not been seen in such force, also gave rise to the notion of a Cubist artistic movement in Paris by 1911 and the popularization of the term "Cubist" in the art press with its concomitant defenders and detractors. Among the latter was Brendel.

In Salle VIII of the 1911 Salon d'Automne (Fig. 10), another celebrated "Cubist room" in the history of Cubism, Rivera is sure to have seen the works of other early Cubists, if not, he was sure to have read about them in Brendel's review. From an early date, Rivera displayed a penchant for keeping track of what, and by whom, was written about him as evidenced by the few known letters that he wrote home from Europe.

The paintings of the original "Salon Cubist" group named above had attained a considerable advance in stylistic sophistication and synthetic, geometrical distortion over those exhibited in the spring. The group was now also joined by Jacques Villon, Marcel Duchamp, and Rivera's future close friend André Lhote. If Rivera did not understand what the exhibiting Cubists were driving at in their work, he was surely not to miss the detailed and not entirely negative observations about the "recently arrived Cubists of Room 8" made by Brendel. In his review, Brendel reserved his most critical and illuminating remarks for the Cubists:

> For art there is no worse calamity than the pretension of those who are inept enough to pretend to be geniuses. Seduced by the inspirations of the congenial genius Picasso, that Picasso to whom hours of the terrible bohemian life caused him to burst out in violent words which were like dynamite bombs, a group of painters have ventured forth, in order to quickly acquire fame, to create a school based on a geometrical technique. Theoretically, this tendency is not illogical if we take into account how the divine Leonardo expounded in the Codex Vaticanum. And if one analyzes his works he utilized geometry in them with the maximum results.[55]

Cubism to Brendel, was but another attempt to reconcile art and science, if only in pure theory; and the Cubists indeed had a long way to go to realize in the "formless cataclysm" of their work what they projected in theory. He quoted whimsically but sympathetically from a recent article by Metzinger, whom Brendel called the Cubists' "corifeo" ("coryphaeus"), where the artist stated a simple but fundamental aim of the Cubist painters: to attempt to fix space and time in their works by "moving around the object in order to present a concrete representation made up of several successive aspects."[56]

There is no record of what Rivera's reaction to this most modern
manifestation of painting was in the fall of 1911, or if his interest was the least
bit piqued about this "congenial genius Picasso," whom he would not meet
until 1914, but if one is to judge from his subsequent work, the impact of
seeing Cubist paintings for the first time was surprisingly nil. This fact is
significant for reconstructing Rivera's transition into Cubism, which was an
exceedingly gradual one. It is even questionable as to whether Rivera had yet
even "discovered" Cézanne. There is absolutely no evidence in his work from
1911-1912 to support this later claim. Instead, Rivera seems to have been
completely taken by the Neo-Impressionist and Divisionist revival that was
concurrently underway in Paris in 1911.

After collecting his works at the close of the 1911 Salon d'Automne, Rivera
parted for the mountains of Cataluña where he undertook a series of
Divisionist paintings of the sharply-outlined and celebrated mountain mass,
the Montserrat ('serrated mountain' or Montsagrat, 'sacred mountain') of the
Catalans. His choice of subject matter appears to be related to his now lost
paintings of the Mexican volcano, the Iztaccíhuatl, painted during his trip to
Mexico and reveals Rivera's predilection for depicting imposing symbolic
motifs and dramatic views in his landscapes. This characteristic of Rivera is
also apparent in his epic Cubist landscape of the *Plaza de Toros* painted in
Madrid in 1915.

Rivera's actual involvement with Divisionism and a pointillist technique
was short-lived until he later adopted it in a purely decorative manner in his
Cubist painting. His interest in Divisionism, the laying down of separate
strokes or "points" of pure colors to theoretically achieve optical mixture and
maximum luminosity, during 1911 coincided with the important general
resurgence of interest in Neo-Impressionism in Paris during that year.[57] Rivera
returned to Paris and exhibited two Montserrat landscapes in the 1912 spring
salon without attracting much critical attention. When one of Rivera's
Montserrat landscapes was later shown along with Cubist paintings in New
York in Rivera's 1916 one-man exhibition at the Modern Gallery, it elicited the
remark that "In 1911, Mr. Rivera was doing quite nice Signacs," and the
observation that

> Mr. Rivera is a follower of the most advanced schools of contemporary
> French art, his earliest canvas shown here (it dates from 1911) being
> of the 'confetti' type of pointillism, and while it is lovely in color there
> is not a trace of originality in an inch of it.[58]

After the closing of the Salon des Indépendants in May 1912, Rivera and Angeline Beloff packed up their belongings and vacated their Avenue du Maine apartment in Montparnasse. It is not known if they bid farewell to their neighbor, a young Dutch painter by the name of Piet Mondrian, who had briefly shared the same address that spring of 1912.[59] In any event, they would again be neighbors when the Riveras returned to a new Montparnasse apartment in September 1912. This spring they traveled south to Spain, possibly stopping in Barcelona, and spent the rest of the summer on the parched and arid Meseta of New Castille in the ancient Moorish-Gothic city of Toledo. Rivera had briefly painted there before in 1907, when he first arrived in Spain from Mexico, but this stay was to be much longer. He met a fellow-Mexican painter there, Angel Zárraga, who was also based in Paris and with whom he had by now cemented a strong artistic and personal friendship. Zárraga had come to Toledo on a "pilgrimage journey to admire the works of El Greco, which he had not seen for many years."[60] Rivera, Beloff, and Zárraga rented a house at No. 7, Calle del Angel that was to be their home away from Paris on and off for the next two years. The house was located only a few blocks away on the same street as the famous chapel of Santo Tomé that housed, in situ, El Greco's masterpiece, *The Burial of the Count of Orgaz*. In addition to this celebrated painting, Rivera and Zárraga would have ample opportunity to study closely many major original works by the Toledan master in his adopted city. Zárraga later returned to the house during the First World War where he entertained such guests as the Delaunays, the American painter Samuel Halpert, and Alfonso Reyes and Jesús Acevedo who were then in exile in Spain.[61]

Rivera returned to Spain in 1912 with a rekindled interest in Zuloaga, El Greco, and the plastic characteristics of the Spanish landscape and its picturesque people. However, El Greco's mannered depository of sources for Cubism were discovered by Rivera only after realizing that he was wasting his time approaching him through the stylish, second-hand mannerisms of Ignacio Zuloaga. He soon surpassed Zuloaga at his own style. Writing about one of Rivera's most important and monumental paintings executed in Toledo in 1912, *The Old Ones* (Olmedo Collection, titled *A las afueras de Toledo*, Fig. 11), the Peruvian critic Francisco García Calderon noted in the first major article devoted to the Mexican artist and his Cubism in 1914,

> In this painting done in Toledo, *Los Viejos,* which dates from 1912, we discover an undeniable personality. Sure influence from El Greco to Pantoja to Zurbaran can be detected perhaps more fully in the Mexican artist — a spiritual similarity with Zuloaga and Zubiaurre in the evocative background, but in the expression of his figures there is the most beautiful originality. Rivera could have been a rival of the great Spanish painters. Among the descendants of the Greek Theotocopuli who prospered in the austere peninsula, his (Rivera's) intense and personal work would have conquered for him loyal support. Sincere and mutable he leaned toward Impressionism. The critics praised him before as a rival to Zuloaga...[62]

That Rivera was to develop something more out of his introduction to El Greco and his renewed contact with the Spanish soil from the vantage point of Paris was inevitable. The landscape and *costumbrista* scenes that Rivera painted in the environs of Toledo in 1912 began in a Zuloagan style but ended

Figure No. 11
Diego Rivera, *Los viejos (The Old Ones)*, 1912
Oil on canvas
Collection of Sra. Dolores Olmedo, where it is
titled *En las afueras de Toledo*

in something entirely different. His strongly Realist and expressionistic
character studies of Spanish peasants backed by panoramic views of the
austere, rugged, and harsh Spanish landscape eventually gave way to
geometricizing and broad faceting of planes, or in short, Cubism by 1913. This
path can be followed along the lines of his development in the Toledan
paintings, *The Samaritan* and *The Old Ones* of 1912 and in the transitional
Cubist works: *Landscape near Toledo, At the Fountain of Toledo (Women at
the Fountain, Toledo I)*, and its related works, and in *The Old Hamlet, Toledo*
and *Landscape of Toledo* (Cat. 6) all of 1913.

This transition to Cubism, however, was accomplished through the more
important intermediary of Angel Zárraga, whom Rivera soon overtook in the
new style. It was through Angel Zárraga's lesson and their joint study of El
Greco's works *in situ* that Rivera realized the implications of what he had been
doing that year in Toledo. The deeply creviced and weathered faces of the
regional peasants on which Rivera concentrated as subjects in *The Samaritan*
and *The Old Ones* were forms especially susceptible to angular geometricizing.

33

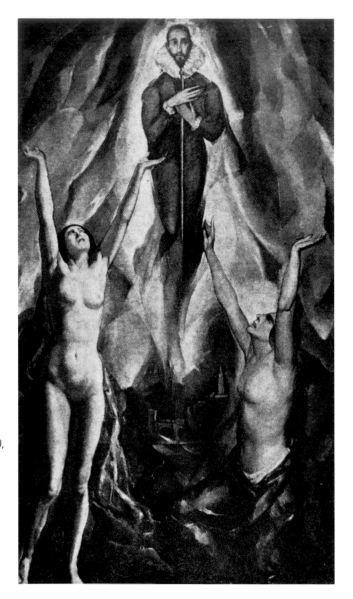

Figure No. 12
Angel Zárraga, *La purificación (Purification)*,
1912
Oil on canvas
Private Collection, Mexico

So too were the sharply contoured landscape and stark cubes of buildings and stone huts that his subjects inhabited. In the *Old Hamlet, Toledo,* and the early 1913 *Landscape of Toledo* , one can see the growing concern for planar and abstract geometric organization that led Rivera to the first stages of his Cubist style in Toledo.

Attesting to the ''Cubist'' appearance of the city and its surrounding landscape, and to the inescapable impression it would make on an artist familiar with Cubism, are the American artist Sam Halpert's remarks to Robert Delaunay:

Toledo is a true paradise for a Cubist and where an artist would end up becoming one for all of Toledo is a superposition of cubes over enormous stones: dramatic cubes. And there is absolutely nothing sinister about it.[63]

Zárraga first realized these formalistic possibilities of the terrain and El Greco's proto-modernist space early in 1912 in *The Purification* (Fig. 12). Rivera took another year before the meaning of Toledo's urban topography and disposition of forms and planes, so similar to his birthplace of Guanajuato, was understood and realized by him in plastic terms. It is interesting to note that whereas only a few critics perceived the evolution of Rivera's early Cubist works as being tied to Toledo and El Greco, Vauxcelles made a point of emphasizing these two important factors in the development of his compatriot Zárraga's Cubism. In a 1920 catalogue preface he wrote,

> When he arrived in Paris (1904), the Fauves ("Wild beasts") were howling at the top of their lungs. For a man who was just returning from a visit to the Uffizi (Galleries), the spectacle was disconcerting. Zárraga watched with curiosity, sympathy, seeing for himself the hurly-burly (confusion) and was not demoralized nor affronted. He then left Paris for Toledo. The stylized elongations of El Greco impressed him; the Cretan painter's influence led him towards Cubism, which shouldn't have surprised anyone.[64]

The beginnings of Zárraga's El Grecoan influence over Rivera is clear from Rivera's portrait of his friend (Fig. 13), which dated from before November 1912 and was probably painted in Toledo before their return to Paris that fall. It was reproduced, minus the long neck that Rivera had elongated to comically awkward proportions in a 1912 *Mundial Magazine* "Cabeza" (literary portrait) of Zárraga.[65] That Zárraga would warrant a laudatory "Cabeza" written by *Mundial Magazine's* director, the Nicaraguan poet Rubén Darío, attests to Zárraga's artistic stature among the Parisian Latin American émigré colony of artists and writers. That Rivera was never accorded one and tended to always take a back seat to Zárraga in the Parisian Spanish-language exhibition reviews attests to Rivera's place in that cultural society. It is also apparent that from this point Zárraga was regarded as a more seasoned artist and his work remained more accessible to moderate avant-garde tastes than the increasingly ambitious work of Rivera. Although the same age as Rivera, Zárraga was well-entrenched in the artistic and social landscape of Paris and Madrid before Rivera's arrival. He was considered "at the side of Diego Rivera, a veritably 'chic' painter."[66] Rivera walked in Zárraga's shadow in Paris and Spain until 1914 and was again overtaken by Zárraga's popularity among Parisian critics after 1918. Zárraga was, however, significantly eclipsed by the more extremist artist on the Cubist terrain when he failed to commit himself to the theoretical degree that Rivera did.

Figure No. 13
Diego Rivera, *Portrait of Angel Zárraga, 1912*
Oil on canvas
Present whereabouts unknown
Photograph courtesy of INBA

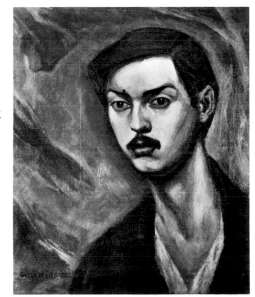

A New Studio at 26, Rue du Départ and a New Style

Diego Rivera and his wife Angeline Beloff returned to Paris from Toledo in the early fall of 1912 just in time for Rivera to frame his two entries for the Salon d'Automne, and to establish themselves in what was to be their Parisian home for the next seven years at 26, rue du Départ (Fig. 14). Returning with them in addition to Zárraga and his old friend Enrique Freymann, was a new acquaintance of Rivera, the Polish-Jewish painter Leopold Gottlieb (1883-1935). Gottlieb was to become one of Rivera's closest pre-war Parisian friends and an intermediary between many bohemian and émigré artistic circles that summer in Toledo. Gottlieb's *Portrait de M. Rivera* (Fig. 15), inscribed "Toledo" on the front, was painted shortly after their meeting and entered in the 1912 Salon d'Automne. Gottlieb's friendship and the Riveras' move into the block of artists' studios off the Montparnasse train station on the rue du Départ marked the important beginnings of Rivera's integration into the milieu of the Parisian avant-garde.

Hermenegildo Alsina, the subject of Rivera's *Portrait of a Spaniard* (1912) and his entry into that year's Salon d'Automne had also returned from Spain to Paris to exhibit. Alsina, whose studio was located at 2, passage de Dantzig in a building known as "La Ruche" ("the Beehive"), was instrumental in introducing Rivera to that "cité artistique" ("artists' compound") on the periphery of Montparnasse. In 1912, the beehive-shaped pavillion of artists' studios in the working-class district of Vaugirard housed the impoverished ateliers of Marc Chagall, the Basque painter Ortiz de Zárate, the Russian Sterenberg, and Alsina's countryman Jaime Otero, who was the subject of a small Fauve-like oil study by Rivera, *El Escultor* in 1912. The notoriously dilapidated studios of La Ruche were frequented at one time or another by Modigliani and his circle and a veritable who's who of what was to become the Ecole de Paris by the end of the First World War and Rivera's milieu. In 1912, the Russian sculptor Elie Indenbaum was also living there and was paid frequent visits by his compatriot Oscar Miestchaninoff. Both became close friends and the subjects of fully Cubist portraits by Rivera the following year in the *Man with the Cigarette* and *The Sculptor (O. Miestchaninoff*, Cat. 11).

Of special critical significance for Rivera's evolution into a Cubist style during the remainder of 1912 and 1913 was his encounter with several Dutch painters, among them Piet Mondrian, upon moving into his rue du Départ studio. As was mentioned earlier, Mondrian had been Rivera's neighbor at another Montparnasse address the previous spring. By the summer of 1912 Mondrian had moved into a group of studios on the rue du Départ rented out to the avant-garde Dutch painter-critic Conrad Kikkert. He was joined there by the painter Lodewijk Schelfhout (1881-1943). By 1912 both Schelfhout and Mondrian (Fig. 16) were themselves converts to a particularly planar Cézanne-inspired Cubist style. After his arrival in Paris in the winter of 1911-12, Mondrian had undertaken his private analytical study of Cézanne and transformed his findings into two schematically Cubist pictures: *Still Life with Ginger Pot I and II*.[67] In 1911 Lodewijk Schelfhout had developed an equally Cubist and Cézanne-derived style while painting in the countryside of his mentor, Provence. Their work contributed significantly to the development of Rivera's 1912-13 Toledan transitional Cubist landscapes.

Figure No. 14
Courtyard at 26 rue du Départ, Paris showing part of building that contained Rivera's and Mondrian's studios c. 1914.
Photograph courtesy of Mr. Harry Holtzmann, Connecticut

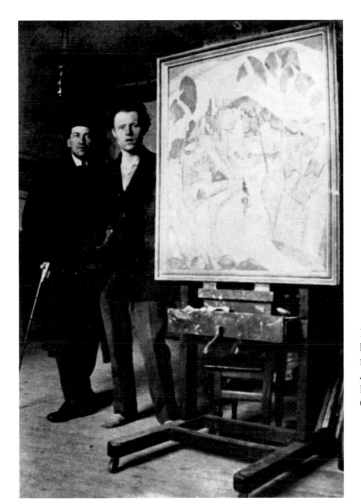

Figure No. 16
Mondrian in Lodewijk Schelfhout's studio at 26
rue du Départ, Paris, c. 1912. Schelfhout's *Les
Angles* of 1912 is on the easel.
Photograph courtesy of Mr. Harry Holtzmann,
Connecticut

Upon Rivera's return to Montparnasse from Toledo, he was greeted by a group of Mexican artists now living in Paris in what must have seemed like a class reunion from his days at the Academy of San Carlos. In addition to his close friends Zárraga, Freymann, and Murillo (who had by now adopted the pseudonym "Atl" and was working in his suburban studio at Le Vésinet), during the course of 1912 Roberto Montenegro had returned to Paris and was sharing quarters at Rivera's first Parisian studio at 3, rue de Bagneux with the young Mexican artist and aristocrat, Adolfo Best Maugard. Best Maugard had recently arrived in Paris on a commission by the Mexican Ministry of Public Education. He was to reproduce copies and facsimiles of "Mexican archeological objects and historical documents related to Mexico," in European museums and libraries.[68] Best Maugard's sister, Emma, also a painter, had arrived with him. In addition to the draughtsman and caricaturist, Ernesto García Cabral, who was now in Paris on a grant from the Madero government, the earliest proponent of a native Mexican "indigenista" artistic style, Jorge Enciso, also joined the group for a brief period. Both Montenegro and Best Maugard exhibited in the 1912 Salon d'Automne, along with Rivera, Zárraga, and Freymann, however, they did not draw the notices that Rivera or the critically more successful Zárraga drew that year.

Rivera's stay in Paris this fall was relatively brief. Neither he nor Zárraga entered their most stylistically advanced works in the Autumn Salon. Rivera chose to save *The Old Ones* and other paintings he had begun in Spain for what was to be his first Parisian group showing at a private gallery in January

Figure No. 15
Leopold Gottlieb, *Portrait de M. Rivera, Toledo,*
1912
Oil on canvas
INBA, Museo Casa Diego Rivera, Guanajuato

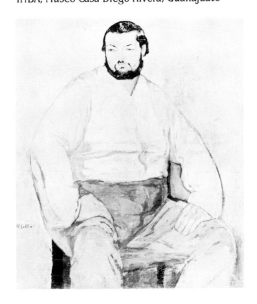

1913, the "Groupe Libre" exhibition at Bernheim-Jeune. He was anxious to return to Toledo to continue his preparations for that exhibition there. Rivera recalled that in the fall of 1912,

> I returned anew to Toledo, leaving behind in the Salon d'Automne a portrait of the Catalan master in book binding, Alsina (*Portrait of a Spaniard*), and a canvas from Toledo that was much influenced by El Greco (*The Samaritan*), but with the undesirable and unpleasant aftertastes of modern Spanish painting...[69]

Adolfo Best Maugard also recalled that shortly after meeting Rivera in Paris that fall (1912), he soon joined him in Toledo:

> In those days Rivera departed for Toledo where we later met together to admire the works of El Greco that were only then being revealed to the art world, and which had an influence on Rivera's paintings, especially his series of women with water jugs and landscapes with dramatic skys.[70]

The Problem of Rivera, El Greco, and Cézanne

Upon Rivera's return to Toledo he continued anew his study of El Greco. He also returned with a new understanding of the Cézannist Cubism to which he had been exposed in the work of his Dutch neighbors at the rue du Départ and in the recent Cubist manifestations in Paris. His preoccupation with the "Toledo of El Greco" and a new approach to painting can best be discerned in Rivera's *View of Toledo*, among the last works he completed there in 1912. It is a dramatic view of the city rising from the deep gorge of the Tagus river painted from a high vantage point southeast of Toledo and across the river. The ochre-colored cluster of towers, steeples, and roofs rise prominently above the angular geometry of the granite promontory. The large diagonals of the composition culminate in the upper left in the spire of the Cathedral of Toledo and in the upper right corner with the ancient Moorish palace, the Alcazar.

In his *Purification*, Zárraga had incorporated the emblematic displacement of architectural monuments of El Greco's *View of Toledo* (Metropolitan Museum) almost verbatim. In his *View of Toledo*, Rivera relied on topographical accuracy and a selective view of the city that lent itself to complex geometrical and perspectival possibilities. The unfolding, tilting pattern of the buildings rendered with degrees of perspectival "distortion" could be and has been misconstrued as exclusively "Cézannesque." Both Arquin and Fernández saw Rivera's *View of Toledo* as being "derived directly from Rivera's close study of Cézanne's paintings."[71] Fernandez even considered the painting "Cubist, but not of the real Cubism of the moment, Analytical Cubism...."

Rivera's *View of Toledo* belongs not to his Cubist period, but to his proto-Cubist work and the painting, which maintains a relatively intact Renaissance conception of space, is not derived directly from Cézanne. The diagonal thrust of the landscape, especially in the line running from the red tree branches in the lower foreground up through the prominent ridge to the Alcazar at the top, is decidedly un-Cézannesque. The composition, on the other hand, is quite similar to El Greco's unconventional and conceptual shaping of Toledo's landscape in his cartographic *Vista y plano de Toledo* with which Rivera would have been familiar. It was on view in the Museo del Greco, only a few blocks from Rivera's house in Toledo. The anti-naturalistic perspective in El Greco's *View and Plan of Toledo*, replete with diagonals that diverge from the spectator, was dictated by El Greco's Mannerist, oblique bird's-eye-view of the

city and its environs. It is remarkably similar in some areas to a Cézannian defiance of perspective rules. However, it remains an essentially Renaissance conception of deep space modified by El Greco's skewed vision of the expressive and conceptually formalist (artificial) possibilities of the geometrically convoluted cityscape. In a comparison between Rivera's *View of Toledo* and El Greco's *View and Plan* of the same, it can be seen that Rivera owes considerably more to El Greco than to Cézanne. Especially noteworthy in the lower left side of El Greco's painting are the obliquely flattened and roughly "cubified" buildings which are inclined sharply and arbitrarily shifted on the sloping hillside. In his *View of Toledo*, and in a closer example, the tilted background cityscape of *The Samaritan*, Rivera's simplified treatment of the receding architecture is identical to that of El Greco. In that small section of *The Samaritan*, Fernández had also seen "already an incipient Cubism...a derivation from Cézanne."

In Rivera's *View of Toledo*, elements betraying the artist's awareness of modern French painting are not directly derived from Cézanne. The angularized trees and rocks in the foreground whose geometricized shadows are hatched in angular brushstrokes recall the same technique current by 1910 in the Cézanne-inspired works of many of the early Salon Cubists. They, in turn, were the result of a variety of post-Cézanne sources, among them Braque's more-developed, experimental L'Estaque landscapes of 1908 — those which had given rise to the misnomer "Cubism" for the geometrically divergent style.[72] In addition to the highly decorative palette, a curious remnant of Rivera's Symbolist period in his *View of Toledo* is the anomalous clump of curvilinear flame-like branches in the lower left-hand corner. Painted loosely in a deep red, the irregular surface-bound shapes become both a color and linear *repoussoir* device with the branches pointing nervously upward and backward toward the cityscape. One of the last naturalistic studies of water reflection in Rivera's oeuvre also appears in the middle-ground of his *View of Toledo* where curious elongations of fortified walls are reflected in the smooth waters of the Tagus.

In addition to the overwhelmingly El Grecoan as opposed to Cézannian sources for Rivera's proto-Cubist and early Cubist works painted in the environs of Toledo, there was the "Cubistic" character of the city itself, as Halpert observed. Rivera's *View of Toledo* and his now-lost *Le Fleuve, les rochers, et le chemin montant (River, Rocks, and the Climbing Road)* attest to his fascination with the dynamic topography around Toledo. It had proved to be well-suited for the mannered transformations of El Greco and was equally important for Rivera's transition into Cubism. A similar artistic response to the architectural and topographical appearance of Horta de Ebro on the part of Picasso in 1909 was pointed out by Alfred Barr who sought to downplay the over-emphasis that had been attributed to Cézannian influence in the development of Picasso's Horta landscapes. Barr noted that although Picasso's half-dozen landscapes painted at Horta during the summer of 1909 still owed much to Cézanne,

> Cézanne never geometrized so resolutely throughout the picture as
> Picasso does in the *Factory*...It is possible that the block landscape,
> or rather buildings of Horta affected even Picasso's figure painting by
> renewing his interest in geometric forms....[73]

The similar deterministic response to environmental factors that occurred in the development of Rivera's El Grecoan, Toledo-based Cubism was overshadowed in retrospect by Cézanne's later Post-Cubist importance for

Rivera. In Rivera's case, the over-emphasis that has been traditionally placed on Cézanne's role in his transition to Cubism originated with Rivera himself. There is the following apocryphal "revelatory and traumatic encounter" with Cézanne's work in Vollard's shop window in 1910. It has been frequently cited by the artist in his memoirs and by his commentators as the catalyst for Rivera's transition to Cubism:

> As I have previously said, I came to Europe as a disciple of Cézanne, whom I had long considered the greatest of the modern masters. I had hoped to study under him, but Cézanne having died before I reached France, the best I could do was look for his paintings...One day I saw a beautiful Cézanne in the window of Ambroise Vollard, the dealer who, I learned later had been the first to take an interest in Cézanne. I began looking at the canvas at about eleven o'clock in the morning...Vollard got up, took another Cézanne from the middle of the shop and put it in the window in place of the first. After a while, he replaced the second canvas with a third. Then he brought out three more Cézannes in succession. It had now become dark...Finally, coming to the doorway, Vollard shouted, 'You understand, I have no more.'...It was late at night when I arrived at my studio, and I was burning with fever. My thermometer read 104 F. The fever continued for the next three days. But it was a marvelous delirium; all the Cézannes kept passing before my eyes in a continuous stream, each one blending with the next. At times I saw exquisite Cézannes which Cézanne had never painted. When Picasso brought Vollard to my studio in Paris in 1915, I told him that I would always be thankful to him and the reason why. Vollard threw up his hands again as he had done then and exclaimed, laughing, 'I *still* have no more!'[74]

There is, however, no evidence of Cézannian pictorial conventions in any of Rivera's work dating from 1910-1912 prior to his *View of Toledo*, and certainly none from his early Spanish period (1907-09), or earlier. And where traces of Cézanne's methods appear throughout his Cubist period (1913-17) they are extremely diluted or already syncretized into an advanced Cubist style. Therefore, it is unlikely that Rivera suffered a dramatic awakening or conversion upon seeing his first Cézanne when arriving in Paris, as he so often stated, elaborating on the anecdote each time by the degree of fever or trauma he suffered as a result. If he did undergo such a shock in 1909, 1910, or 1911, as he later claimed, the only result was a slow intellectual assimilation of Cézanne's pictorial ideas that took him three years to evolve into a form of Cézannist-derived Cubism. By 1913, the Cézannist conventions of the Salon Cubists, such as combined multiple and shifting points of view, stylized Cézannian *passage* (the linking of planes, solid objects, and space through the use of contour-breaking directional brushstrokes), and the general simplification of forms were aleady much in the Parisian air, galleries and Salon rooms.

Rivera's insistence on the great part played by his direct confrontation with Cézanne's works in the development of his Cubist style was based on hindsight and his later, post-Cubist "rediscovery" of the classicizing and constructivist formalist qualities of Cézanne. The misconception of Rivera's pre-Cubist and transitional Cubist involvement with Cézanne has also been bolstered by the chronic misreading of the date as "1914" of several of Rivera's imitative Cézannesque paintings that are signed and dated "1919." This has been due to the similarity between Rivera's cursive "9" and the number "4," which has caused some students of Rivera's work to date these later paintings to 1914, 1912, or even to 1909 when a smudged number "1" is converted to a zero.

It appears that in retrospect, after having left Cubism in 1917 and then conducting an intensive analysis of Cézanne's works, Rivera discovered in his earlier works, themselves influenced by El Greco, the spiritual and formal link between El Greco's "Mystical inner construction" and "le père Cézanne."[75] From the documentary sources available, it also appears that Rivera did not begin to make this link until he was well-ensconced in an austere wartime Parisian Cubist style in 1916 and in the process of elaborating a complex metaphysical theory for his work. At the end of the First World War, when he rejected his Cubist style and became friendly with Cézanne's ardent champions, Elie Faure and Louis Vauxcelles, Rivera was completely given over to an almost fanatical veneration for "le père Cézanne," as will be discussed at the end of this study.

In a surprisingly reasonable attempt to sort out his past and his Toledan paintings of 1912-13, Rivera told Frances Flynn Paine in 1931 that "Unfortunately he had believed that the root of Cubism was in the work of El Greco, and that Cézanne's work in turn had the greater part of its origin in the work of Greco." "Thus Diego reasoned," according to Paine, "that it was preferable to study the painting of Greco direct, if one wished to understand and utilize Cubism." Paine concluded:

> This was a very serious error for Diego to make. He was working entirely from intellectual attitudes now and this produced a new setback. He fell into imitating. It was at this time that he started the *Adoration of the Shepherds.*[76]

Rivera's Entry into Cubism

There is no question that during his period in Toledo Rivera fell "into imitating," first Zuloaga, then the lesser known example of Zárraga, and finally, El Greco himself. Also certain is that instead of imitating Cézanne on the road to Cubism, Rivera fell into imitating the advanced stages of Parisian *Cézannisme.*

When and why Rivera became a Cubist painter is an important question to try to answer. An insightful summary of Rivera's first years in Europe is best provided by the disinterested assessment of his benefactor's biographer, who was unaware of, took lightly, or simply discounted Rivera's purportedly notorious revolutionary activities and proclivities as a youth:

> Diego Rivera, the restless Guanajuatan, was sent by Don Teodoro (Dehesa) to Spain, and later to Paris. The painter wrote from Europe to his protector, letters submissive and obedient to the wishes of the person who with such generosity assisted him on his way to becoming a great artist. The oeuvre of Diego Rivera at this time reveals a man rooted in a bourgeoisie without ideological conflicts, and not yet divorced from classicism in his art nor from the Mexican tradition of religious convictions.[77]

When Martín Luis Guzmán, Rivera's friend from his youthful *Savia Moderna* days, visited the artist in Paris in 1915 he wrote, "Rivera has been a Cubist since 1912." He also noted that

> Rivera did not hurl himself in bewilderment or recklessly into the new painting, rather he arrived calmly and late...and his hand followed Tradition simultaneously and faithfully. Previously, this same fidelity to tradition had caused the artist to resist the natural consequences of his solitary and prolonged meditation before the canvases of El Greco.[78]

Guzmán asked Rivera why it had taken him so long to arrive at Cubism. Rivera's modest reply that "the reason for his late entrance into the radical style was his habit of pondering things thoroughly before acting" did not satisfy Guzmán. Insightfully, Guzmán observed:

> But forgive us that we don't believe him. There is another reason. There is a foreseeable pain involved in leaving what one loves, and Rivera loved his artistic trajectory within the conceptions of Tradition. The old canons had served him well and had been propitious. By invoking them his hands created the canvases that so many know: the *Samaritan of Toledo,* full of an ineffable and ritual mysticism, the *Women at the Fountain,* and *Old Ones,* the *Young Man on the Balcony*...How many more! And from these works he slowly separated himself, seeking each day major consolation in the enthusiasm and struggle for the new art. This is the truth.[79]

Rivera's transition into his early Cubist style could best be documented if there existed a surviving record of the first stages of the *Adoration of the Virgin and Child* (Cat. 7). The painting was begun in Toledo in 1912 and then extensively reworked in the winter of 1912-13 in Paris after his decision to enter full-force into the ranks of Cubism. In spite of this missing record, it can be demonstrated through the finished *Adoration* and intervening works that Rivera arrived at his particular form of Cubism, not by way of Cézanne, Picasso, or Braque, but via the Maniera of El Greco and his hesitant reception of the

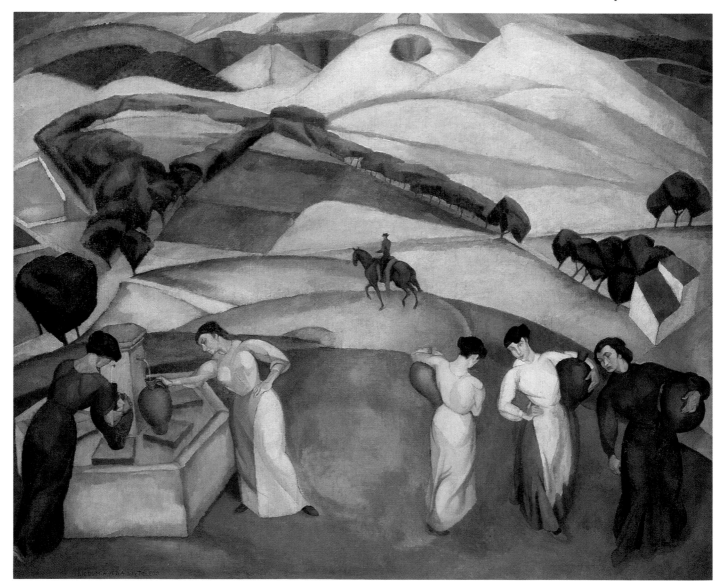

En la fuente cerca de Toledo, (At the Fountain Near Toledo) 1913

Catalogue No. 2

already extensively assimilated Cézannian conventions of the Salon Cubists.

Intervening in the progress of the *Adoration* was a large proto-Cubist painting, the *Women at the Fountain I* (painting in the exhibition from the Olmedo Collection designated as *At the Fountain of Toledo*, Cat. 2). This work evolved out of Rivera's 1912 Toledan landscapes, and the central images of *The Samaritan* and *The Old Ones* centered on the theme of women at a fountain in the environs of Toledo. It belonged to the series of "women with water jars" that Best Maugard recalled seeing when he visited Rivera in Toledo in the fall of 1912. Although dated "Toledo 1913," the painting may have been begun in late 1912. When Martín Luis Guzmán saw the large painting in Rivera's Parisian studio in 1915, he referred to it as the *Mujeres en la Fuente (Women at the Fountain)*. There is also a smaller unfinished oil study for the painting that will be designated here as *Women at the Fountain II* (painting in the exhibition from the Phillpson Collection, titled *At the Fountin Near Toledo I*, Cat. 3). It retains the exact composition of *Women I* partially painted in, and is invaluable for revealing in the charcoal underdrawing the manner in which Rivera drew the figures and landscape for the finished work. A small, crudely painted gouache *Study for the Young Ladies at the Fountain, Toledo*, reproduced by Gual[80] and dated by him to 1912, was probably the initial notation for the large painting. A more finished study of a section of the large work is the watercolor *Landscape of Toledo* that represents the elliptical grouping of trees in the upper left background of the *Women at the Fountain*.

The *Women at the Fountain* depicts five colorfully-clad women with brown water jars in the foreground of a broad panoramic landscape of gently curving mountains and quiet hills. The brightly clothed women in their characteristic

En la fuente cerca de Toledo I, (At the Fountain Near Toledo I) 1913

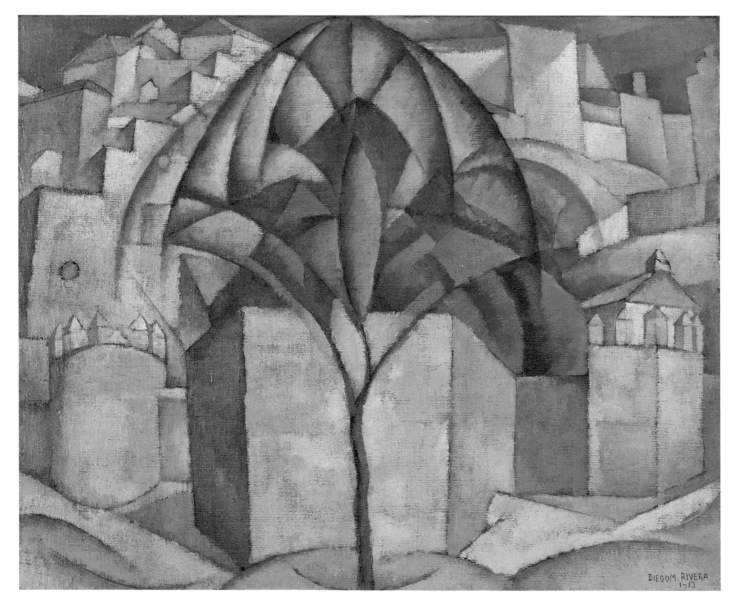

Arbol y muros, Toledo (Tree and Walls, Toledo) 1913

Catalogue No. 12

aproned dresses derive directly from the small figures in the ring of dancers of the *Old Ones,* and the women at the fountain in the background of *The Samaritan.* On a purplish hill in the center of the painting is a rider on a red horse that echoes the same lone horseman in the *Old Ones* and, as the gouache study reveals, was originally riding upwards on a winding road in the same direction as the rider in that earlier painting. Behind the distant hills can be seen a section of the reddish stone walls of the city of Toledo, and located sparsely in semi-naturalistic landscape are two abstracted, white-stuccoed *cigarrales* (countryhouses). Here rendered as two compact, Derain-like "Cubic" houses in simplified, inclined planes, they become Cubistic signs for the numerous *cigarrales* that dotted the hills around Toledo at the time. These *cigarrales* are the subject of several transitional Cubist landscapes by Rivera from 1913 in which one can follow his simplification of forms and increasingly complex geometrication of landscape and architectural features: The *Landscape Near Toledo, The Old Hamlet, Toledo,* and *River Scene.*

What is most revealing in the proto-Cubist geometrical structure that lies beneath the *Women at the Fountain* in the study is Rivera's fascination with broad sweeping arcs and elliptical and triangular planes. In the underdrawing they are reassuringly plotted with strong rectilinear and curvilinear definition. The women's breasts beneath their blouses are reduced to their geometrical elements mechanically rendered as uniform pyramidal cones, and there are further indications of broad faceting in the anatomy and clothing of several of the figures. There is a very conscious design effort at work in the echoes of curvilinear forms and rhythms laid down lyrically in sweeping curves and planes. It is likely that all of Rivera's Cubist works underwent similarly intricate preparations as revealed in this underdrawing.

The carefully choreographed dance of poses among the figures repeats these calculated rhythms. The three figures at the right, also repeat in a circular direction what could be read as an attempt at depicting an individual figure in chronophotographic or simultaneous motion were it not for the clearly differentiated faces and costumes of the figures. Soon to be a major concern of Rivera's emergent Cubist style, sequential and dynamic movement represented in a complex, static and "simultanist" technique is seen in his *Women at the Fountain* in its primary and proto-Cubist stages. Also evolving out of his earlier Toledan works in this painting is Rivera's exploitation of the formalist and metaphorical possibilities of one of his favorite motifs, the Spanish *cántaro,* or water jug. Its delicate thin opening and characteristic billowing shape terminating in an equally delicate, narrow base are exploited in the *Women at the Fountain* for their lyrical "feminine" qualities. Later in 1913, these shapes are further abstracted and presented in a metaphorical allusion to the female form in Rivera's fully Cubist *Woman at the Well.*

The pastel and richly variegated palette of the *Women at the Fountain* rendered in smooth, enamel like finish displays Rivera's enormous talent as a colorist. It too is derived from his earlier Toledan paintings. The painting's decorative evocations of color are also reflective of Rivera's neo-Symbolist background in his entrance into Cubism. In addition to the anti-naturalistic, decorative palette of the *Women at the Fountain,* the elliptical, synthesized patterns of the tree lines and stylized landscape mounds are thinly brushed and drawn in a late Nabi-like manner.

As in all of his Toledan landscapes and many of his later Cubist works, the view in the *Women* spans enormous distances with a broad and high horizon that tends to compress the space between the foreground and the background. Rivera's directly frontal presentation of a broad distance in which he begins to reduce natural forms to simple geometric volumes and planes reflects an affinity with, and by now, probably an awareness of the Cubist predilection for the panoramic landscape in the 1910-13 works of Léger,

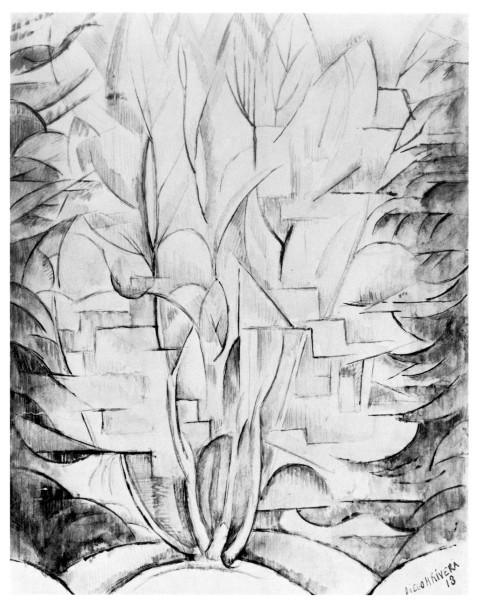

Arbol, (Tree) 1913

Catalogue No. 14

Gleizes, Le Fauconnier and other artists who have been characterized as "Epic Cubists"[81] during this period. Another parallel with the concerns of the "Epic Cubists" can be seen in Rivera's large compositions incorporating human figures and distinctive activities tied to the local landscape. However, in this and other Cubist paintings, the sources for Rivera's figures in the landscape lie in Spanish *costumbrismo* and had not yet attained the concrete social content and iconographical intentions of the Epic Cubists.

The fact that *costumbrista* painting was concerned with specific nationally renovating references to the life and social activity of the Spanish people, in particular the popular classes, and that Rivera dominated this painting genre for at least four years prior to his involvement with Cubism might explain the dominant iconographic concerns that his particular type of Cubism would display. For his first Cubist experiments Rivera did not concentrate exclusively on inanimate and neutral still life objects, but relied on human subjects, their typical activities and environments, symbolic architectural motifs (e.g., the bridges of Toledo and Madrid's Plaza de Toros), and a concern for dynamism in a modern world. Such concerns can be seen as consistent if one compares his proto-Cubist and still lyrically semi-naturalistic women drawing water at the fountain and his Cubo-Futurist and dynamically abstract rendition of a similar subject in the 1913 *Woman at the Well.*

The landscape's treatment in Rivera's *Women at the Fountain* also reflects his close familiarity with the early Cubist style of his rue du Départ neighbors, Mondrian and especially Schelfhout. The configuration of Rivera's polygonal fields distinctively recalls the similar treatment of contrasting landscape forms and triangulated planar divisions in Mondrian's large *Dunnelandscape* (c. 1911) in the Hague, Gemeentemuseum. Rivera adds an exaggerated angular tilting of these divisions toward the picture surface in a conscious attempt at an antirecessional perspective. One need only compare such a picture as Schelfhout's *Les Angles* of 1912 (*Les Angles* is the painting depicted in Fig. 16) to see the extremely close similarity between Schelfhout's style and that of Rivera's 1913 Toledan landscapes. The Dutch painter's Provencal landscape also depicts a horserider traveling up a curving road flanked by starkly volumetric and geometricized rock formations on both sides. Atop these rocks are several tall trees with their foliage simplified and synthesized into curvilinear and triangulated planes. Both Rivera's and Schelfhout's paintings are panoramic landscapes in which shapes are reduced to simple geometric volumes in an attempt to unify the pictorial space and make it autonomously flat, integrally plastic, and anti-natural.

Although Rivera does not mention Schelfhout in his memoirs, he did recall specifically his "good friend and neighbor Mondrian," during this period "with whom I had been exchanging ideas and artistic experiences."[82] Rivera even went so far as to proclaim that "My closest friend, besides Picasso, became Piet Mondrian, the most sensitive, rigorous and ferocious purifier...."[83] Rivera's obvious interest and reliance on Mondrian in 1913 became greater towards the end of 1913 when he executed the Mondrianesque *Tree* (Cat. 14), the analytical and schematic *Tree and Walls, Toledo* (Cat. 12), and incorporated Mondrian's linear structural accents to his Meudon landscape, *The Viaduct* (Cat. 13) and the background of his 1914 *Two Women*.

In spite of the fact that the *Women at the Fountain* is inscribed "Toledo 1913," Rivera may have finished it in his Parisian studio. The *Adoration of the Virgin and Child*, which follows this work in importance and stylistic development in his Cubist oeuvre was extensively worked on in Paris that winter. Rivera returned to Paris in the winter of 1912-13 in order to exhibit his Toledan landscapes at the Galerie Bernheim-Jeune in January. Rivera's first debut in a Parisian exhibition outside the Salon was in the "Groupe Libre" exhibition in the famous gallery where he exhibited six paintings, all apparently from Toledo, including *The Old Ones* and the *View of Toledo*. The latter was illustrated in the catalogue.[84]

It is not known how Rivera came to be involved with the diverse group of "young artists who aesthetically had not much in common."[85] He did not exhibit in the previous Parisian exhibition of the Groupe Libre, which as a group had its origins in Brussels. One element that the eleven painters and three sculptors of the "Groupe Libre" did have in common, and that would aptly correspond to Rivera's proto-Cubist aesthetic, as the catalogue preface written by the reactionary critic Camille Mauclair points out, was the conception of rendering "nature in a decorative synthesis." The conservative nature of the independent group and the relatively high finish of their works is further indicated by Mauclair's observation that "They agree only on the essential point, which is to work seriously to the exclusion of contrivance and to not be content with *impressionistic or sketch-like works* (emphasis added)." Although Mauclair discussed other artists' works in some detail in the catalogue, he dismissed the Mexican artist with the condescending remark that "Rivera's work is notable for his race."

LOS DESAGUISADOS DEL CUBISMO

Algunos cuadros--"por el nuevo estilo"-- de Diego Rivera

¿Sabe el noble y hu-manísimo lector lo que representa este cuadro? Posiblemente no, y por ello se lo revelamos: Represen-ta a la ciudad de Toledo.

Este que aquí véis, pálido y triste, en-guantado y de bastón, y con la rueda de la fortuna a sus espaldas, es Fer-nando Best.

Malpensados que sóis al suponer que el anterior cuadrito debería encontrarse en nuestra sección de acertijos!... En él aparece—¿óislo?—ni más ni menos que un marino jarocho.

En medio de estos triángu-los, "rectángulos" y "cua-driángulos" dos doncellas entablan un diálogo.

A este montón de cosas inauditas lo tituló el pintor:

Figure No. 17
One of the earliest photographs of Rivera's Cubist paintings to be published in Mexico. "Los desaguisados del cubismo: Algunos cuadros – 'por el nuevo estilo' – de Diego Rivera," in *El Universal Ilustrado*, Mexico City, May 24, 1918.
("The Outrageous Works of Cubism: Some Paintings in Diego Rivera's 'new style' ")

The "Groupe Libre" exhibition received little notice in the Parisian art press and Rivera even less. Although Apollinaire distinctly recalled the exhibition and several exhibitors in his *Montjoie!* review of the 1913 Salon des Indépendants, Rivera was not among those singled out by the avant-garde critic. Among the more generous reviewers of the "Groupe Libre" exhibition was the critic of the *Mercure de France,* the Symbolist writer Gustave Kahn, who remarked:

Monsieur Rivera has a great gift of representing a natural quality of movement; he places the last Spanish masters into sharp relief. He draws his human figures well and delights in broad landscapes.[86]

Kahn's remarks about Rivera's great gift for rendering movement and his interest in 'broad landscapes' is significant. It may possibly refer to such works as Rivera's *Women at the Fountain,* which may have been included in the exhibition as one of the unidentified "Landscapes," or a similar now unidentifiable work. This "natural quality of movement," a concern for both gestural human and dynamic compositional movement, was to be the characteristic hallmark of Rivera's early Cubist works of 1913.

Louis Vauxcelles, the only other prominent critic to take note of Rivera and whose remarks about the Cubist Zárraga were quoted earlier, characterized the young Mexican artist in the "Groupe Libre" exhibition as,

M. Rivera who paints Toledo after the manner of Theotocopuli, called El Greco, but with infinitely less pathos (pathétique).[87]

Perhaps encouraged to overcome the unenthusiastic response to his works by the French critics, or perhaps indifferent, Rivera remained in his rue du Départ studio diligently preparing for the spring Salon des Indépendants, with every intention of returning to Toledo after submitting his works. He may have even included two Toledan landscapes from the "Groupe Libre" exhibition among his entries to the Indépendants, but it is impossible to identify the two works that are listed in the catalogue only as *Toledo (Landscape)* and *Landscape.* What can be identified positively is his third entry entitled *Portrait of M. Best* (Maugard). The monumental portrait remained for many years in a very private Mexican collection until its recent bequest last year to the National Museum of Art in Mexico City. Little known, and although never reproduced in color until last year, the *Portrait of Adolfo Best Maugard* (Cat. 5) was among the first of Rivera's "Cubist" works to have been reproduced in Mexico as early as 1918 (Fig. 17). At that time it elicited the reaction from an offended "avant-garde" Mexican writer, that the painting was a "practical joke played on Best Maugard by Rivera."[88]

The *Portrait of Best* falls stylistically out of the sequence of Rivera's Cubist development, probably because it was a portrait of a respectable Mexican friend, the elegant and refined artist Adolfo Best Maugard, and because it was intended by virtue of its size and large scale as a great and impressive Salon "machine" meant to remain accessible. Nevertheless, there are elements of even more advanced conceptions in the painting. Based on the lyrical, highly stylized treatment of the figure and traces of subtle faceting applied over the naturalistic rendering of the face, the portrait appears to have been painted after the *Women at the Fountain.* The greater complexity of its background and composition, incorporating Simultanist techniques also suggests that the portrait was painted later.

Best Maugard had recalled seeing Rivera's "women with water jars" in Toledo in the fall of 1912. He further recalled that

> Upon our return to Paris, Diego painted a large portrait of me which along with the Toledan paintings was exhibited in the 1913 Salon d'Automne. That portrait marked the transitional point between Spanish influence in his painting and his complete entry into Cubism.[89]

Best Maugard confused the chronology, for his portrait and the Toledan landscapes were exhibited in the 1913 Salon des Indépendants in March 1913 and not in that year's autumn Salon.

Rivera also considered the *Portrait of M. Best* his most important work up to that date and the painting that "in reality marked my entry into the Parisian art world."[90] He recalled significantly that in the 1913 Indépendants he "didn't yet exhibit works that were definitely Cubist which I had already painted, but rather works from my preceding period that can be associated with Derain's 'organized naturalism.'"[91] This tends to support the fact that although Rivera did not exhibit publicly any decidedly Cubist works until the 1913 Salon d'Automne, his Cubist experiments may have indeed begun in the fall of 1912 as his contemporaries stated and he later maintained. This is in spite of any extant firmly dated works from 1912 exhibiting a Cubist vocabulary among his known oeuvre.

In Rivera's *Portrait of M. Best,* the sharply angled view off the balcony of Rivera's rue du Départ studio is of the platform and tracks of the Gare Montparnasse. This same balcony view was also Rivera's favored motif for several later post-Cubist still lifes in which he experimented with juxtapositions of interior and exterior space and curvilinear perspective, for example, in his *Still Life in a Window, Paris-Montparnasse* (1918, Fig. 18) and the *Ferrocarril de Montparnasse* (1917). The warped configuration and tilting of the large building beneath and behind the figure of Best Maugard and other buildings in the background seem to indicate that Rivera had by now seen Delaunay's early *The City* paintings, or independently shared Delaunay's fascination with the curvature of space and the problems involved in depicting the simultaneous viewing of height and depth. The retinal distortion and possible mechanical and conceptual corrections of the visual field had first been made known to Rivera by Velasco's teaching. The problem became of paramount importance in Rivera's post-Cubist works of 1917-18 as can be seen in his Cézannesque *Landscape,* and his drawing *Paris, Still Life* (Cat. 76).

Aside from the similarity between Rivera's background buildings in the *Portrait of M. Best,* and Delaunay's *The City, First Study* (1909, Tate Gallery, London), Léger's early *Smoke over Roofs* series based on the view from his studio window also come to mind. Rivera has simplified the plumes of smoke in the air and the planes of some distant buildings into the dynamic circular geometric shapes that were the early concerns of both French painters. However, if there was a precedent-setting Cubist painting, albeit more abstract, for Rivera's *Portrait of Best Maugard,* there was Gleizes' *Man on the Balcony* that was exhibited in the momentous Cubist exhibition of 1912, the Salon de la Section d'Or.[92]

Rivera's large and elegant painting of a man on a balcony is unique in that it combines a highly personalized and mannered figure style in the foreground with the psychological and formal elements of Simultanism and Futurism in the background. Although not to the same formally complex degree of fragmentation and spatial and geographical dislocation as the 1911-13 Epic Cubist paintings of Delaunay, Gleizes, Metzinger, Le Fauconnier, and Léger, Rivera's *Portrait of M. Best* displays a literal Simultanist consciousness in semi-naturalistic and proto-Cubist form.

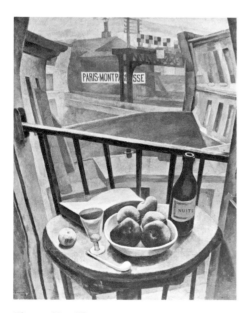

Figure No. 18
Diego Rivera, *Still Life in a Window,*
Paris-Montparnasse, 1918
Oil on canvas
Private Collection, Denmark

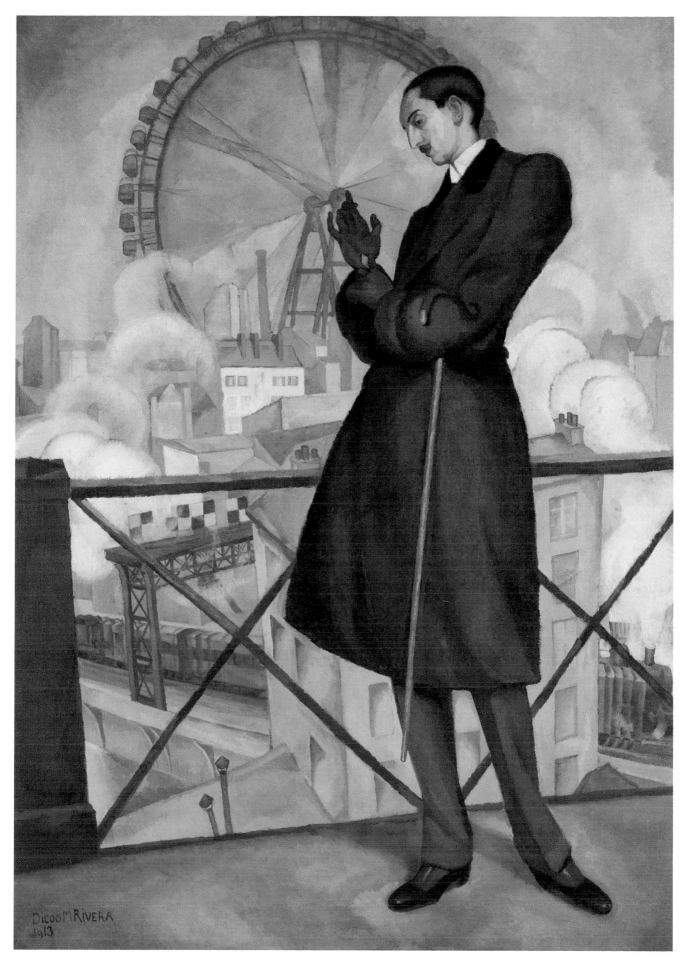

Retrato de Adolfo Best Maugard, (Portrait of Adolfo Best Maugard) 1913

The concept of Simultaneity, or *simultaneità* was a very vital and widespread one among the literary and artistic avant-garde of Europe in the early twentieth century. Virginia Spate, who has shown it to be one of the most important influences on the evolution of art, and in particular Orphism and abstract art, during this period defines Simultanism as

> Basically...an attempt to embody a *change of consciousness* in response to a feeling that sequential modes of thought and expression were inadequate to realize the fullness and complexity of life and, even less, the fullness and complexity of modern urban life. Instead of focusing on a single thread of feeling, instead of concentrating on a single clear emotion (and subject), the Simultanists tried to represent the interrelatedness of all things, mental events, and feelings which might be widely separated in time and space but which were brought together by the mind.[93]

Two uses of the term and the concept of Simultaneity became current in Cubism from 1913 on. One involved the simultaneous incorporation of multiple views of an observed object into a single image, a technique that was claimed by Apollinaire in his 1913 essay "Simultanisme-Librettisme" to have been utilized initially by Picasso and Braque as early as 1907. The second involved the idea of combining disparate objects, ideas, expansive vistas, or realms of consciousness into a single painting. The latter, which was the more conceptually oriented and practiced by many of the Salon Cubists, is the concept to which Rivera's *Portrait of Best* can be related. A combination of both concepts of Simultaneity became the basis, with increasing degrees of abstraction, for the whole of Rivera's Cubist production.

In the iconic image of the Great Ferris Wheel turning slowly in the background, the trans-European trains that rolled in and out of the Montparnasse station directly beneath his window, and the ever-puffing smokestacks, symbols of a vigorous industrial society, Rivera painted his symbolic response to the city of Paris and modern life. Rivera's interest in the epic nature of technological change in the modern world, paramount since his youth as we have seen, is majestically rendered in the great rotating wheel behind the figure of Best Maugard. It is painted in successive and slipping planes of different tones to suggest movement as are the cars and locomotives of the fastly moving train. In his *Portrait of Best Maugard*, Rivera placed the Great Wheel conspicuously in the midst of buildings and factory smokestacks to fill up the vast background space.

The Great Wheel, a fin-de-siècle monument to modern technological man that had been left on its site on the Champ-de-Mars after the end of the 1900 Exposition Universelle, could significantly *not* be seen from Rivera's studio window. Located in a different direction, it was over two kilometers away and obscured by buildings. This can be verified by a photograph that Mondrian took from his own balcony studio window (Fig. 19), which was on the floor beneath Rivera's, of the same track and iron-trussed train signal in 1912.[94]

The Mexican journalist Carlos Barrera saw the *Portrait of M. Best* in Rivera's studio on the rue du Départ shortly after it was finished. He too noted that the Great Wheel could not be seen from his studio window, although the painting displayed "an imaginary background of the Champ-de-Mars in which Rivera had reproduced the Great Ferris Wheel."[95] Another Mexican writer, Martín Luis Guzmán, on his visit to Rivera in Paris two years later, saw the painting and was also struck by its Simultanist qualities. Coming to Paris from his recent exposure to New York, the most modern of modern cities, Guzmán remarked significantly that the "*vigorously syncretic* background of the *Young Man on the Balcony* (Portrait of Best Maugard) gave me the impression that I was seeing New York and Paris at the same time" (emphasis added).[96]

Figure No. 19
View from the window of Mondrian's studio at 26 rue du Départ.
Photograph courtesy of Robert P. Welsh, Toronto.

Coincidentally or not, in the 1913 Salon des Indépendants where the *Portrait of M. Best* appeared there was exhibited another Simultanist painting that incorporated the Great Wheel and consciously modern subject matter by one of the major Salon Cubists, now considered an Orphist, Robert Delaunay. Delaunay's Orphic Cubist *Troisième Représentation. L'Equipe de Cardiff, F.C.*, considered "the most modern painting in the Salon" was slightly larger than Rivera's large painting and was described by Apollinaire as "living and simultaneous; the whole of the painting an ensemble of rhythms with modern elements which weave together in life."[97] It is not known if by 1913 Rivera had met Delaunay or seen any works from his Ferris Wheel series begun in December 1912. But he could not have escaped seeing the implications of the images in his *Portrait of M. Best* in relationship to Delaunay's *L'Equipe de Cardiff*. Rivera's decision to embark fully down the Cubist road followed.

In spite of what Rivera said about the popularity of his *Portrait of Best* (according to the artist "it had attained a certain popularity, from the most favorable criticism to the honor of being caricatured")[98] none of the major critics, such as Apollinaire, Salmon, Vauxcelles, Kahn, mention it or Rivera in their reviews of the 1913 Salon des Indépendants. In the one important review where it is mentioned, in the recently founded anarchist art journal, *L'Action d'Art*, the author of the review was Rivera's former mentor and mythical leader of the Mexican avant-garde, Atl. He dispensed with it succintly and harshly with the comment:

> Rivera. — Portrait. The background is rather well constructed and displays a certain grandeur, but the figure lacks any relation whatsoever with the whole.[99]

The son would be leaving the father who could not follow him, for the reactionary nature of the eccentric Atl's aesthetic was manifest throughout his lengthy review of the Indépendants where he reserved his most caustic remarks for the Cubists, Futurists, and in particular, Picabia.

In the spring of 1913, Rivera met the influential Bolshevik writer and habitué of the Académie Russe, Ilya Grigoryev Ehrenburg (1891-1967). Ehrenburg recalled in his memoirs,

> I met Diego at the beginning of 1913. He was then starting to paint Cubist still-lifes. Earlier canvases hung on the walls of his studio, and one could distinguish the landmarks: ... El Greco ... Zuloaga. For a brief period Diego admired Zuloaga; some art historians go so far as to define some Rivera canvases as the Zuloaga period. By 1913 he had said goodbye to Zuloaga.[100]

That Diego had by early 1913 said goodbye to Zuloaga is clear to be sure, though he had not yet said goodbye to El Greco. He soon returned to Toledo to complete his long and labored encaustic painting, the *Adoration of the Virgin and Child*. By now he was fully aware of the Cubist possibilities of El Greco's Maniera style and sought to fuse them with a Salon Cubist Cézannist form. The greatest irony is that Rivera broke fully into what was up to then the most iconoclastic style in the history of art, Cubism, with one of the most conservative and *passéiste* subjects in the history of painting, the *Adoration of the Virgin and Child*.

There are two possible explanations for Rivera's choice of subject matter. One, he may have been inspired by a now-lost group of religious paintings executed by Zárraga during 1912-13, which included a *Virgenes Prudentes* and two "Blue Annunciations."[101] Or two, Rivera may have been working from one of the motifs of either of the two local Toledan shrines located in the hills to the south and across the river from Toledo: the *Ermitas* of the *Virgen del Valle* or *Nuestra Señora de la Cabeza*. From either chapel, one had the vantage point of looking north and downward toward a bend of the River Tagus and

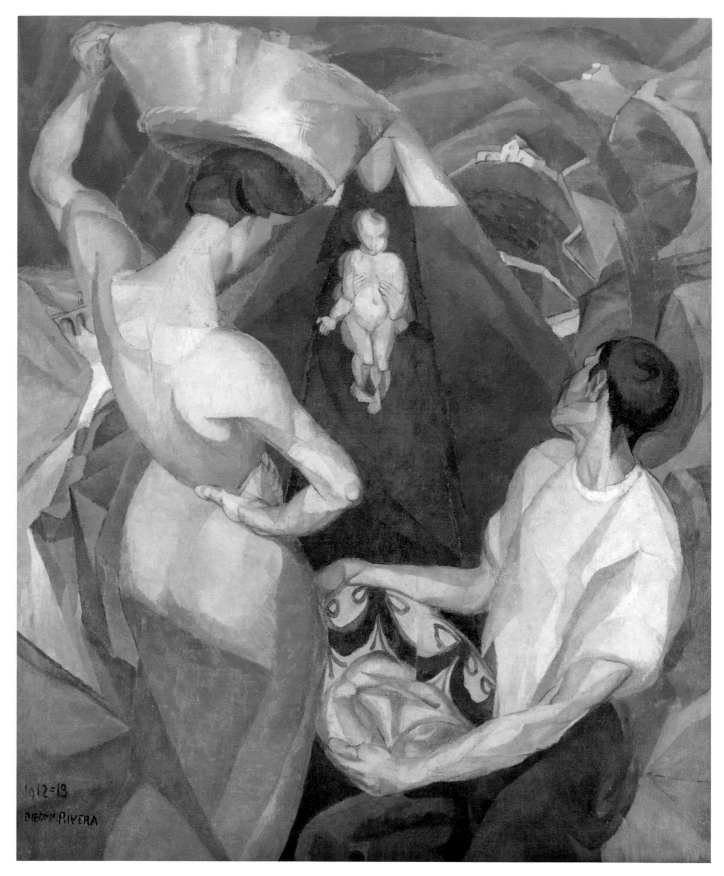

La Adoración a la Virgen con el Niño, (The Adoration of the Virgin and Child) 1912-1913

Catalogue No. 7

either the St. Martin's Bridge in the west or the Alcántara bridge in the east. There were precedents for Rivera's depicting the altarpiece of a major local shrine in his earlier Spanish work, such as his *Virgen de la Cabeza* that he painted in Avila in 1909. In the 1913 *Adoration,* the simplified image of the Madonna and Child is flattened and patterned into a pyramidal complex that is reminiscent of the earlier painting and the hierarchic configuration was a common one among Spanish altarpiece statuary.

The painting was originally exhibited in 1913 with the title *Composition, Encaustic Painting,*[102] but since then it has been titled "The Adoration of the Shepherds." Given the female bearing a basket of fruit, it appears to be more convincingly an "Adoration of the Virgin and Christ Child," by representative local genre types. The site of one of the chapels might also have been transposed by Rivera into the site of an original apparition. The most local reference to Toledo appears in the ceramic design of the bowl, which has slipped into two places, containing bread in the hands of the male figure. It bears the distinctive markings of the famous Talavera ware produced in the region. The background, another Grecoesque evocation of the Toledan landscape, is a summation of Rivera's transitional Cubist work there.

El Greco's mannered depository of sources for Cubism, which was Rivera's most original contribution to the Cubist movement in his early Cubism is fully tapped in this painting. The device of framing a hierarchical religious vision with boldly elongated figures slightly beheath it is distinctly El Grecoan. The twisted, complex poses of the two figures "adoring" the Christ Child are artfully sinuous and undulate geometrically in a graceful dynamism and twentieth-century version of what Mannerist theorists called the "figura serpentina."[103] The geometricated female figure dressed in Rivera's favorite emerald-green color is similar in configuration and sharp modeling to the virtuoso foreshortened left figure in El Greco's *Assumption of the Virgin* (Art Institute of Chicago) where the sensuous qualities of the elongated neck are contrasted with the crisp clothing. Although the Christ Child (whose form contrasts so vividly with the flattened patterns of his Mother) bears a distant similarity to Cézanne's cupid in *Still Life with Plaster Cupid,* the small faceless figure corresponds more closely to the simple, angular faces of Le Fauconnier's child in his recent epic Cubist allegory *L'Abondance (1910-11).* El Greco's protoplasmic, elongated and Mannerist figures of the Christ Child could also conceivably be behind Rivera's geometricated rendition.

In the *Adoration of the Virgin and Child,* Rivera utilized a Cézannist approach of laying out the picture vertically with a high horizon in which the background hills are stacked above the figures. The figures are "cubified" into long angular and curvilinear facets and triangular planes that are echoed in the flinty grey-blue and pale-green hills and crevices of the Toledan landscape. The geometricized planes that merge distance with foreground also display Rivera's understanding and stylized adaptation of the epic panoramic landscapes of the Salon Cubists. There are certain similarities with Léger's *Bridge* of 1910 and the intricate geometric rhythms of intersecting and overlapping forms in Gleizes's and Metzinger's early Cubist landscapes without their restrictive palettes. However, the concentration of monumental figures into a narrow cone of space close to the picture plane remains distinctively El Grecoan.

The *Adoration of the Virgin and Child* with its densely packed composition combining fully assimilated El Grecoan traits and a Maniera palette with broadly faceted, Cézannian Cubist planes can be considered Rivera's first emphatic break with his past. It can also be considered Rivera's first "Cubist" work if one takes into account the vague contemporary definition of the style as "an art of conception." According to two perceptive critics, Maurice Raynal and Olivier Hourcade,[104] the principle aim of Cubism as they saw it in 1912, was to reduce objects to their simplest geometric forms; to arrive at their *essence* rather than attempting to artificially reproduce the photographic appearance of objects in a false and contrived Renaissance conception of space devoid of the dynamics of time, real space, and visual and psychological perception. Understandably, such a broad definition of Cubism as an "art of conception," a style which still sought to retain the subject in painting no matter how conceptually abstract the forms got, would lead to a confusion about what was and was not "Cubist." It is indicative, however, of how elusive a definition for the style was at the time and is to this day; [105] and how wide the parameters were for artists — in this case Rivera — to present what they considered to be the essence of their subjects and their forms.

In its reductive large crystalline elements, geometrical "signs" for objects, broad curvilinear planes and elliptical lines and polyhedral forms, the *Adoration of the Virgin and Child* is a first example of what Rivera's particular type of Cubism was to be. Its subject, chosen for whatever reason, exists in the most abstract realm of psychological conception, that of a mystical religious vision and religious symbolic allegory. This fact, coupled with the autonomous formal treatment of the unusual subject (for Cubism), relegates this work to a place among its diverse Cubist counterparts.

To consider this work as "Cubist" and not "pre-Cubist" or something else is, of course, at odds with the later historically imposed definition of Cubism based on the arbitrary categories of "Analytical" and "Synthetic" Cubism that were originated by Kahnweiler, the German art dealer. Kahnweiler's *History of Cubism (Der Weg zum Kubismus,* 1920), the source for much of the later received history of Cubism, was written to "explain" the works of his painters, namely Picasso, Braque, Léger, and Gris. Those artists, who, like Rivera knowingly arrived "late" at adopting a Cubist style and in many cases had equally valid and revolutionary aims distinct from the style's innovators, were as a result labeled so-called "minor" or "lesser" Cubists who did not "fully understand Cubism." In the pioneering work of the art historian Daniel Robbins[106] and a new generation of students of Cubism, this myopic look at the nature of the Cubist style and denial of its pluralism has been demonstrated as having been false and a great historical slight against such artists as Gleizes, Metzinger, Le Fauconnier, the Duchamp brothers, and Kupka to name a few. Rivera's Cubist work has been so little known that his name rarely appears among those artists receiving this slight. In the early years of Cubism, these artists published tracts and articulated their aims, distinctive from those of the *Picassistes,* in their works and in recorded conversations of the period. It was with these Cézannist Salon and Epic Cubists that Rivera became aligned in his first Cubist years.

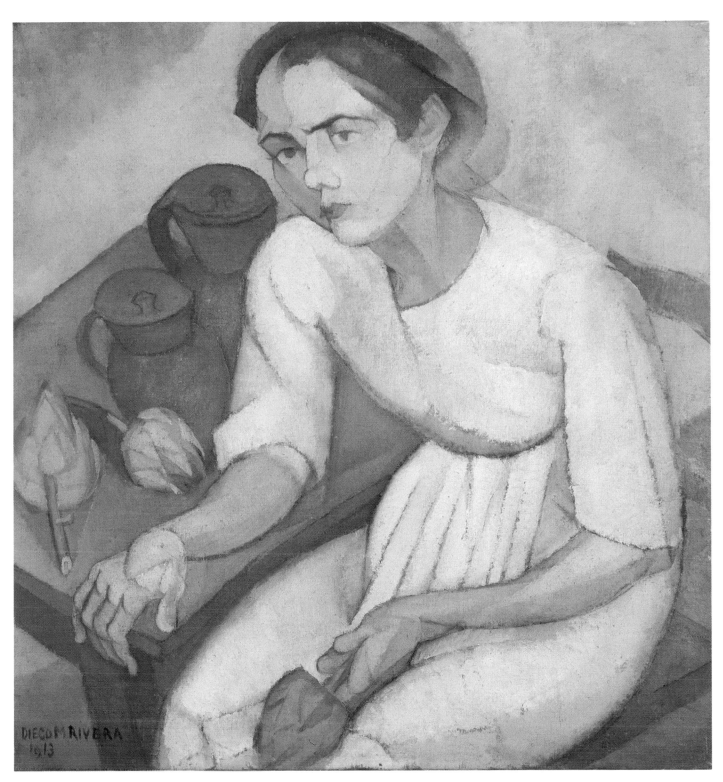

La Jeune Fille aux artichauts, (Young Girl with Artichokes) 1913

Catalogue No. 9

The *Adoration of the Virgin and Child* was, among Rivera's extant works, his last painting executed under the overwhelming spell of El Greco. From the completion of the *Adoration,* Rivera's style changed rapidly and drastically in 1913. Increasing in abstraction and geometrication was his *Paisaje Espanol* (Cat. 8) in the Rivera de Iturbe Collection. This small *Spanish Landscape* had a special significance for Rivera for in his exit from Cubism in late 1917 he returned to it and analyzed its Cézannesque constructive principles in an elaborate and schematically refined copy of the painting.

Paisaje de Toledo, (Landscape of Toledo) 1913

Catalogue No. 1

"Is He a Cubist or a Neo-Cubist?" (Francisco García Calderón)

When Rivera returned to his Parisian studio in the late summer of 1913, he continued to work on paintings with Toledan motifs such as his complex *Saint Martin's Bridge, Toledo* (Cat. 17) and the *Woman at the Well* from studies. The degree to which his painting had progressed was assessed with a fair degree of alarm by his Mexican friend from the days of *Savia Moderna,* the writer Alfonso Reyes who had arrived in Paris that year in a form of voluntary exile from the Mexican Revolution. In a letter back to Mexico dated September 30, 1913, to their mutual friend, the writer Pedro Henríquez Ureña, Reyes wrote, with a curious aside to Angeline Beloff's possible role in the matter,

> The big news! Today I had dinner with Diego Rivera — who has just returned (from Toledo) — and with his Russian wife. It's scandalous! *Diego Rivera is making (painting) Futurism!* And they assure me Zárraga is too (although I haven't seen him since he hasn't returned yet to Paris). Zárraga also has a Russian woman at his side. Could the Russians possibly have dispatched an army of amazons to corrupt Western civilization?
>
> Whoever you might be, Oh God of Aesthetics (now I'm not so sure that Wagner is Him), do what You can, at the least, to see to it that these two serious talents did not make a mistake.[107]

By the middle of 1913, Rivera was beginning to be identified with avant-garde painting circles in Paris, and his return from Toledo was announced in the Parisian press in October. *Gil Blas* reported in its "Les Arts" section:

> We are promised a very original exhibition of the bold works of the Mexican painter Diego Rivera. This artist has just returned from Toledo where he painted views of the city and undertook research in the dissociation of arabesques and geometrical figures, so to speak, to characterize his style which is new. He will send a *Portrait of the Sculptor Miestachannof (sic) to the Salon d'Automne.*[108]

The "research in the dissociation of arabesques and geometrical figures" from Toledo that the anonymous writer from *Gil Blas* (probably André Salmon) saw would have been Rivera's *Women at the Fountain,* his *Spanish Landscape,* and the *Adoration,* which all display these characteristics. That the *Portrait of the Sculptor* (Cat. 11), which is fully Cubist in style and also displays Rivera's penchant for elliptical curves and arabesques, is mentioned is significant for indicating that it was completed at least by early October. Although it was not shown in the Salon d'Automne, a work that stylistically preceded it, the delicately colored *Young Woman with Artichokes* (Cat. 9) was shown. This painting was the first example of Rivera combining different views of the head and figure simultaneously, in this case quite subtly, into a single image. The technique was one of the most important revolutionary features of Cubist painting that had had its origins in Picasso's *Demoiselles d'Avignon.* By the time Rivera adopted it in 1913, it had become the stock in trade point of departure for much Cubist painting in Paris. The hesitancy and refinement with which Rivera used the technique in the *Young Woman with Artichokes,* whose elongated figure is rendered in elegant arabesques and elliptical curves, reveals his classicizing and still primarily decorative concerns.

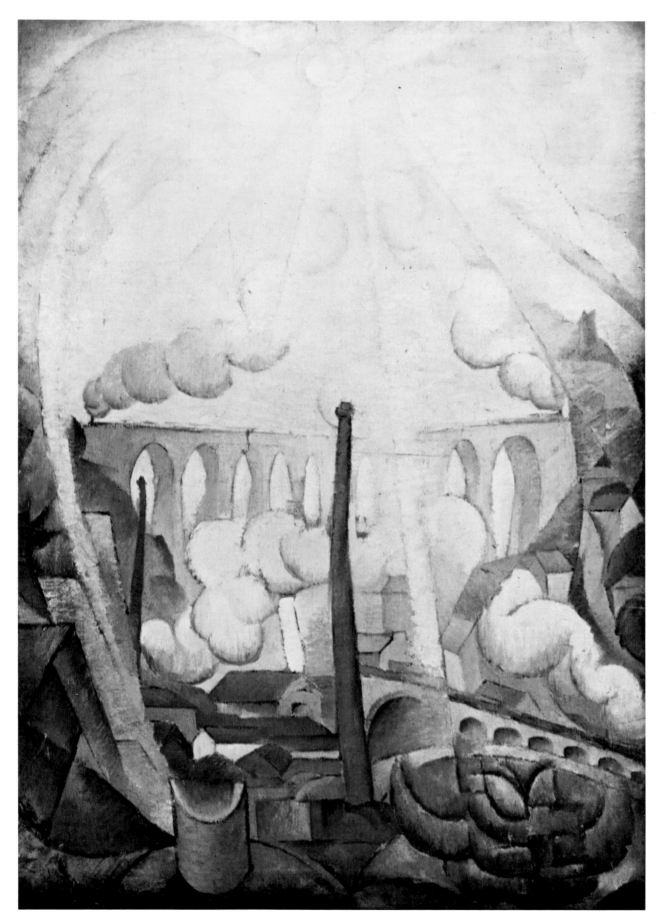

El viaducto - El sol rompiendo la bruma, (The Viaduct - Sun Breaking through the Fog) 1913　　　　Catalogue No. 13

Retrato de Oscar Miestchaninoff - El escultor, *(Portrait of Oscar Miestchaninoff - The Sculptor)* 1913

Catalogue No. 11

The Neo-Symbolist and decoratively idealist qualities of this and another early Cubist work exhibited by Rivera in the 1913 Salon d'Automne were commented on by the art critic and collector Gustave Coquiot. In the characteristics of Rivera's early Cubist painting, Coquiot also prophetically foresaw the Mexican artist's future love and technical preoccupation — fresco painting. Coquiot stated,

> These two paintings the *Young Woman with Artichokes* and the *Young Woman with a Fan,* in a grey, rose, and green harmony, possess a beautiful decorative feeling. They resemble two frescoes and have all the austerity and all the attraction of frescoes.
>
> I have placed M. Rivera among the Cubist troops. But M. Rivera, when he consents not to fall all the way into that rug-maker's — or simply ornamental — art which is known as Cubism, is, I repeat, a decorator endowed with the most seductive qualities. And he at least may very well develop his gifts without need of dumbfounding the spectator by carving outrageously into the flesh — become wood — of the figures that he places in the scene, only to distribute in turn these chips of wood haphazardly as in a tapestry-weaver's drunken fantasy![109]

The *Young Woman with Artichokes* also displays, for the first time in Rivera's oeuvre, a reference to Cézanne's famous up-tilted tabletops with inclined still life elements, however, Rivera's is more akin in simplicity and austere arrangements to Derain's Cézannist adaptations.

The *Portrait of the Sculptor* is considerably more complex in its Cubist aims than the previous picture and reveals Rivera's growing understanding of the Cubist syntax of tangible space. The figure's graceful arcs and elliptical curves also reveal a self-conscious, Cubist "Maniera" derived from El Greco that is now completely integrated with Rivera's dynamic curvilinear style of "Cubism." The complex solution for combining a fully-profiled and three-quarter view of a head and neck retaining a semi-naturalistic appearance is worked out in an elaborate system of simplified, stylized contours, transparent planes, *passage* and tonal gradations in the head that create an almost naturalistic optical illusion of a head turning in space. In the *Portrait of the Sculptor,* Rivera's technique of representing forms within their own self-contained extra-dimensional "cuts" or slices of space prefigures the conceptual spatial capsules of his later synthetic Cubism. These volumetric spatial containers of forms can be seen in the transparent and gradated tones around the sculptor's head, the marble bust, and in the narrow curvilinear plane surrounding the bronze head on his knee.

The complete break of the figure's contour and its somewhat awkward integration with its surrounding space by means of extended broad and undefined planes occurred in Rivera's next Cubist portrait of an artist, the *Portrait of the Painter (Zinoviev).* The combined views of profile, three-quarter and frontal representation of the model is totally fragmented and then broadly re-integrated, retaining some stylized naturalistic features in the head, hands and clothing. Rivera's treatment of the simultaneous representation of multiple views of the subject became increasingly complex after the *Portrait of Zinoviev.* In his *Saint Martin's Bridge, Toledo* and the *Viaduct, Landscape of Meudon,* both of late 1913, architecture, landscape, and objects have been dismembered and are recorded in conceptual views taken from each imaginable dimension and perspective including higher dimensions of space hypothetically perpendicular to the three conventional ones. These views and slices of views have then been conceptually re-combined on the two-dimensional surface of the canvas into synthetic images evoking the memory and experience of specific sites and subjects. In the case of the *St. Martin's Bridge,* it was the fortified Hispano-Moorish bridge spanning the gorge of the Tajo with the simultaneous views of the Cigarrales in the background and

historically diverse elements of the bridge's Moorish, Gothic, and Renaissance architectural details; in the *Viaduct,* the busy train viaduct in the forested, industrial suburb of Meudon, quite familiar to Rivera, on the outskirts of Paris is evoked.

The evolution of Rivera's fragmentation of planes, movement, and color culminated at the end of 1913 with his Simultanist painting of the multiple aspects of a woman drawing water from a well. Its rich palette long-hidden behind a layer of purple paint and its back re-used as the support for the masterpiece of Rivera's Cubist period, the *Zapatista Landscape,*[110] the *Woman at the Well* (Cat. 18) is also the culmination of Rivera's Toledan series of works on the subject of women and water.

The degree of sophistication and complexity of idiosyncratic decorative design in the *Woman at the Well* makes it difficult to decipher. In a trellis-enclosed, clay-tiled patio, a female figure in the process of drawing water from a well is depicted in various stages of movement and is analytically decomposed into broad planes of fragmented impressions. The erie *trompe l'oeil* hand grasping the slipping planes of the water jar is the point of departure for this exercise in repetitive progression towards plastic abstraction within the same picture. The "subject" is the activity of drawing water from the well. This activity is represented in a variety of passages of time from multiple, actual, and conceptual points of view. A gradual disappearance of the figure's naturalistic references into a visually geometrical and theoretically abstract realm is here represented. The figure on the right goes through a geometrical metamorphosis to the figure on the left of the decorative metal armature with only multiple views of the figure's elongated neck remaining recognizable in the third dimension. Its other features and anatomy have been reorganized in a conceptually higher dimension.

The *Woman at the Well* is Rivera's most successful "Cubo-Futurist" work. It combines the principles of Cubism (stereometric treatment of forms and construction of a tangible pictorial space) and of Futurism (the sequential decomposition of movement).[111] It also utilizes the Bergsonian concept of memory and the mutual interaction of objects and their environment remembered as visual impressions.[112] In the *Woman at the Well,* Rivera represented the remembered impressions of a scene in Toledo. Multiple views of objects such as the vase, a lid opening and closing, the opening of the well, the turning of the winch to pull up water, and the movement of the female figure herself fragmented and abstracted into various levels of reality are all combined in a carefully coordinated design of contrasting angular and curvilinear lines. Rivera's gift as a superb colorist who transformed El Greco's Mannerist colors of high-keyed, yellow-green, fiery red-orange, ultramarine and metallic grey-blue, and a peculiarly Mexican rose-pink into a dynamic Cubist palette had its most successful application in this painting. The colors in this work, however, remain somewhat muted by the film of the layer of purple paint that once covered its surface.

The *Woman at the Well* was probably Rivera's last and most-developed Cubist painting in 1913. It was not yet completed by mid-November which was the opening of the Salon d'Automne and Rivera did not enter the work in that exhibition. He did however, make his debut as a Cubist in the Autumn salon with three other Cubist works: the *Adoration of the Virgin and Child,* which was titled in the catalogue *Composition, Encaustic Painting,* the *Young Woman with Artichokes* and the Cubo-Futurist *Young Woman with a Fan.* The latter was a prelude to the *Woman at the Well,* with its combined views of the head, face, and billowing pleats of the figure's dress going through a series of fragmented rotations interpenetrating the fan's movement. It was described by Brendel as being "Very Spanish — a figure of the people, in spite of its Cubism."[113]

Two Women, (Dos mujeres) 1914

Catalogue No. 22

La mujer del pozo, (Woman at the Well) 1913

Catalogue No. 18

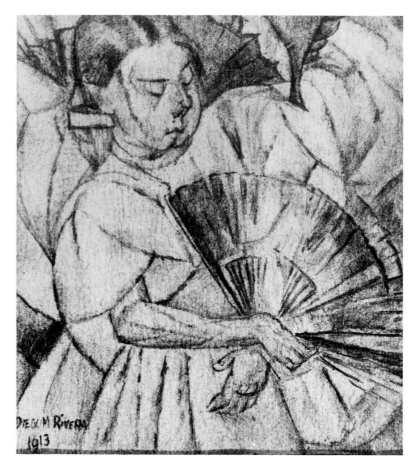

La niña de los abanicos, (Young Girl with Fans) 1913 Catalogue No. 10

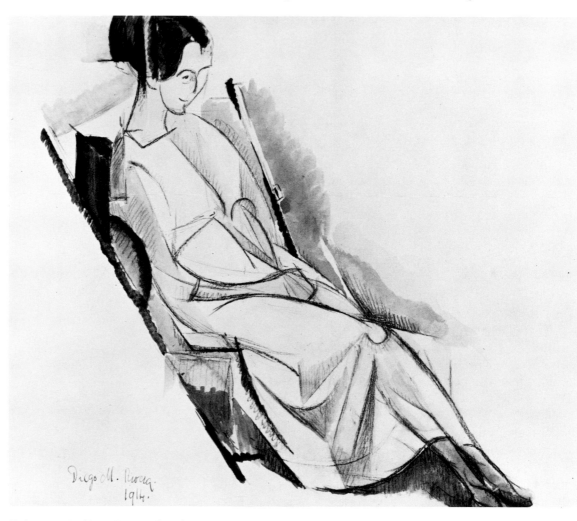

Mujer sentada, (Seated Woman) 1914 Catalogue No. 21

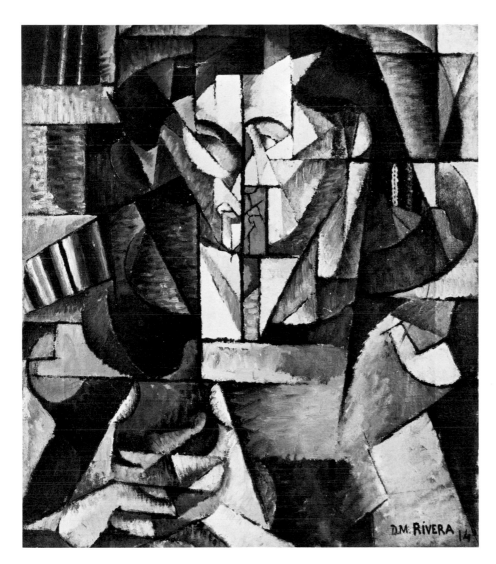

Jacques Lipchitz (Portrait of a Young Man), 1914
Jacques Lipchitz (Retrato de Joven)

Catalogue No. 26

Rivera's *Adoration of the Virgin and Child* was the most popular of the three paintings and, more than his previous *Portrait of Best*, marked his entry into a place among the Parisian avant-garde. The painting was reproduced in several important reviews, among them the recently founded avant-garde journal, *Montjoie!* (February 1913–June 1914), the Parisian Russian-language art journal, *Helios*, and in the more established and conservative journal, *L'Art Décoratif*. Rivera had by now certainly arrived on the Parisian art front for not even Zárraga's Cubist paintings received as much exposure on this occasion. Zárraga's entries to the Autumn Salon, which he had painted in Florence, were four decorative Cubist *panneaux*, more interesting for their subject matter than for their form. His entry was comprised of a heroic frieze of four large decorative panels with the unprecedented subjects in a superficially Cubist style of the Aztec warrior chief, Ilhuicamina, David, St. George, and an Aviator. Salmon's review of the salon in *Montjoie!* singled out the "Cézannian canvases of Diegon Rivera, who does not ignore Derain, (sic)" but dispensed with Zárraga's four panels as "rather vulgar in their melancholy and bleakness."[114]

Rivera's new association with the Parisian avant-garde that centered
around the dynamic figure of Riccioto Canudo, the Italian founder of
Montjoie! dates from the fall of 1913. The offices of the journal were described
by Delaunay as a 'rendezvous of avant-gardisme,' and served as a weekly
meeting place for gatherings where Rivera met such people as Apollinaire,
Alexandre Mercereau, Roger Allard, Blaise Cendrars, the composers Stravinsky
and Satie, the American Morgan Russell, Delaunay, Léger, Chagall, and the
Puteaux Cubists who included the Duchamp brothers, Kupka, De la Fresnaye,
Gleizes and Metzinger, and the Russian Larionov and Gontcharova.[115] Mme.
Gleizes recalled that about the same time before the war, a "primly dressed
and well-mannered" Rivera about whose talent everyone talked, would come
out on occasion to the Sunday gatherings at Puteaux.[116]

At the end of 1913, Rivera was asked by Canudo to contribute a drawing to
an issue of *Montjoie!* dedicated to Modern Dance. The schematic drawing he
submitted (Fig. 20) to illustrate an article on "The South American Dance,"[117]
demonstrates a linear pattern of elliptical lines and curves that is more
Futurist in its directional indications than any previous or subsequent work
of Rivera.

The dynamic implied movement that interested Rivera all of 1913 was
transformed the following year into a more static representation of
simultaneity controlled by an overlaid grid. From the winter of 1913-14 appear
two paintings which although signed and dated 1913 are dated in such a way
that does not coincide with the way Rivera signed and dated his other works at
the time. Nor does their style coincide with the developmental sequence of

the known dated works. These two works are the Bergen *Still Life with Stringed Instrument (Balalaika)* (Cat. 19) and the *Portrait of Elie Indenbaum.* The Bergen picture is conspicuously signed with a stencil "D.M.R.," beneath which appears "1913" in prominent figures. Rivera did not consistently use a stenciled signature until his Mallorcan paintings from the summer of 1914 on, and, the signature on the *Portrait of Indenbaum* is his characteristic post-1917 cursive signature which may have been signed after the work returned with Rivera to Mexico.

The *Portrait of Indenbaum* displays completely flattened planes and an elimination of the naturalistic modeling and contours of the head and mouth within subordinate planes in the grid. Since these characteristics appear in the signed and dated *Portrait of Lipchitz* and the *Two Women,* it must consequently come after those two 1914 works. Although the Bergen *Still Life* may have been post-dated by Rivera to 1913, it appears to have been executed in the early part of 1914 to judge by its proximity in style to the *Alarm Clock* and the *papier collé, Still Life with Carafe.* Both works were executed in early 1914 and the collage incorporates a piece of cardboard painted in the *trompe l'oeil* version of the same flowered wall paper in the Bergen picture.

The Simultanist *Portrait of Lipchitz* (Cat. 26) utilizes a geometrical grid system of what might be Golden Section rectangles and triangles within which are contained fragmentary aspects of Lipchitz's profile, facial features, moving hands and fingers in simultaneously projected views. It is a recognizable elaboration of Rivera's late 1913 *Portrait of Zinoviev* which did not yet have a grid. The wide sequential movement in the Lipchitz portrait, simplified by the enlargement of the fingers, is no longer as active as in Rivera's 1913 Simultanist works. This slower, more static representation of simultaneous movement is repeated in the hands of the *Sailor at Lunch.* The vertically oriented rectilinear grid of the Lipchitz portrait that by 1913 had become a stock-in-trade convention of Parisian Cubism, may have been derived by Rivera from Juan Gris whom he had recently met. Metzinger, whom Rivera also met about this time, also uses a similarly derived grid incorporating semi-naturalistic features within the grid in his paintings of 1912-13.

The large painting, *Two Women* (Cat. 22), of early 1914 also displaying a sparse superficial grid bears similarities with Metzinger and Gleizes' epic Cubist style of the previous year. Prepared for and exhibited in the 1914 Salon des Indépendants along with the Lipchitz portrait, it depicts Rivera's wife Angeline and her recently arrived friend from St. Petersburg, the painter Alma Dolores Bastián ("Mouscha"). A static classicizing form of simultaneity is Rivera's primary aim in this work in the carefully balanced planes and repetitive lines of the different sequential positions of the figures and their surrounding space. When it was exhibited, an observer noted that "in that beautiful composition, *The Figures (Two Women),* we can study the preoccupation with movement that excites today's painters, a fusion of the arts comparable to the musical drama...the orchestra that describes landscapes in detail as a melodious impressionism."[118] The gracious lyrical form and movement of the seated figure is worked out tentatively with Rivera's earlier predilection for elliptical curves in the little watercolor study, *Seated Woman* (Cat. 21). In the finished work, the same curves are transformed into stratified angular planes. Certain elements in the *Two Women* such as the stepped planes and the synthetic interpenetration of physically separate but psychologically related objects are related to Gleizes' large *Harvesters* (1912) which also contains a similarly treated dog lying in the foreground. In his epic composition of *Two Women,* Rivera took great liberties with integrating cityscape forms and Mondrian-like schematic trees in the background making the distinction between interior and exterior objects and

city and landscape ambiguous. Its carefully applied horizontal brushstrokes and rich, sober coloration made the painting a tour de force which understandably attracted much attention at the Salon. It was the *Two Women* and the *Portrait of Jacques Lipchitz* that prompted Apollinaire's remark in his review of the Salon that "Rivera is not at all negligible." Rivera's salon entries in the 1914 Indépendants also spurned the volatile art critic and boxer, Arthur Cravan (Fabian Lloyd), to soon proclaim Rivera the "Champion of Cubism."[119]

The firm design and volumetric density of Rivera's *Portrait of Lipchitz* and its self-confident brushwork and palette indicate that Rivera was by now in complete command of his Cubist style. Rivera's autonomy is further indicated by his inclusion of the decorative patterns of a Mexican sarape — an idiosyncratic iconographical element that Rivera used in his Cubism to assert two things: his Mexican identity and the high plastic intrinsic decorative qualities of the motif, the sarape, itself. Rivera later included various patterns of Mexican sarapes in *The Alarm Clock* and the study for that work, the *Composition with Clock;* in his later 1915 *Portrait of Martín Luis Guzmán,* the *Portrait of Bertha Kritoser* (Cat. 47), and in its most grandiose manifestation, in the *Zapatista Landscape.*

Rivera's interest in native Mexican motifs was either awakened or reinforced by the recent large exhibition of Russian folk art that had been organized by Nathalie Ehrenburg for the 1913 Salon d'Automne. Entitled "Popular Russian Art in Images, Toys, and Spice Breads,"[120] the exhibit included Russian peasant arts and village crafts of every variety with their heightened effects of brilliant color. The Neo-Primitivists among the Russian artists colony in Paris voiced an unbridled enthusiasm for the genuinely pure forms and painterly beauty in their folk art. In the same issue of the avant-garde Russian art journal, *Helios,* in which Rivera's *Adoration* was reproduced, there appeared a long article about Russian folk art written by Ehrenburg and accompanied by reproductions of numerous examples. Rivera surely must have recognized the similarity between the Slavic folk art admired by his Russian friends for its artistically pure and plastic properties and such Mexican popular traditional arts as candied bread skulls *(Pan de Muertos),* *retablos* (votive icons), weavings, and other crafts that he had seen as a child in Mexico. His inclusion of a decoratively patterned weaving, possibly of Mexican origin, in his late 1913 drawing *Still Life with Teapot* is among the earliest examples of this new iconographical interest of Rivera.

In his early 1914 still life, *The Alarm Clock,* Rivera included as the prominent iconographical motif, the decorative patterns of the Mexican sarape painted in highly saturated colors. Upon it are spread several no less idiosyncratic elements that are decidedly foreign to the repertoire of Parisian Cubism. The iconography of Rivera's entire Cubist output was to be extremely personal and biocentric as opposed to the selection of intentionally neutral motifs by other Cubists for their universal, purely formal, and unobtrusive qualities.

Wolfe surprisingly asserted that the *Alarm Clock* was an example of Rivera's "imitativeness" of other Cubists, and that it represented an assemblage of a number of conventional Cubist motifs that were "alien" to Rivera. He stated,

> The musical instrument, the playing cards; Diego has little sensibility for music, never touches an instrument himself, and detests all forms of cards, moreover, I doubt if he ever used an alarm clock; the fan too is alien.[121]

However, contrary to Wolfe's assertions, Rivera later recalled that *The Alarm Clock* did have a special significance for him.

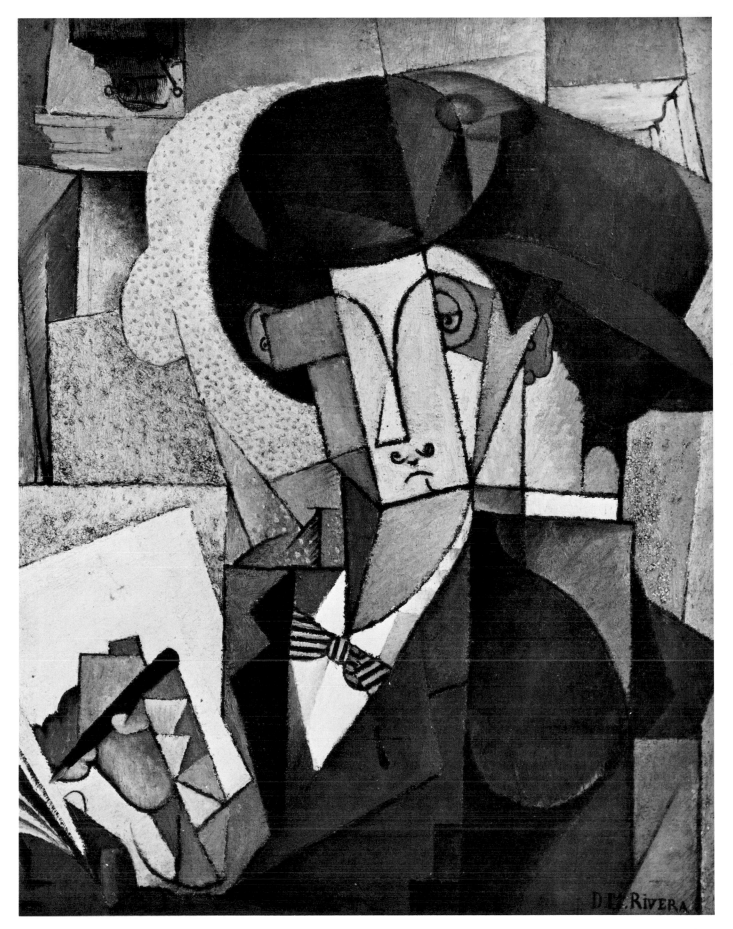

El joven de la estilográfica, (Young Man with a Stylograph) 1914

Catalogue No. 24

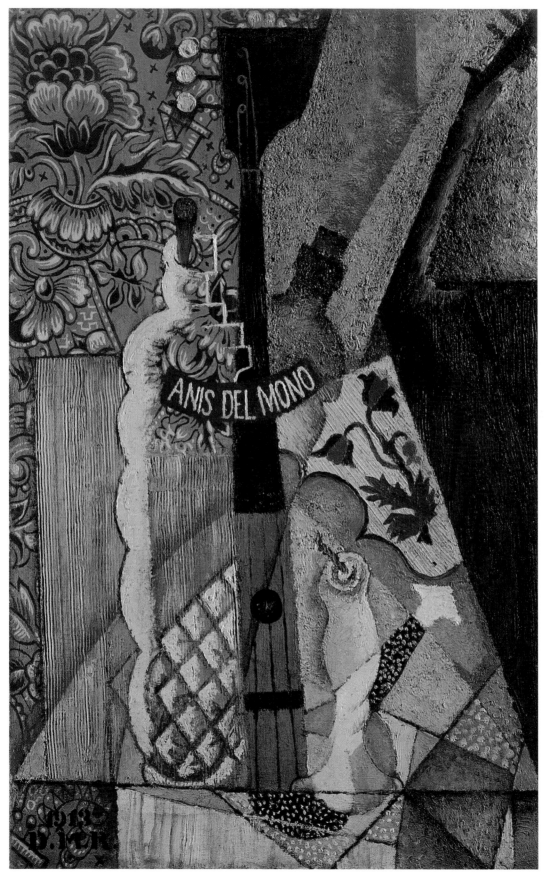

(Naturaleza muerta con balalaika) Still Life with Stringed Instrument, 1913 Catalogue No. 19

... The clock was there as a premonition of something soon to happen in time, (this was before the fateful day in August 1914) in the background could be seen a Mexican cow-boy sarape next to a Parisian carafe accompanied by a small bellows that one used to kill fleas. There was also a balalaika, an instrument of Russian popular music over a blue notebook and a label of the great 4 Aces cognac naturally in the language of the Czar and Lenin, with everything under a red fan.[122]

Setting aside Rivera's hindsight attempt to politicize the painting, his description is illuminating. As Rivera indicated, what was depicted was not a group of playing cards but a label, actually of a popular brand of Russian vodka, of which he was fond. His interest in the fan had already appeared in his 1913 *Young Woman with a Fan.* The balalaika was not all that common a motif, even among the Russian Cubists such as Popova, the early Vasil'eva or Goncharova who curiously depicted guitars in their Cubist paintings but not balalaikas. Yet Rivera utilized it in two significant works: *The Alarm Clock* and the *Still Life with Stringed Instrument.* When Wolfe surprisingly asks about this motif "Has Angeline, or another brought it into his studio" the obvious answer is that she had; and other aspects of her culture that she introduced to Rivera, in particular, her language, were just as important for the Mexican artist who became a central figure in the coteries of Russian émigré artists and writers during the war. The Parisian carafe was also a favorite motif for Rivera. He used it in several Cubist works and was fond of the circular grooves or cuts in the crystal that he wittily positioned in the *Alarm Clock* as signs for fingers playing the neck of the balalaika.

Rivera included the same carafe that appeared in his 1913 *Portrait of Miestchaninoff* and the *Alarm Clock* in his only known example of a *papier collé* (pasted-paper collage), the *Still Life with Carafe* (1914, Cat. 23). Here he also playfully drew the grooves of the cut crystal so as to be read as hands and fingers grasping the black stylographic pen which was cut out of cardboard and pasted underneath the carafe. Beneath the pen, carafe, and cut-out newspaper glass, is glued a telegram addressed by the painter to himself. The flowered wallpaper painted in brown and white in a startling trompe l'oeil technique is amazing for its decorative and technical quality. The pattern was derived from a curtain that the Riveras had in their studio (Fig. 21), and no less startling is its identical recreation in paint, not collage, in the sumptuous Bergen *Still Life with Stringed Instrument.*

These two latter works are also related in their incorporation of simulated wood grain and in the particularly Gris-like axial tilting of the composition. By early 1914, Rivera had met the Spaniard Juan Gris and become familiar with his work. Rivera's *Young Man with a Stylograph (Portrait of Best Maugard)* (1914, Cat. 24), displays a similar composition clearly divided into vertical and diagonal axis placed slightly off-center. Based possibly on Golden Section calculations, the painting was very similar to Gris's 1913 still lifes and, particularly, his *Smoker* of the same year. About the same time, as can be seen in *Young Man with a Stylograph,* Rivera began to mix sand and aggregate with his paints. The Cubist portrait of Best Maugard from February 1914 displays various interesting textures under a cover of decorative Pointillist dots and planes of impastoed pigments.

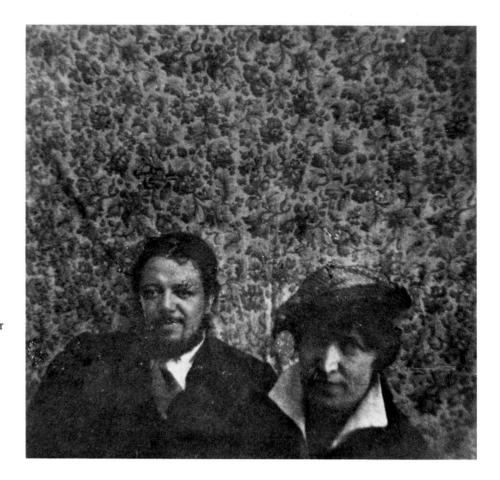

Rivera's concentration on Cubist portraiture (of which he became a master) began in the spring of 1914. His Cubist style was attaining a distinctive expression in highly saturated decorative colors that tended towards a peculiarly Mexican and undefinable quality: olive and drab greens, turquoises, lavenders, roses, and a distinctive reddish purple to be found in the *Young Man with a Stylograph's* hand, behind the *Sailor at Lunch* (Cat. 29) and throughout the *Grandee of Spain (El Caballero).* In his Cubist portraits of Lipchitz, Best Maugard, the *Sailor at Lunch,* and the *Caballero* (Cat. 25), the simultaneous views of the sitter and facets of his actual and conceptual environment enrich the psychological expression of the portrait and enhance the tangible plastic qualities of each painting. In practically every one of his Cubist portraits there is some ingeniously represented reference to the identity of his sitter. In the *Young Man with a Stylograph* it is the stylograph and fretted profile hand of the dandyish copyist-draughtsman of Pre-Hispanic artifacts, Adolpho Best Maugard. In the so-called *Grandee of Spain (El Caballero),* it is the strategically placed pistol and saber of the portrait that could be, if one believes Rivera, of "that fantastic, aggressive, and extraordinary personage who would soon obtain the admiration of the Russian people for his combat exploits in the tartar cavalry, the Marshal Semyon Mikhaylovich Budenny."[123] If Rivera did paint this portrait in Paris, for which there is the small pencil study illustrating the naturalistic and elliptical point of departure employed by Rivera, then its traditional title of "Grandee of Spain" was acquired later.[124] Since the work seems to precede stylistically the clearer composition of the *Sailor at Lunch* with a similar but more refined facture than the *Caballero,* the latter was painted in Paris before Rivera's departure for Spain later that year.

Among Rivera's lost Cubist portraits from early 1914 besides that of the other Mexican artist at the time, Jorge Enciso, are two portraits of the Japanese painters Foujita and Kavashima. The *Portrait of Kavashima and*

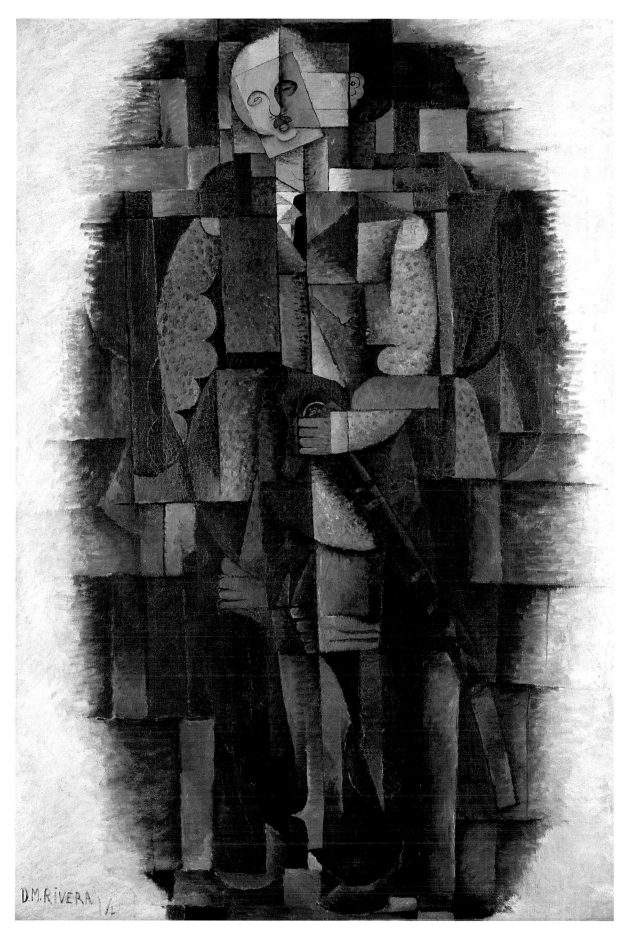

El Grande de España, (El Caballero), (Grandee of Spain) 1914

Catalogue No. 25

Figure No. 22
Diego Rivera, *Portrait de Messieurs Kawashima et Fushita* (sic), 1914
Oil on canvas
Present wherabouts unknown
Photograph from the catalogue of "De Onafhankelijken" exhibition, Amsterdam, May-June 1914, No. 441. Reproduced from Donald Gordon's *Modern Art Exhibitions*, I, p. 302, with permission of Prof. Gordon.

Foujita, exhibited in Rivera's one-man show in Paris, is an important example of how Rivera relied on Mondrian's figure studies (Fig. 22) during this period as he later acknowledged. It is also significant in that the painting's execution also provides a date for Rivera's momentous meeting with Picasso. At the time he was painting this portrait of his two Japanese friends, Rivera recalled:

> ...the talented Chilean painter, Ortes de Zarete (sic) came to my apartment early one morning. 'Picasso sent me to tell you that if you don't go to see him, he's coming to see you.'
>
> I accepted the invitation with pleasure and gratitude and immediately accompanied Zarete to Picasso's, together with my friends, the Japanese painters, Fujita and Kavishima, who were posing for a canvas I was then doing. This was a portrait showing two heads close to one another in a color scheme of greens, blacks, reds and yellows. *Typical of my work of this period, it owed not a little to Mondrian, a good friend and neighbor, with whom I had been exchanging ideas and artistic experiences* (emphasis added).
>
> Dressed in costumes used for the portrait, my Japanese models looked picturesque and amusing. Both wore long toga-like robes and sandals. Their hair was cut in bangs over their foreheads and encircled with colored ribbons.
>
> I went to Picasso's studio intensely keyed up to meet Our Lord, Jesus Christ. The interview was marvelous. Picasso's studio was full of his exciting canvases.... As for the man...a luminous atmosphere seemed to surround him. My friends and I were absorbed for hours, looking at his paintings...he let us see his most intimate sketchbooks. ...Picasso asked me to stay and have lunch with him, after which he went back with me to my studio.

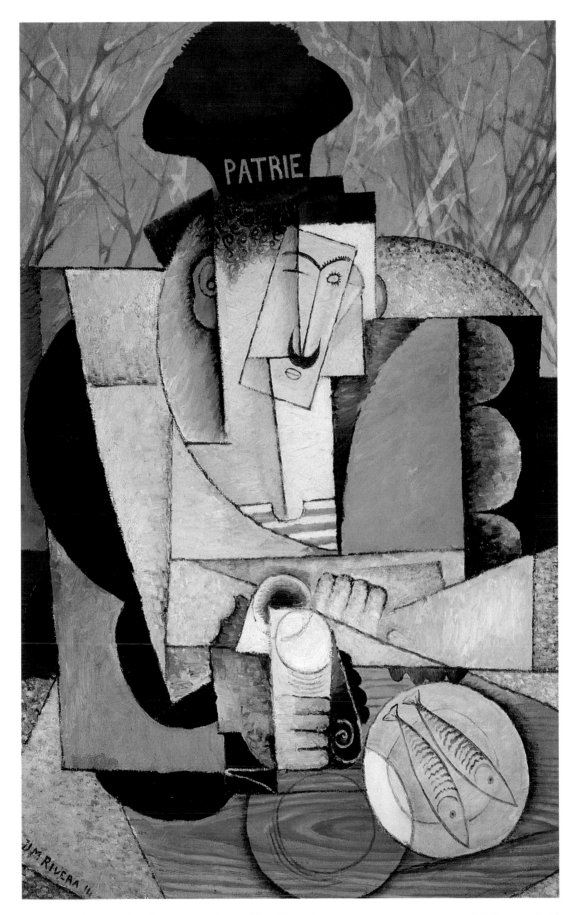

Fusilero marino - Marino almorzando, (Sailor at Lunch) 1914

Catalogue No. 29

Cabeza de marino, (Sailor's Head), First Version 1914 Catalogue No. 27

Cabeza de marino, (Sailor's Head), Second Version 1914 Catalogue No. 28

There he asked to see everything I had done from beginning to end. I had completed my painting *Sailor Eating and Drinking*, and several others that I liked: a second portrait of Adolfo Best called *The Man in the Stilograph* (sic) (now in the collection of the sculptor Idenbaum) and the still lifes, *Balalaika* and *Bottle of Spanish Anise* (the *Alarm Clock* and the Bergen *Still Life with Stringed Instrument*).

After I had shown Picasso these paintings, we had dinner together and stayed up practically the whole night talking. Our thesis was Cubism — what it was trying to accomplish, what it had already done, and what future it had as a 'new' art form.[125]

Rivera's meeting with his acknowledged master, Picasso, in the spring of 1914 coincided with the Mexican artist's first and only one-man exhibition of paintings in the Parisian capital. Rivera's Cubism could now be seen to have evolved into a highly personal style containing elements derived from El Greco, the Cézannist Cubists of the salons, Juan Gris, and his own very Mexican qualities of delicately coarse surfaces and textures and highly saturated exotic colors. The enthusiasm that Picasso showed for Rivera's work, according to Rivera, was overshadowed only by Rivera's awe for the Spanish genius who from that day on he considered his master. Even later when the wounds of their wartime quarrel over artistic precedence and Rivera's accusation of plagiarism had not thoroughly healed, Rivera would still refer to the Spaniard as "mi maestro Picasso."

The first one-man exhibition in Paris of "Diego H. Riviera" (sic) opened on April 21, 1914 in the miniscule gallery of Picasso's first Parisian dealer, Berthe Weill, at 25, rue Victor-Masse on the Right Bank. According to the catalogue, it consisted of eight "Landscapes from Toledo (1913)," which included such non-landscapes as the *Young Woman with a Fan, Young Woman with Artichokes,* the *Woman in Green* (1913) — possibly the covered painting today on the reverse of the Art Institute of Chicago's *Portrait of Marevna,* and the *Landscape of Meudon (The Viaduct).* Nine paintings from 1914 followed including the two portraits of *MM. Kavashima and Fushita* (sic) and "Le Dessinateur" *(The Draughtsman,*the *Young Man with a Stylograph).* Seven drawings and watercolors concluded the exhibition of a total 25 works — a considerable amount for the past year and one-half which was indicative of Rivera's prolificness.

The minor scandal that was provoked by the catalogue preface of Rivera's one-man exhibition, in which Picasso was indirectly insulted by the preface's anonymous author, Berthe Weill, obscured any significant impression that Rivera's Cubist works might have had on Parisian critics. The exhibition went for the most part unnoticed in the press. When Apollinaire reviewed it under the title of "A Curious Preface,"[126] he did make the 'discerning appraisal' that "the sensitivity of two or three of these drawings would itself have justified the exhibition." The rest of Apollinaire's review was devoted to reproducing the "odious preface" in which the "someone who signs himself simply 'B' practically insults the artist he is supposed to introduce to the public." Apollinaire concludes,

> M. Rivera has not been able to find out who wrote this preface, which heaps abuse on everything he respects in modern art. But what is one to say about a critic who agrees, without even being asked by the artist to write the preface to an exhibition of whose whole tenor he disapproves?

Does Apollinaire's assessment of the situation indirectly reveal Rivera's incredible naiveté at the time?

In an article about Rivera written shortly before the exhibition opened in the spring of 1914, the Peruvian critic Francisco García Calderón, intimately describes the young Mexican artist and relays some of Rivera's views on Cubism. The article was Rivera's first major Parisian exposure and the most detailed account of his career up to then. Its value as a contemporary document offering little-known insight into Rivera's personality and work warrants its partial reproduction:

> I have sought out on the remote hillock of Montparnasse in the Paris of bohemian artists, a solitary person. There lives Diego Rivera, an enlightened painter in search of new chimeras (fanciful creations of the imagination). In the human polichromy of the quarter — shaven North Americans, Russians who alternate bombs with paintbrushes, English *misses* of lamentable tenacity, and scions of the mongrel Americas — this young Mexican has raised his studio like a watchtower. In his gaze and his attitude there is a great kindness, a strange mysticism towards the present struggles. Modest and proud like all true artists, he believes in the dignity of his struggles and before the far-off goal, he judges his present works as merely provisional. He figures in the caravan of the new and like a thirsty dromedary is in search for new waters. In his attempts and search

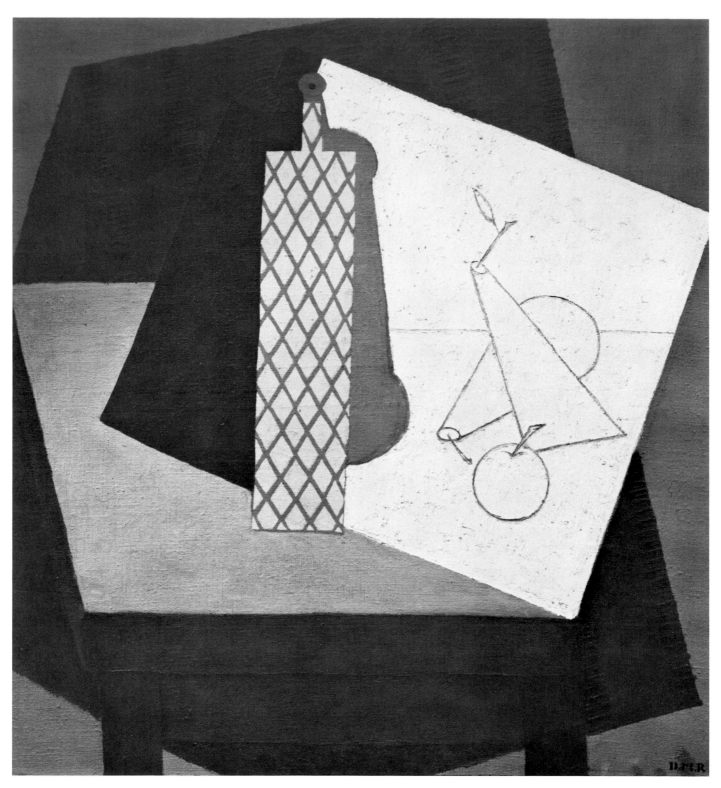

La Bouteille d'Anis, (The Bottle of Anis) 1915

Catalogue No. 43

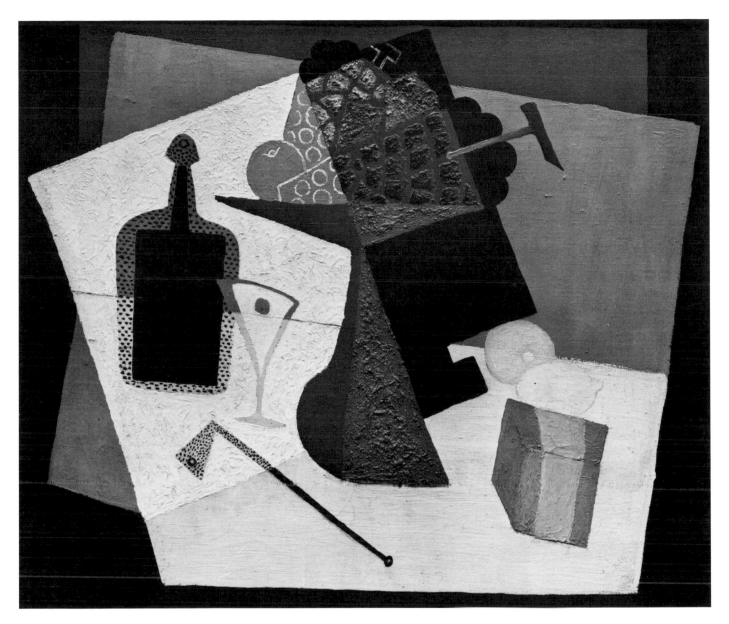

Naturaleza muerta con limones *(Still Life with Lemons)* 1916

Retrato de "Berthe Kritosser," (Portrait of "Berthe Kritosser") 1915

Catalogue No. 44

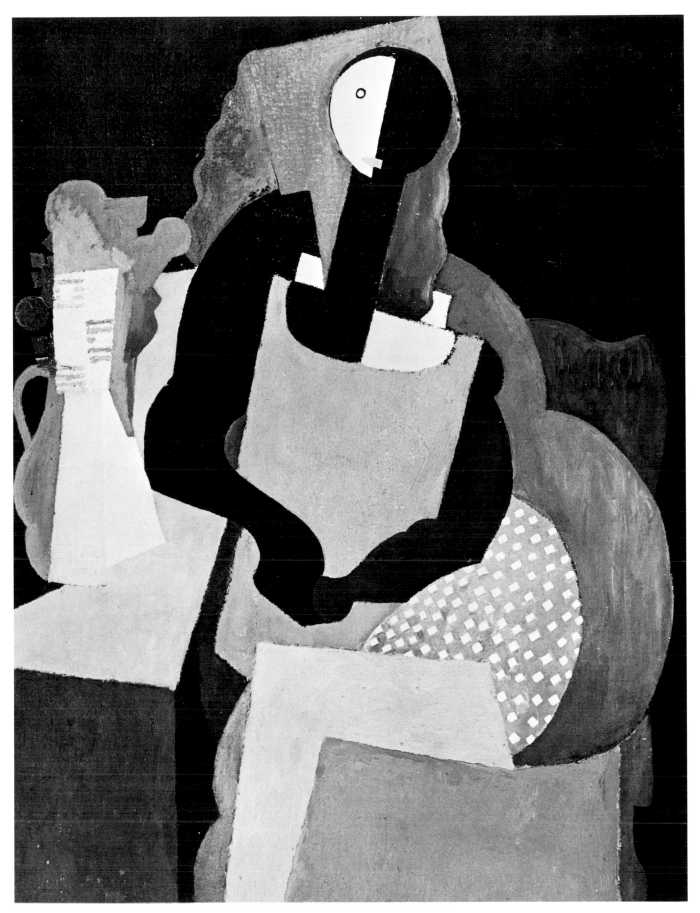

"Berthe Kritosser," (Portrait of Berthe Kritosser) 1916

for his own wealth in the mystery of his profound id, he leaves his spiritual confession behind in admirable and controversial works.

I don't pretend to judge Rivera's multiple oeuvre, but only to relay to our public his tenacious faith. He already has a credo, but without the rigidity of a dogma. In the various new schools, Cubism, Orphism, Neo-Cubism, Simultanism, Futurism, Cerebrism, the young painter finds salutary tendencies. Is he a Cubist or a Neo-Cubist? He is disposed toward the new tendencies and within them freely searches for his own route.

In art, the (Cubists) announce a revolution that would be as radical as the substitution of our three-dimensional geometry by those fantastic non-Euclidean considerations of Riemman (sic), "4" or "n" dimensional space, as irregular and macabre as a story by Poe. They teach us to see in volumes (volumetrically) instead of retaining our vision on the immediate surface. They complete the primary image by adding to it dynamic combinations. The unencumbered face of an object seen from the front or in profile, gives us, they say, the real image: false is the picture that translates it (the subject or object) into a static representation. We provide in the language of space, the total cubic expression, and for this we combine two or three complementary positions that correct the primitive, superficial, representation.

Rivera is (now) a Cubist. However, in the vast wave he maintains his autonomy. He exhibited in this year's Salon des Indépendants. Towards the direction of Cubism there was the progression from his timid beginnings with the *Young Girl with Artichokes,* which he presented in last year's Salon d'Automne; towards decisive rigorous canvases, in the new exhibition, such as the *Young Man in the Grey Sweater.* His work displays firm edges, the predomination of the angle over sinuosity, a frenetic Cubism of geometric mystery and profound symbol. In *The Bridge,* a picture from Toledo painted one year after *The Old Ones,* the dance of planes, the vertigo of the plotted rocks, also reveal the decision of the artist believer.

Diego Rivera reveals to us his faith and in his peaceful appearance we discover a prophetic vivacity. It is a religion this Cubism which suffers misery and ostracism for the glory of a beloved art. In place of regal compositions we have the bitter struggle of the Knights of Chimera. We admire the noble Mexican painter, his stubborn hope. 'In Prague,' he explains, 'Cubist architecture has triumphed: an entire quarter of audacious houses announced the future domination.' We, modest 'know-hows,' blind *laudatores temporis acti,* tell him modestly our disquiet. And he smiles without longing for the successes that could have held up his

adventurous transformation. He smiles with his gentle bovine figure, tall, handsome, and undaunted in his struggle to find truth in his art.[127]

Whether further naiveté or goodheartedness was expressed by Rivera in deference to his friend and master, on the day of the opening we do not know. According to a notation made by Alfonso Reyes on his copy of the exhibition catalogue,

> Diego didn't count on that malevolent preface nor on the allusion to his friend (Picasso). There was a scene between himself and the woman of the little salon. The exhibition was suspended — Diego was very poor. Paris, 21 April 1914.[128]

The exhibition and the above article are further elucidated by a letter of Reyes to his and Rivera's mutual friend from the *Savia Moderna* days, Pedro Henríquez Ureña who had now left Mexico for exile in Cuba.

> Naturally it was I who introduced García Calderón to Rivera which resulted in the article. Diego is immersed, mystically in *Cubism.* He considers himself a disciple of Picasso. Lately, obliged by his penury, he opened an exhibition in a diminutive shop next to the Place Pigalle in the middle of Montmartre.... The owner published a little catalogue for Diego's exhibition (without consulting with him about it) to which she attached a preface in which she attacked Picasso. Poor Diego had his exhibition closed down and he dispensed with the support of this terrible bitch, for the sake of a friend who perhaps sees matters of moral with very different eyes; in the meantime it's possible that neither Rivera nor his poor Angeline Beloff (his Russian printmaker, very intelligent and humble) will have anything to eat! I am just realizing this now. I'm going to see them tomorrow morning....[129]

Reyes' letter was dated "May 8, 1914," two days after the closing of Rivera's exhibition at the Weill gallery. That very evening Rivera came by to tell Reyes the good news which must have precluded Reyes' plans to intervene in their penurious situation the following day. In the same copy of the catalogue that Reyes had kept, he wrote beneath the first notation:

> May 8, 1914 (in the evening). Finally everything has been settled. (Rivera) has just come to tell me. He has had a success.

Presumably, Reyes meant a financial success and that Rivera had sold many works. The minor scandal, however, was just to be one of several that Rivera got embroiled in in Paris as a result of his artistic and ideological alliances. The next one was not far off. In the next month, shortly before his trip to Spain, Rivera was a "second" in a much-publicized duel between two Polish painters, his friend and god-son, Leopold Gottlieb and his acquaintance, Moise Kisling.

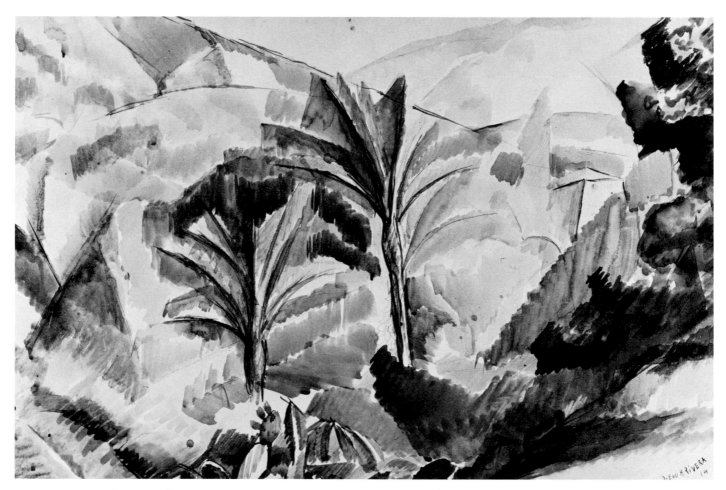

Paisaje, (Landscape (of Mallorca)) 1914

Catalogue No. 30

Gottlieb got the better of Kisling by slicing the tip of his nose with a saber. And as reported in the Parisian press, Kisling proclaimed it to be "the second partitioning of Poland!" The duel was concluded without Rivera having to fight.

Rivera's mention of Prague and Czechoslovakian Cubism in the interview with García Calderón, no doubt relates by this time to his association with the writer Alexandre Mercereau and his circle. Mercereau was an important link between the avant-gardes of the East and West with interests in the theoretical and metaphysical basis of Cubism on higher mathematics and philosophical speculation. By 1914, "Prague was the most fertile ground for Cubist art outside of Paris,"[130] and Mercereau organized the great Cubist exhibition held by the Mánes Society at Prague in February. Rivera contributed, in addition to four Cubist drawings, the *Woman at the Well* and the *Portrait of an Artist (Zinoviev)* to the Prague exhibition. Rivera's participation in international exhibitions was the most active of his entire European stay in the spring of 1914, and he participated as a Cubist.[131] In addition to the Mánes exhibition and the Parisian Salon des Indépendants (the last one to be held until 1919 on account of the war), Rivera sent Cubist works to progressive exhibitions in Brussels and Amsterdam. This flurry of activity and dissemination of his works accompanied by nominal success would soon abruptly cease for Rivera in the midst of an idyllic summer on the Balearic Islands.

An "Integral" Painter

The summer of 1914 unsuspectingly witnessed the dispersal of the Parisian avant-garde which was to become semi-permanent. Picasso, Gris, Braque, and Derain all departed with their wives for the south of France on their yearly painting vacations in mid-July. Also in that same month, with the imminence of war in the air, Rivera and his wife departed for a walking and sketching tour of the Balearic Islands and Spain. They were accompanied by Jacques Lipchitz and a group of friends from Montparnasse. During the peak of their idyllic yet ominous summer, the dark news of the outbreak of the First World War surprised the group on the island of Mallorca. Rivera was experimenting there with a ponderous, new Cubist style of broad, flat, modulated and impastoed planes and heavy geometric solids applied to the hot exotic colors and tropical motifs of the Mallorcan coastal landscape. His conceptualization of stylized palms and cacti emblazoned in anti-naturalistic colors over granitic rock forms can be seen in the *Landscape of Mallorca*. The *Landscape of Mallorca* prefigured the precocious proto-surrealistic inversion of realities that would become the hallmark of Rivera's metaphysical Cubist style. The rose and blue-colored areas of tree-bark of the tropical palms can be read as either magnified images of what they are, tree bark, or as ambiguous elements of sky, clouds, brilliant sunlight, or rocks and landscape. Another Mallorcan landscape from this period, the *Sea of Mallorca*, once in the collection of Alfonso Reyes was described by him as a "purist painting in which the acidic blue-green of the sea appears to have eroded and left naked the multi-colored rocks of the coastline.[132]

From the burning hot beaches and sun-bathed cliffs of Mallorca and after a brief stop in Barcelona, Rivera, Angeline Beloff, and Lipchitz relocated in Madrid at the end of 1914 where they met Rivera's old friends. Among the Spaniards were Ramón Gómez de la Serna, María Gutiérrez Blanchard, Julio Antonio, and Valle-Inclán. The recent arrivals from Mexico and Paris, Alfonso Reyes, Jesús Acevedo, and Angel Zárraga were also there. The writer Martín Luis Guzmán, a colonel under the Mexican Revolutionary forces of Pancho Villa and a friend of Rivera from his *Savia Moderna* days also arrived that winter. They were soon joined in Madrid by a group of French-based artists that sought exile from the war including Robert and Sonia Delaunay, Marie Laurencin and her husband the German painter Otto Waetjen, and the Japanese painters Foujita and Kavashima, all close friends of Rivera. In the words of Lipchitz, "the spirit of Montparnasse seemed transported to Madrid."[133] Alfonso Reyes had been happy to see Rivera upon his arrival in Madrid and referred to him in his letters as "Diego Rivera cubista, grande y noble" ("the great and noble Cubist Rivera"). However, he was soon complaining to a friend about the "monsters of ignorance and petulance — those foreigners from Montparnasse," adding that "some day we will talk about our lost forever Diego, who is now a real biddy and who has gone crazy with lies and 'Parisianness.'"[134] In spite of the gaiety that resulted from the camaraderie and nights

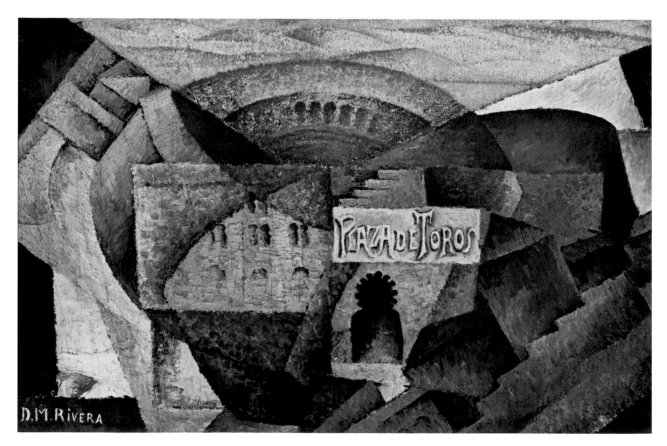

La Plaza de Toros, (The Bullfight Ring) 1915

Catalogue No. 31

of discussion and storytelling at Ramón Gómez de la Serna's famous *tertulia* of El Pombo, for Rivera and Angeline Beloff, it was a period of "horrifying and rending poverty," according to Reyes.

In writing his friends back in Mexico, Reyes also mentioned that "Rivera was all fired-up for getting back to France and going to war"[135] ("Diego Rivera está loco por irse a la guerra"), which accords with recollections by other friends of Rivera about his French patriotism. This enthusiasm may have prompted Rivera to paint his paean to the beacon of French culture and strength in the face of war, his *Eiffel Tower* of November 1914. The combined view of a ghost of the Eiffel Tower looming above and within the rotating cars of the Great Ferris Wheel is seen behind what appear to be various views of an inclined ship's bow. Broad, tilted transparent planes revealing the cornices of Parisian buildings are tilted and inscribed within decorative Pointillist and impastoed frames. Standing out most prominently beyond the grayness of the iconic images in the background is a bluish-green, white and red building facade at the end of a proto-Surrealist, empty street. The building to the edge

Figure No. 23
Principal Entrance to the New Plaza de Toros, Madrid, c. 1910.

of this mysterious grey industrial park may ambiguously symbolize both the basic colors of the Mexican flag and the French tricolor. That the work was painted not in France in November 1914, but in Spain, would place an entirely different meaning on the iconography of the painting. Ramón Gómez de la Serna called the painting "that gloss of the war, hair-raising, and sober without the ostentation of the image (that) is serious and chilling."[136]

The epic Cubist landscape, *Plaza de Toros* (Cat. 31), among Rivera's first paintings from Madrid dramatically combines exhilaratingly tilted simultaneous views of the height and depth of the famous bullring (Fig. 23). It had recently been built on the outskirts of Madrid not far from a house and studio that Rivera, his wife and Lipchitz shared with María Gutiérrez Blanchard. According to Reyes, the painting was inspired by a piece of impressionistic prose by Acevedo entitled "Paisaje del este: en torno a la plaza de toros" written in 1915. In the essay, Acevedo describes the solitary plaza in great poetic allusions as a silence-filled funnel rising in a whirlwind from the leaden grey and rose-colored earth that surrounds it.[137] It was a subject that lent itself perfectly to Rivera's interest in symbolic architecture and monuments tied to humanity, and epic and panoramic views from a high vantage point. It also facilitated his predilection for sweeping curves combined with stepped facades and rectilinear divisions in motifs and pictorial structure. A comparison with the complex and highly fractured composition of the *St. Martin's Bridge, Toledo* of the previous year reveals how Rivera's analysis of a landscape motif and conceptual synthesis of remembered forms, simultaneous views, textures, and colors had become more classicizing and austere. His architectonic forms and objects have become more generalized and unified in the *Plaza de Toros* and his ingenious coloristic use of the natural colored sand (probably brought from Mallorca) for the background reflects his creative inventiveness.

The *Plaza de Toros, Still Life with Demijohn* ("Ultima Hora") and his series of Mallorcan landscapes were included by Rivera in the famous exhibition of "The Integral Painters" ("Los Pintores Integros) that was organized in Madrid by Ramón Gómez de la Serna in the early spring of 1915. Gómez de la Serna had chosen to call them "Integral" painters and not "Cubists" or "Futurists" as he explained, "because they have evolved beyond the Cubist formulas to find their own integrity and autonomous (arbitrary) identity which they also applied to the nature of their subjects and the way they depicted them." Besides the Cubist work of Rivera, the exhibition included the no less Cubist and reductive work of his close friend, María

Gutiérrez Blanchard. Rivera's works were all listed in the catalogue under two categories: "Paintings, Mallorca, 1914 (6), and "Paintings, Madrid, 1915 (7) including one listed as a "Portrait"). In addition to the works of Rivera and María Blanchard, there were works by the sculptor Agustín-Choco and the caricaturist Bagaría who were included for their "reductiveness." Although several sources have indicated that Lipchitz and in some cases Laurencin and the Delaunays exhibited, they do not appear in the catalogue nor are their works mentioned in the reviews published in the Madrilenian press.

Every review of the exhibition was negative and if there was a positive thing said it was that the exhibition was a good diversion worth a good laugh, which prompted large crowds to pack the small gallery and go away in disappointment when it had closed. In the most insightful review of the exhibition of the "Integral Painters," José Francés ironically recalled that "Several years ago, when that business of Cubism, Futurism, and other such things were a novelty in the civilized world, Eduardo Chicharro told me, 'You'll see how that will never reach Spain. We Spaniards have an unsurmountable obstacle to all that: the fear of the ridiculous.' "[138]

Chicharro was by 1915 living in Rome as the Director of the Spanish Academy and could not attend his former protégé's showing which would have proved him wrong and surprised him as much as it did everyone else. After castigating María Gutiérrez Cueto (Blanchard) for "wasting her promising and glorious career and future by the turn she took towards Cubism" Francés remarked,

> As to Diego María Rivera, before exhibiting in Paris the *Young Woman with a Fan* in 1913, he had exhibited in 1911 those admirable landscapes entitled Ixtaccíhuatl (which were) much more superior in color and poetic emotion to those of his compatriot, Atl, who is himself a veritable master in that genre. We also remember Rivera's pictures in which the soul of Castile appeared strong and romantic with all its integrity. (And in this case one can truly speak of an 'Integral Painter.')
>
> Even in the very series of Mallorcan landscapes that he exhibits presently, his aesthetic sincerity, his marvelous aptitude as a colorist, appear in spite of the misguided cerebral direction of the artist today, and he interprets the sky and sea of Mallorca in an insurmountable fashion.
>
> I know very well that they will not take my heed. Nevertheless, in the name of those admirable paintings of before, I will permit myself to beg señorita Gutiérrez Cueto and señor Rivera that they immediately forget these paintings of today.[139]

Figure No. 24
Ramón Gómez de la Serna in his writing studio
in Madrid.
Photograph Alfonso

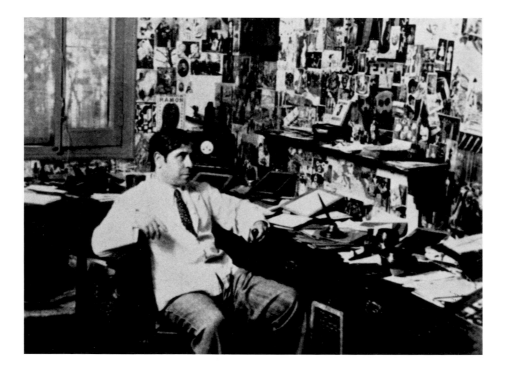

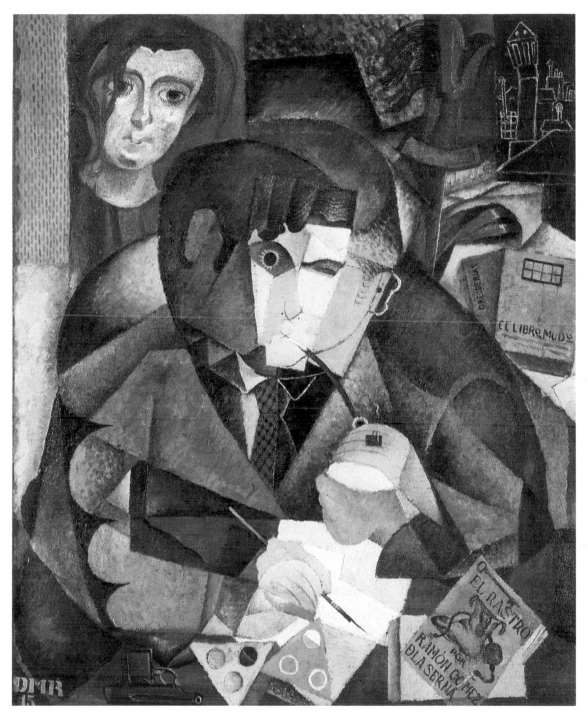

Retrato de Ramón Gómez de la Serna, (Portrait of Ramón Gómez de la Serna) 1915

Catalogue No. 32

El Rastro, (The "Rastro") 1915 Catalogue No. 33

Francés' review was illustrated by an unkind caricature (Fig. 25) that epitomized the public's reception of the exhibition and the two unconventional Cubist artists. As the reviews noted, it was literally the first exhibition of radically modern art in Madrid, and along with Rivera's "rotative" Cubist Portrait of Ramón Gómez de la Serna that was later displayed in the gallery's window, the exhibition caused a sensational stir in the musty Spanish capital. The *Portrait of Gómez de la Serna* (Cat. 32) so disturbed the traffic on Madrid's streets that the gallery owner was obliged to remove it from the window by the police. According to Gómez de la Serna, "Among the comments which the public made was the frequent observation that it was the record of a crime, a crime which I had committed by killing my victim — whose head remained visible behind me — with the automatic which I had at my side, afterwards decapitating her with the broad sword with hair on the handle which is also visible in the picture."[140] Actually the iconography of the painting was more innocent but no less bizarre, in that the objects depicted, besides the books making reference to the titles of Ramón's many published tomes, were just a few of the many collected strange props and *objets trouvés* with which he surrounded himself in his writing tower (Fig. 24). Gómez de la Serna was an avid frequenter of Madrid's famous flea market, *El Rastro* which he described with proto-Surrealist lucid fantasy in one of his earliest published books by the same name. *El Rastro* (Cat. 33) was also the title and subject of a small painting Rivera executed in Madrid which incorporates some passages from Ramón's book in its iconography. Ramón Gómez de la Serna, whom Rivera had met during his first stay in Madrid, had invented a new literary genre, the *greguería* (a reference to the untranslatable name appears in the *Portrait)* as early as 1910, in his published aphorisms and descriptive metaphors of incongrous juxtapositions of real everyday objects with literary leaps into the irrational, humorous and the ironic. Ramón's penchant for illogical transpositions may have influenced (or coincided with) Rivera's own proto-Surrealistic devices that he had begun to work out in his 1914 paintings in Paris (e.g., in the *Sailor at Lunch* where the green, marbleized tabletop of a Parisian cafe becomes the background for a sailor eating lunch on and within abstract, decorative evocations of blue sky and sea), and which were to become extremely elaborate in 1915.

Figure No. 25
Caricature by Fresno. "La Srta. Gutiérrez Cueto y el Sr. Ribera, pintores íntegros, que han celebrado una Exposición de obras cubistas en el salón 'Arte Moderno' " (Srta. Gutiérrez Cueto (María Blanchard) and Sr. Rivera, the integral painters who have just opened an exhibition of their Cubist works in the gallery 'Arte Moderno' "), *El Mundo Gráfico*, Madrid, March 17, 1915, n. pag.

In his long article on the Mexican artist entitled "Riverismo," Gómez de la Serna described in great detail Rivera's working method in painting his Simultanist Cubist portrait — which he coined in Spanish a "rotative" portrait. He called the portrait the most "palpable, ample, complete consideration of my humanness turning on its axis," and described Rivera's Simultanist technique:

Everything is well done in this portrait, even to the position of other hand which holds the pipe in smoking, in its three aspects: first, that of raising the pipe to the mouth; second, that of having it in the mouth; and third, that of resting the pipe in the hollow of the hand; the three instantaneous, successive, almost simultaneous, in amalgamation, which he attained almost without the dead point of the line between one and the other, because he was the first painter who realized that the art of painting is an act of movement.

The heaviness of one part of my body needed a darker color and with a certain thickness, just as the lightness of the other part is diffumination and lively color, livelier than it appears. The colors are not stupid and naturalistic mixtures, not at all.... In the portrait of Rivera I am rotative.[141]

Alluding to Rivera's metaphorical and pseudo-scientific inclinations in this Cubist painting, Gómez de la Serna noted that when Rivera painted his eyes, he did not look for their normal appearance as chestnut eyes, but

observed them as a technician. "As a marvelous 'optician,'" he stated, Rivera "synthesized in the round eye, the moment of luminous impression, and in the long shut eye, the moment of comprehension."

A similar technique with increasing refinement was utilized by Rivera in his large airy portrait of the architect *Jesús Acevedo,* among the last works Rivera painted before he left Madrid for Paris. Acevedos' half-moon eye replacing the burning illuminating sun of Ramón's signic eye, and his naturalistically rendered other eye and moustache as well as the configuration of the forehead, make the painting uncannily representative of the actual appearance of Acevedo at the time. *The Architect* (Cat. 35) incorporates the decidedly Gris-like checker-board tile floor which also appears in *Ultima Hora. The Architect's* increasingly abstract and large transparent planes contain Rivera's proto-Surrealist metamorphosis of objects into clouds and incongruous materials (e.g., in the formal play of a cloud-like profile of Acevedo's back in a sky-blue field which is only hinted at in the blue-tile transformation of the brown and white floor; the billowing smoke outline shape of the cigar's other half; and the ghost outline of the architect's table over which is superimposed a geometric wedge of illusionistically painted wood).

The dynamic Simultanism of Rivera's early Cubist portraits is completely arrested in the *Architect's* linear clarity and austerely cool, broad, and luminous planes. Rivera's use of sand and modulated impastoed brush techniques also become more sophisticated and refined in the complex portrait which was at the head of the 1915-1917 series of synthetic metaphysical Cubist portraits by Rivera.

After the limited commercial success of "The Integral Painters" ("Los Pintores Integros") exhibition, Rivera returned alone to his Parisian studio at

Figure No. 26
Marevna, *Parade, rue de la Gaîté, Paris. Modigliani, Soutine, Rivera, Marevna, Voloshin, Ehrenburg, Picasso, Max Jacob*
Drawing
Photograph courtesy of Diego Rivera's daughter, Mme Marika Rivera, London

26, rue du Départ. Lipchitz had preceded him back to Paris but he temporarily left Angeline behind with the Reyes. María Gutiérrez Blanchard went off to a teaching post in the Spanish provinces and did not join the Riveras in Paris until 1916. Rivera returned in the spring of 1915 to what was the beginning of the reorganization of the Parisian artistic milieu that had been dislocated at the beginning of the war.

In August 1914, the artistic center of Paris and laboratory of Cubist discovery, Monparnasse, had been surprised "en pleine mutation" ("in the midst of a mutation"). Everything had been suspended: the poetic reunions of Paul Fort at the Closerie des Lilas, the *Montjoie* and *Soirée de Paris* gatherings, the free art academies, the Indépendants and Automne Salons cancelled until after the war; and numerous modern artists' careers were disrupted in their prime. With most of the French avant-garde artists and critics either in exile or at the Front, it was a very different milieu. For the foreigners, or métèques[142] as they were pejoratively called, which included Rivera, it was a period of intense personal reinforcement in which artists and writers, mostly foreigners or women by now, fell to visiting each other. These included Picasso, Gris, Modigliani, Survage, Hayden, Lipchitz, Zárraga, Marevna, Soutine, and the Russian writers, Ehrenburg and Voloshin, the latter two especially intimate friends of Rivera (Figs. 26 and 27).

The war itself inevitably exerted both symbolic and practical forces on the artists who remained in Paris. Being a time of great strain, hardship and social dislocation, artistic and ideological alliances became more critical, more amplified. Art and aesthetics were more apt to be used to satisfy psychological needs and there are numerous and varied examples of artistic responses to the war by the Parisian avant-garde. At the beginning of this insular period in 1915, Rivera created some of the most beautiful decorative works of his Cubist production. These works combined rich color, delicate thin facture, Picassian Pointillist stippling, and trompe l'oeil realism with proto-Surrealist inversions of sky and land, and interior and exterior space. Rivera, alongside of Picasso and Gris, experimented with the innovative motifs of still lifes in landscapes and landscapes in still lifes. For Rivera, this visually and psychologically complex motif has its beginnings in the *Still Life, Mallorca* that was painted in Paris in the early spring of 1915 from Rivera's Mallorcan studies of the previous summer. The motif evolved through the *Still Life with Grey Bowl* (Cat. 39), *Still Life with Bread Knife* (Cat. 38), and *Still Life with Bottle of Liqueur* to the climactic *Zapatista Landscape.*

Rivera's duplication of his earlier Spanish composition the *Still Life with Demijohn* in the *Book and Cauliflower,* besides sending the obvious linguistic and geographical message, is an example of Rivera's common practice of painting variations on the identically same formal composition with minor changes in subject details, that was to be a characteristic of his later Cubist work. This practice, in effect, literally makes his works laboratory experiments.

Rivera soon progressed to a more sober, austere, and volumetric expression of his decorative Cubist style in a series of paintings loaded with references to distant ties with his native Mexico. These references were quite out of the Parisian Cubist norm in their coloration and their charged iconography. Rivera's recent contact with Mexican exiles from the Revolution in Madrid and Paris, and conversations over the deteriorating situation in Mexico, in particular with his charismatic and dynamic friend, Martín Luis Guzmán, had much to do with Rivera's resurgent interest in his native land and in Mexican Revolutionary iconography. Mexican motifs can be seen in

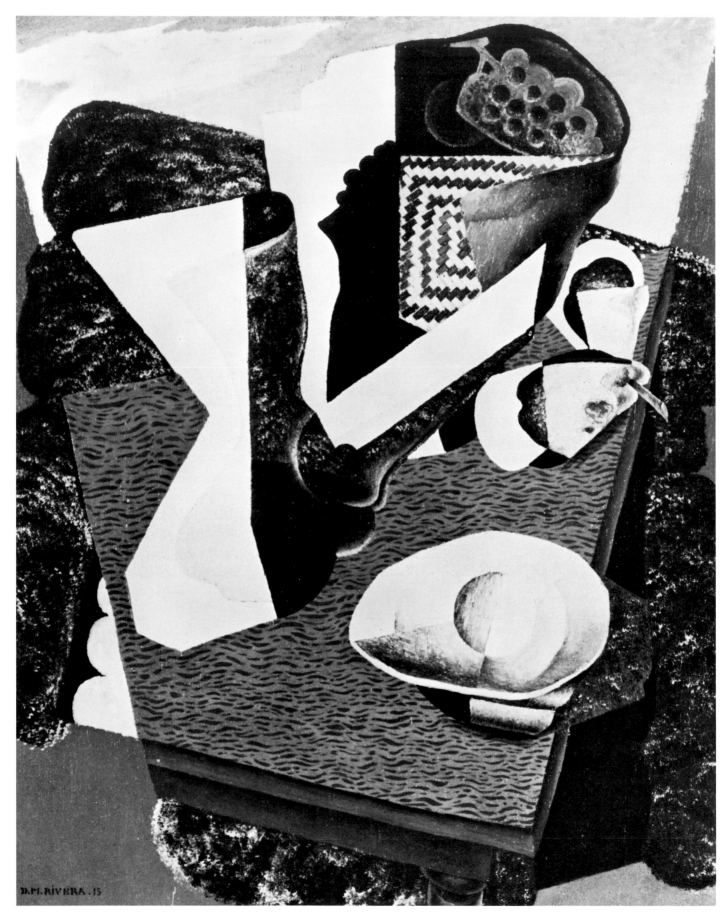

Still Life with Gray Bowl, (Naturaleza muerta con tazón gris) 1915

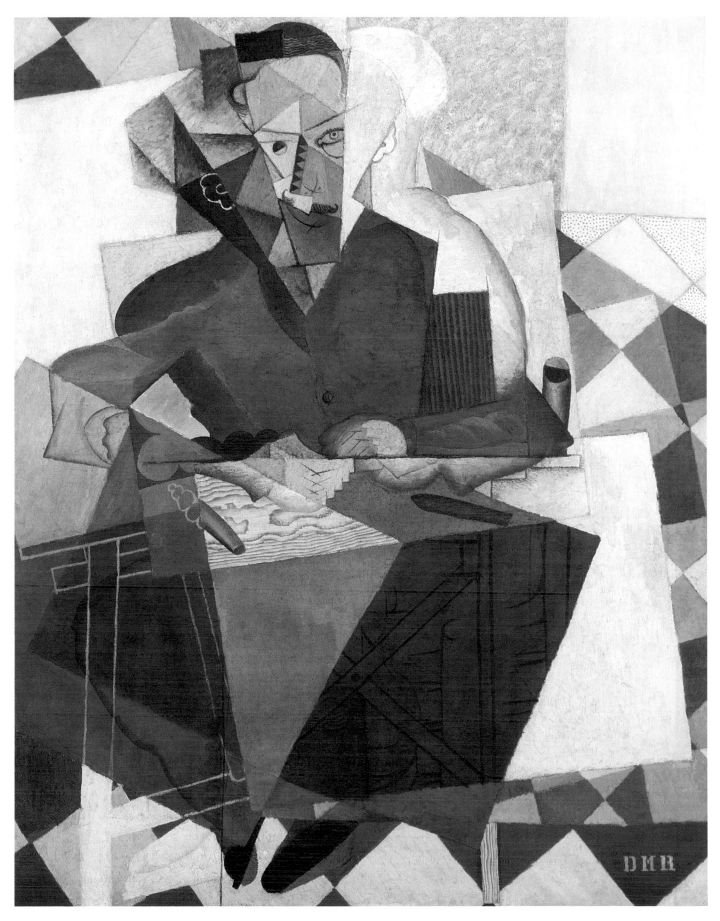

El Arquitecto, (The Architect) 1915

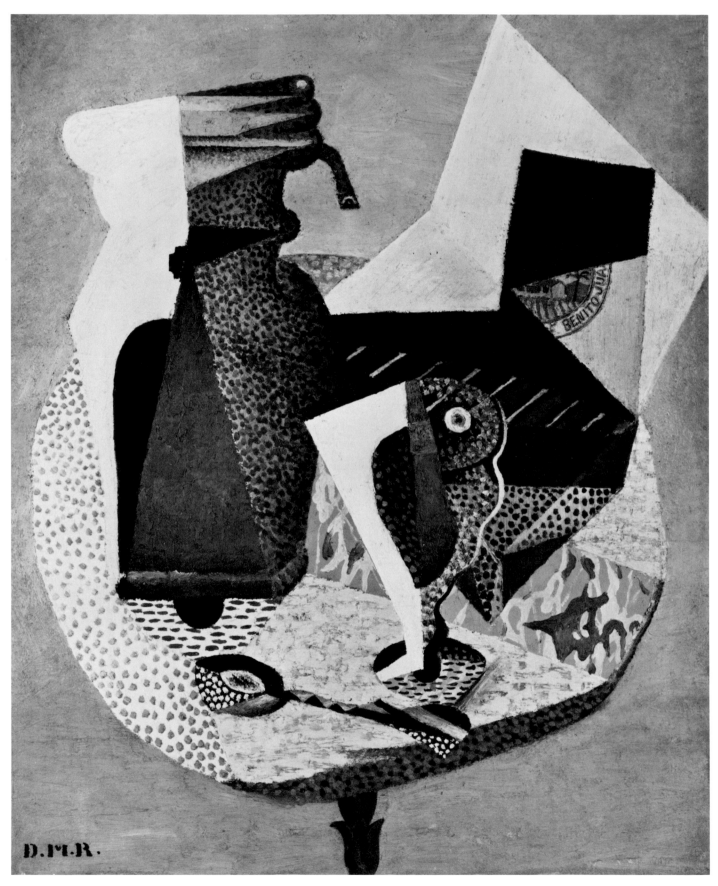

La Terrasse du café, (The Café Terrace) 1915

Catalogue No. 36

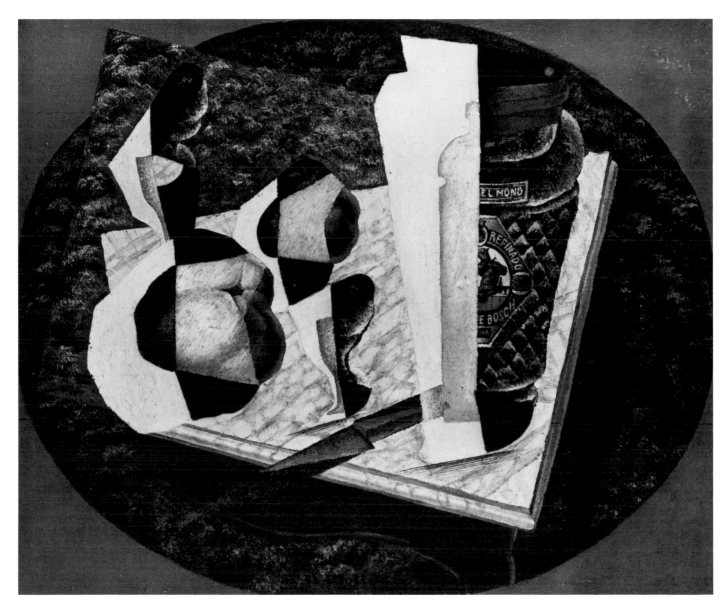

Still Life with Bread Knife, (Naturaleza muerta con cuchillo) 1915

Catalogue No. 38

Figure No. 27
Marevna, *Diego Rivera, Modi, and Ehrenburg,*
1916
Drawing
Photograph courtesy of Mme Marika Rivera,
London

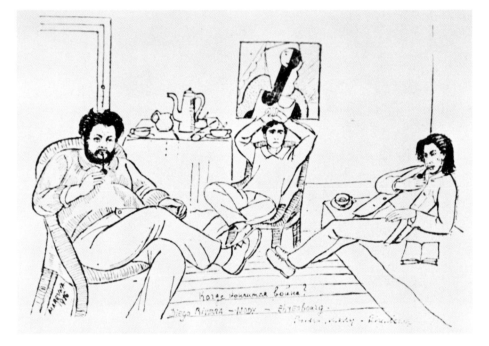

Figure No. 29
Rivera in his Parisian studio, c. spring 1915.
The Mexican *equipal* in which he posed Martín
Luis Guzmán can be seen in the background.
Photograph courtesy of INBA

three important paintings from 1915. In the *Terrasse du Café* (Cat. 36), Rivera included a Mexican cigar box with a tiny label displaying the partial letters "BENITO JUA..." and a miniature Mexican farm landscape circumscribed within, both obvious references to the origin of the box and the national Mexican hero Juárez. The *Portrait of Martín Luis Guzmán* (Fig. 28) was painted in the artist's Parisian studio in sessions where the conversation flowed between abstruse Cubist theories and Mexican political activity. Rivera posed the future chronicler of Pancho Villa in a "Zacatecan sarape" and sat him on his own large Mexican *equipal* (Fig. 29).These two most prominent features of the portrait are combined with stylized renditions of the top of Guzman's head in the shape of a matador's "montera" (headpiece) alluding to the Mexican's Hispanophilia. And there was his most successful Cubist work, the celebrated *Zapatista Landscape* (Cat. 40), replete with iconographical references to the current Mexican situation in the felt Zapatista hat, the rifle, sarape, *cananas* (cartridge belts), and Mexican *guajes* (gourd canteens) metamorphosing out of Parisian pears, before the tropical and highland topography of his native land. This still life in a landscape majestically expressed Rivera's plastic recollection of Mexico and its iconic landscape of volcanic cones immortalized by José María Velasco. The same distant land of the Mexican central plateau ("meseta central") had only recently been characterized in poetic synthesis by Rivera's friend, Alfonso Reyes, as existing in "the most transparent region of the air" ("La región más transparente del aire") *(Vision de Anáhuac,* Madrid, 1915). It was a characterization that could not be more accurately descriptive of Rivera's own vision of his *tierra natal* in the *Zapatista Landscape.*

Figure No. 28
Diego Rivera, *Portrait of Martín Luis Guzmán,*
1915
Oil on canvas
Collection of the Martín Luis Guzmán Estate,
Mexico City

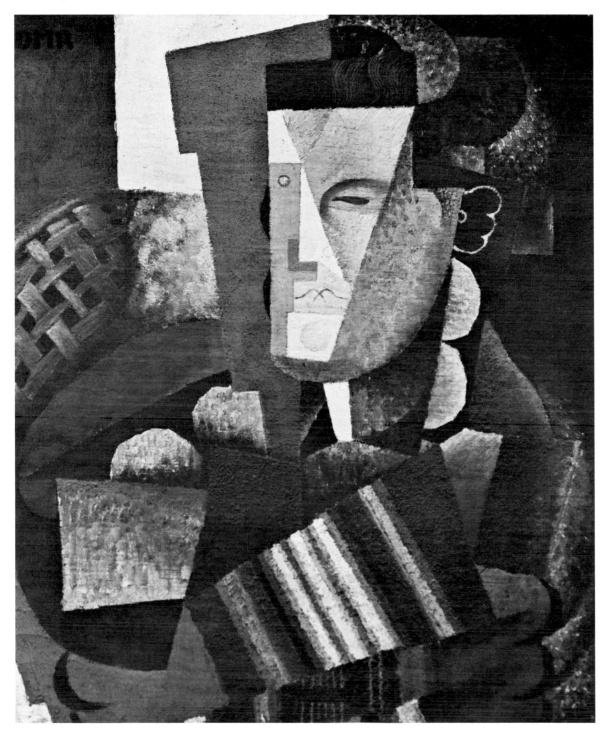

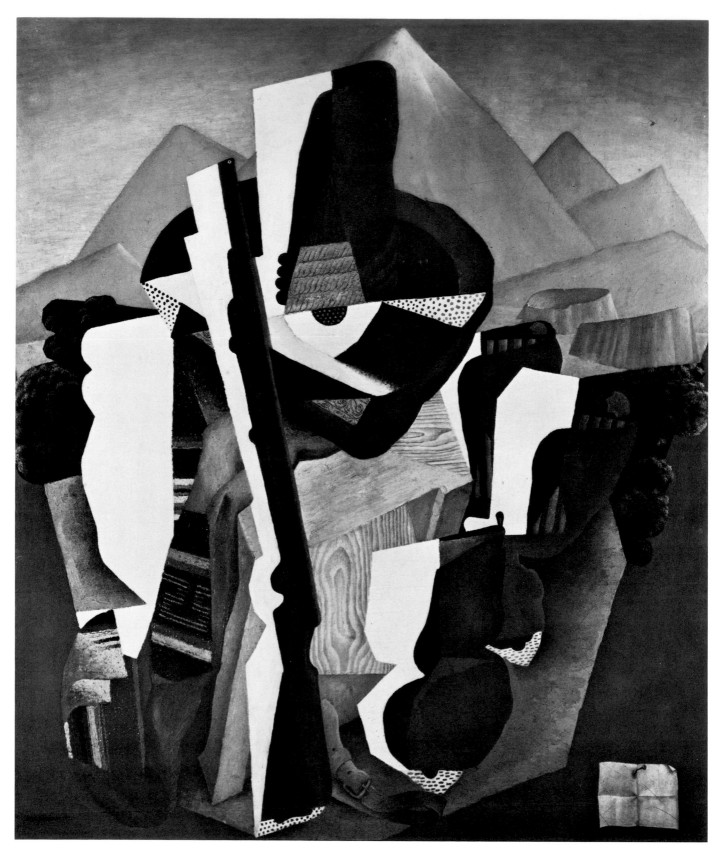

Paisaje Zapatista - El guerrillero, (Zapatista Landscape - The Guerrilla) 1915

Catalogue No. 40

Figure No. 30
Emiliano Zapata, Head of the Revolutionary
forces of the state of Morelos.
Photograph Casasola

Although it appears that the painting did not originally bear the
revolutionary title "The Guerrillero, Zapatista Landscape," its iconographical
meaning for Rivera and his Mexican exile friends was clear. When Martín Luis
Guzmán visited Rivera in the summer of 1915 and sat for his portrait in his
Parisian studio, the *Zapatista Landscape* had just been completed. In his 1915
article on Rivera, Guzmán noted that he had just seen Rivera's "latest painting
which is a material and spiritual landscape of the Mexican altiplane."[143] In a
discussion about the painting in a letter to Guzmán the following year, Rivera
called it "My Mexican trophy."[144] And in a satirical chronicle published in the
New York review "291" Max Jacob related a conversation that he had had with
Rivera also about having seen his "trophée mexicain" at Rosenberg's which he
had mistaken for a painting by Picasso.[145]

Although the graphic images of the Mexican Revolution had long been
readily available to Rivera in the European and Mexican press which circulated
in Europe (Fig. 30), the deadliest and most pivotal battles of the struggle
occurred in the summer of 1915 when this painting was executed. Rivera's
response to the cataclysmic upheaval in his distant Mexico with a classically
traditional art form, a "trophy," is indicative of his temperament and high

107

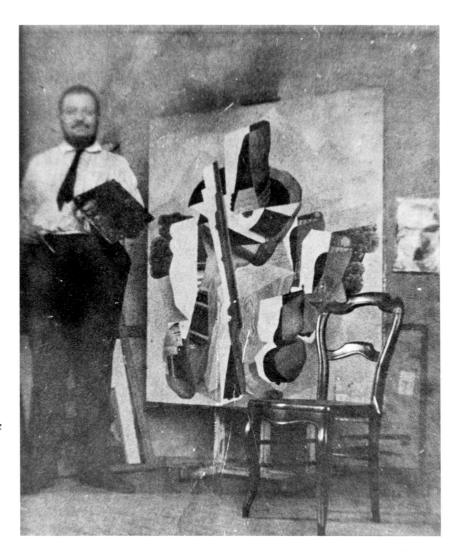

Figure No. 31
Rivera in his Parisian studio with the *Paisaje zapatista*, 1915
Photograph courtesy of INBA

artistic sophistication. Nevertheless the meaning of the painting in its Parisian context was obvious. It was about the accoutrements of a civil war and revolution existing in the sky-blue realm of the artist's detached consciousness. Rivera was separated from that Revolution by broad expanses of time and space.

In the most complete published reference to the painting by Rivera, which was not extensive, he later stated to Gladys March:

> I recall that, at this time I was working in order to bring into focus the inmost truth about myself. The clearest revelation came from a Cubist canvas, *The Zapatistas* (sic) which I painted in 1916 (sic.) ``It showed a Mexican peasant hat hanging over a wooden box behind a rifle. Executed without any preliminary sketch in my Paris workshop (Fig. 31), it is probably the most faithful expression of the Mexican mood that I have ever achieved.[146]

In spite of the ``exotic'' and unconventional subject matter of the *Zapatista Landscape,* the painting was important enough artistically to be the first work purchased from Rivera by his wartime Parisian dealer, Léonce Rosenberg. It remained in Rosenberg's stock until the 1930s. The majestic and mysterious work is a complex synthetic, metaphysical Cubist painting. Its deformation and abstract synthesis of objects in a tangible positive and negative space with oblique *trompe l'oeil* references to reality is understandable within conventional wartime Cubist theories. However, some

of its crisply rendered forms defy interpretation in their Surrealistic metamorphosis from recognizable shapes and objects (the sarape, hat, pears, possible saddle-bags and cartridge belts) into amorphous colors and disturbingly familiar yet undefinable textures. In its content and recognizable allusions to the Valley of Mexico, his country's tropical seacoast existing in a distant ocean-sky of pristinely deep blue, the *Zapatista Landscape* is without question the "most faithful expression of the Mexican mood" that Rivera achieved in his Cubism. In its absolute mastery of Cubist formal techniques it remains his greatest and clearest expression of his personal adaptation of that style.

Max Jacob's initial response to the *Zapatista Landscape* which he mistook for a painting by Picasso is revealing and not entirely without basis. The problems of precedence in artistic innovation which strained the relations between Rivera and Picasso during this period originated in the problematic relationship between the *Zapatista Landscape* and a contemporary work by Picasso, his *Man Leaning on a Table* of 1915-16. When Guzmán visited Rivera in August of 1915 and Rivera took him to the Spaniard's studio, Guzmán described the "*Seated Man*...(as) still unfinished...which I recently saw in the studio of this painter Picasso. With his hand on his cheek it etches itself into one's memory."[147] Guzmán also noted that by then Rivera had completed the *Zapatista Landscape*. If one compares the photograph of Picasso's *Man Leaning on a Table* (Fig. 32) in its initial stages to Rivera's completed painting, it can be seen that both works were originally extremely similar in composition with the central pyramidal grouping of Synthetic Cubist planes penetrating a large expanse of open space and a similarly inclined hat at the

 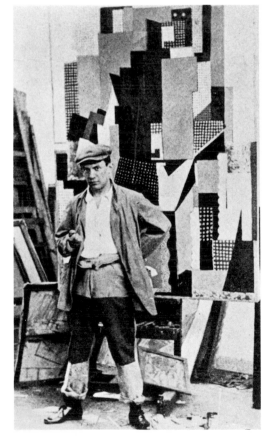

Figure No. 32
Picasso in his studio at 5 *bis*, rue Schoelcher, before his unfinished *Man Leaning on a Table* in 1915.
Photograph published in *Cahiers d'art*, II, 1950, p. 284

Figure No. 33
Picasso in his studio at 5 *bis*, rue Schoelcher, before his radically transformed *Man Leaning on a Table*, sometime in 1916.
Photograph published in *Cahiers d'art*, II, 1950, p. 283

top of Picasso's painting. There are also identical areas of stippled foliage surrounding the angular planes of Picasso's figure and the illusionistically painted wooden table legs.

Picasso's subsequent radical change of direction from his original composition to almost complete abstraction as can be seen in the photograph of the completed work on his easel (Fig. 33), may have had at its roots, a desire to remove any traces of similarity between his work and that of Rivera. It was possibly as a result of these two specific works that accusations by both of them that one was "stealing" the ideas of the other might have reached a peak and resulted in the quarrel that caused them to break their friendship in 1916.

The Russian émigré painter, Marevna, who by now had become Rivera's mistress, recalled that

> Picasso...used to come by to Rivera's studio and wander about freely, turning over canvases at will to look at them. Rivera complained to me more than once. 'I'm sick of Pablo. If he pinches something from me, people will rave about Picasso, Picasso. As for me, they'll say I copy him. One of these days either I'll chuck him out or I'll shove off to Mexico.'
>
> Soon afterwards, they nearly came to blows. 'He left when I picked up my Mexican stick and threatened to break his skull,' Rivera told me. I never learned the full details of this incident, but I know that for some time there was a coolness between the two painters.[148]

The poet Jean Cocteau, who came to befriend Rivera and was the subject of one of his Ingresque portraits, also related an interesting anecdote about Rivera and Picasso that accords with Marevna's recollection:

> During the great period of Cubism, the Montparnasse painters barricaded themselves in their studios for fear that Picasso might carry away some seed and bring it to bloom in his own soil. In 1916 I was present at interminable confabulations outside half-open doors when he (Picasso) took me to see them. We used to have to wait until they locked up their latest pictures. They were just as mistrustful of one another.
>
> This state of siege nourished the silences of the Rotonde and the Dôme. I remember one week when everyone there was whispering, wondering who had stolen from Rivera his formula for painting trees by spotting green on black.[149]

That Rivera and Picasso were working closely along similar lines in 1915 can also readily be seen in a comparison of Picasso's *Still Life in a Landscape* (Fig. 34) with any of Rivera's 1915 still lifes in exterior settings. The most perceptive contemporary analysis of Rivera's Cubism and its relationship to Picasso's was provided by Martín Luis Guzmán. Guzmán had prepared himself for his trip to Cubist Paris in 1915 by reading Gleizes and Metzinger's *On Cubism,* and Apollinaire's *The Cubist Painters,* undoubtedly recommended to him by Rivera. After making his rounds of the Parisian studios which included those of Picasso, Gris, and Braque, Guzmán concluded in his article on "Diego Rivera and the Philosophy of Cubism" that

> Although an enthusiast and admirer of Picasso, Rivera follows his own road. Not in vain did he nourish and make flower the preoccupations produced in his soul by the work of El Greco. Between a painting by Rivera and one by Picasso there is as much distance as between a mountain and a forest: in one (Rivera's) matter splits and rends the air, in the other (Picasso's) the air flows softly through the matter. Flexible, vaporous, and whispering is Picasso; sudden, dominant, and firm is Rivera. Rivera was born in Anáhuac; what he first learned to see were its mountains.[150]

At the conclusion of his visit with Rivera and his new friends of the Parisian avant-garde among which counted Picasso, Gris, Braque, Max Jacob, and the

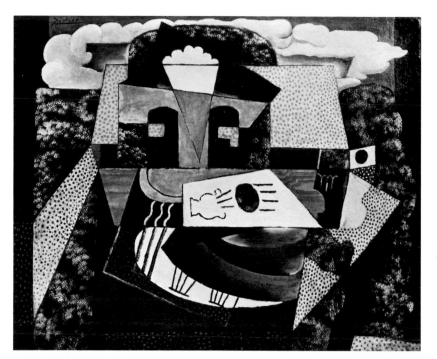

Figure No. 34
Pablo Picasso, *Still Life in a Landscape*, 1915
Oil on canvas
The Meadows Museum, Southern Methodist
University, Dallas

poet Pierre Reverdy at the time, Guzmán returned to Spain and soon emigrated to New York. Rivera anxiously wrote him to see if this article might be published about the time of his first New York one-man exhibition of Cubist works.[151] It was being organized by their fellow Mexican compatriot, Marius De Zayas. De Zayas had become by 1916 the leading figure among the New York modernist circle of Stieglitz's "291" gallery and magazine, and had ventured off to form his own gallery. He had been to Paris in the fall of 1915 where he selected a number of paintings by Rivera for his new gallery, the Modern Gallery at 500 Fifth Avenue. Rivera's works were included in several group exhibitions along with those of Cézanne, Braque, Picasso, Picabia, and Van Gogh throughout the year of 1916. On October 1, 1916, the "Exhibition of Paintings by Diego M. Rivera and Mexican Pre-Conquest Art," opened at De Zayas' Modern Gallery with only slight critical response.

The exhibition consisted of nine paintings by Rivera representing his development from the Pointillist landscapes of 1911 through several phases of Cubism up to where he had arrived in his most metaphysical synthetic Cubist canvases of 1915 and 1916. The ten examples of Mexican pre-Conquest art, mainly Aztec, about which little was also written, derived from the collections of De Zayas and his partner Paul Haviland. Among the paintings that can be identified as having been exhibited are the *Still Life with Demijohn ("Ultima Hora"), The Sugar Bowl (Still Life with Candles),* the *Terrasse du Café, Tree and Walls, Toledo,* the *Book and Cauliflower,* and the so-called *Portrait of Mme. Marcoussis,* which was then correctly identified as a *Portrait of Marevna* (although mispelled "Mariewny" in the press reviews).

It was the "first comprehensive exhibition of Diego M. Rivera, a native of Mexico, long resident in Paris,"[152] to be held in this country. Such a large number of Cubist works by Rivera (eight) have not been exhibited as a group in the United States until the present exhibition. Practically every critic who reviewed the show remarked to some effect about Rivera's cumulative "modern work" appearing "as if he would like to show that he understands

Bodegón con taza, (Still Life with Cup) 1915

Catalogue No. 41

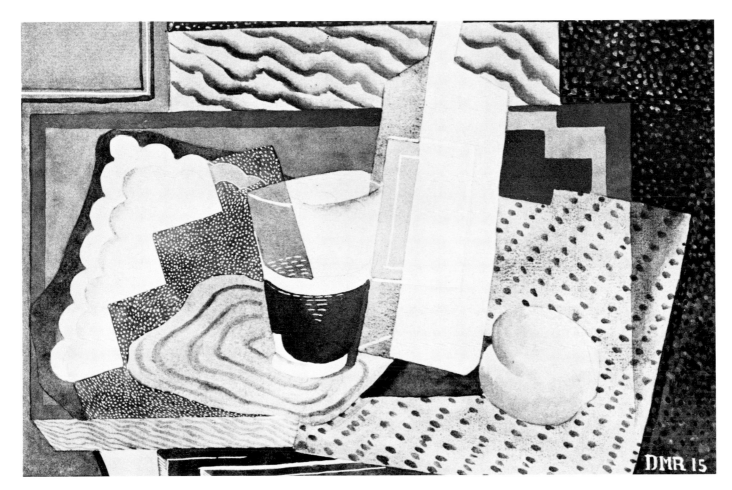

Naturaleza muerta – Bodegón con vaso y botella, (Still Life with Bottle and Vase) 1915

Catalogue No. 42

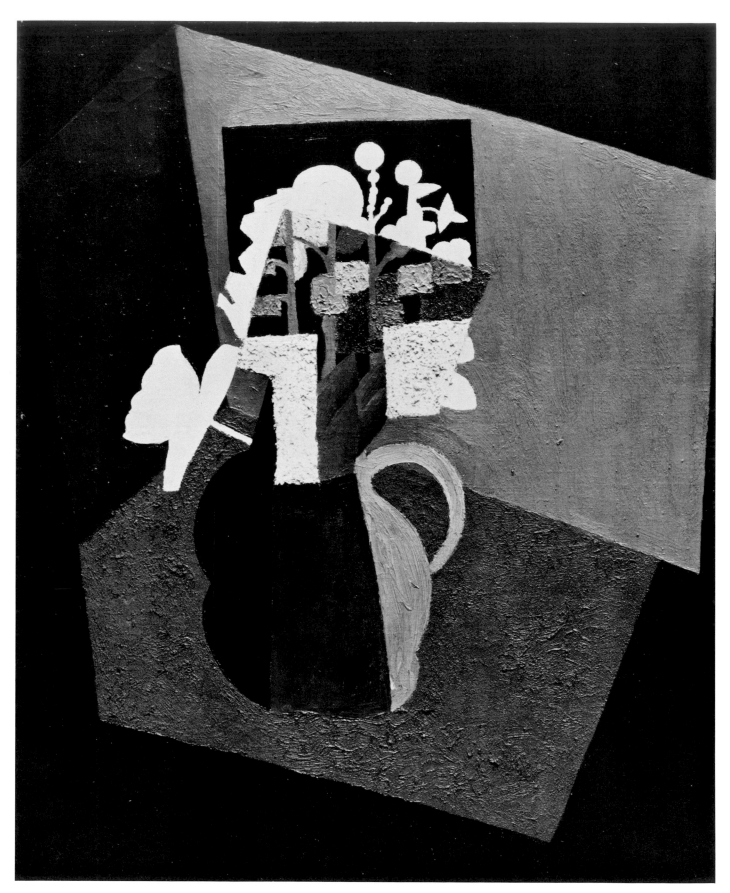

Still Life with Vase of Flowers, (Naturaleza muerta con flores) 1916

Catalogue No. 49

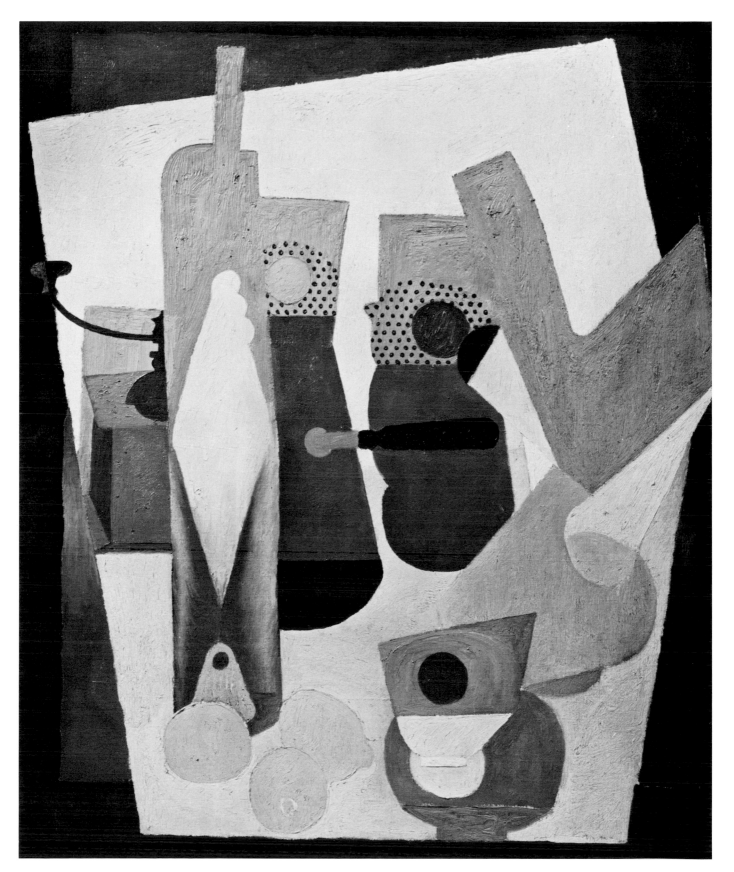

Still Life with Lemons, (Naturaleza muerta con limones) 1916

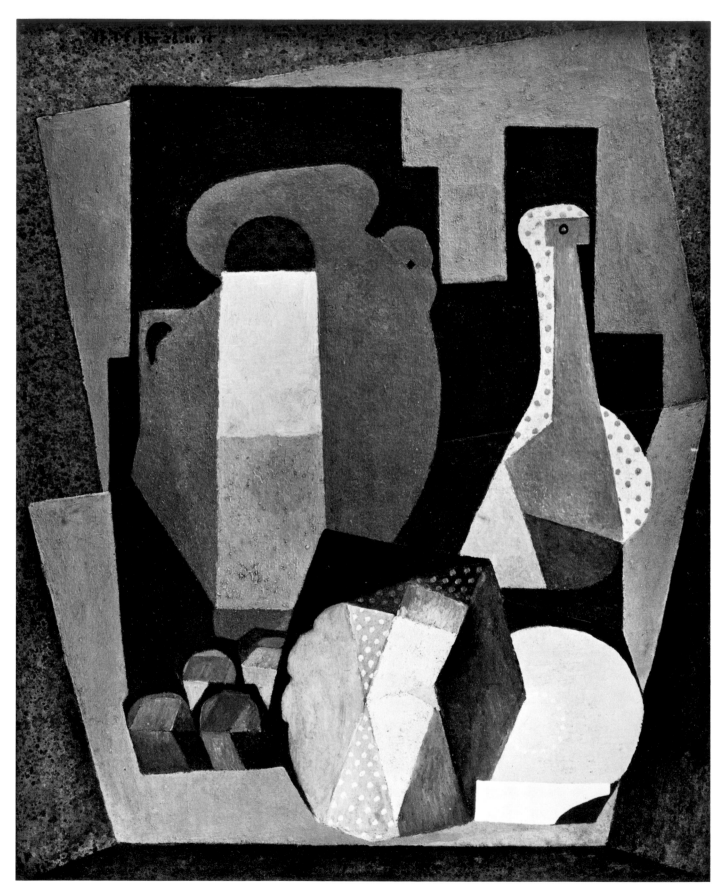

Naturaleza muerta con utensilios, (Still Life with Utensils) 1916

Catalogue No. 51

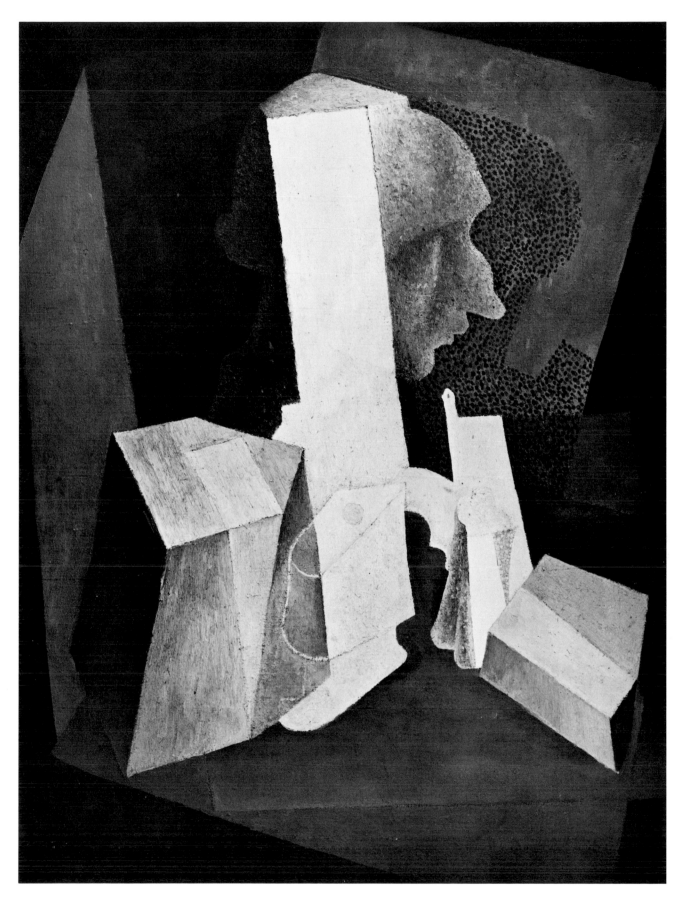

Composición con busto, (Composition with Bust) 1916

Catalogue No. 53

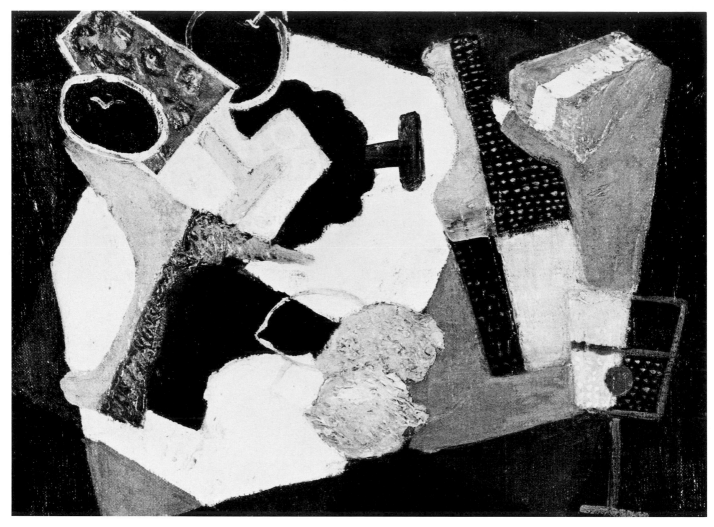

Naturaleza muerta, (Still Life) 1916

Catalogue No. 52

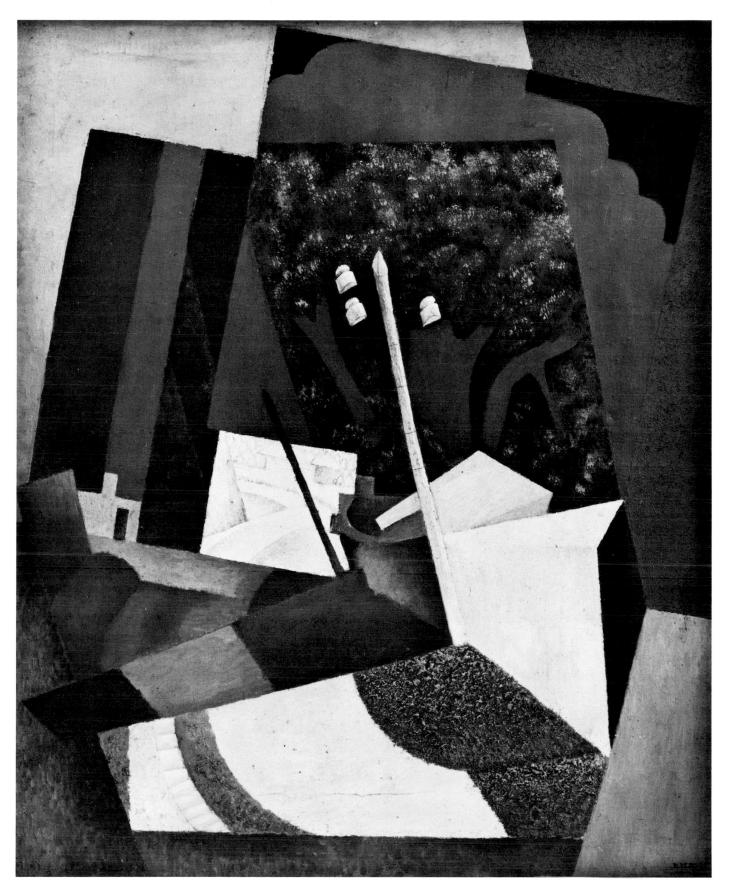

El poste de telégrafo, (The Telegraph Pole) 1916

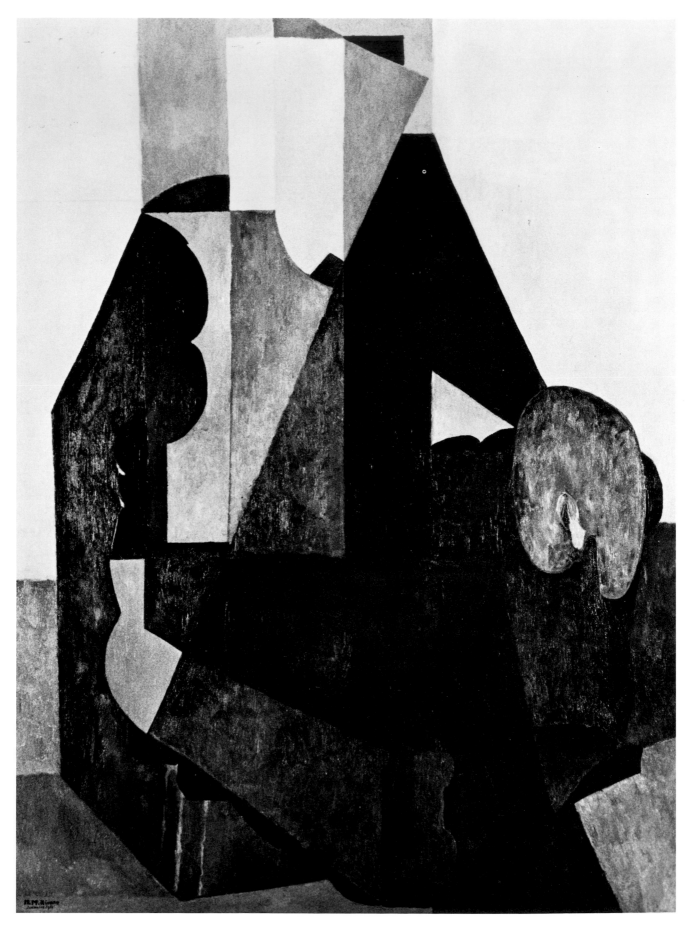

El pintor en reposo, (The Painter in Repose) 1916

Catalogue No. 56

each kind and is not certain which he prefers. Nonetheless, his present individuality is detected."[153] About his canvas called "The Sugar Bowl" confirming Rivera's strong academic background, the art critic of the *New York World* observed that

> It shows that when he had caught the spirit of the Cubist school, his creative powers evolved a product distinctively his own, in which his facile brush did its best work. One who can deal impressively in canvas abstractions needs to have behind him a reserve of technique and a creative impulse, and nature and training have well supplied Mr. Rivera with both.[154]

Parisian Wartime Cubism and "L'Affaire Rivera"

The year after Rivera returned from Madrid to a deserted and war-threatened Paris, he emerged as a major figure among the theoretical branch of the Parisian wartime Cubists. By 1916, this group included, besides Rivera, the painters Gino Severini, André Lhote, Juan Gris, Jean Metzinger and the sculptor Jacques Lipchitz. They were proponents of what the critic, Maurice Raynal called "Crystal" and "Classical Cubism" referring to the severe, crystalline austerity of their synthetic Cubist works and their highly intellectualized doctrines of scientific pictorial research. Rivera's Cubism during this period is imbued with a certain "Mexican-ness" that is metaphysical and arcane. In his most austere, crystalline, Cubist works there are dark, foreboding elements. In their drab, enamel-like surfaces they appear epoxied, sealed in time and evoke a dusky classicism that is ponderous and heavy like the physical persona and intellectual complexity of their creator.

Rivera's abstruse theorizing during this period related to the problem of the Fourth Dimension and the higher metaphysical realms of plastic consciousness and space. In a letter Rivera wrote in 1916 to Marius de Zayas in New York, he stated his metaphysical aims and explained his concept of the Fourth Dimension which he called the "super-physical dimension."

> Form exists in a plastic ensemble, as a relative entity changing into as many different expressions as the causes which limit the space that surrounds it are modified. Example: the reformations of Cézanne, which people usually call 'deformations.' Form exists per se in everything, everlastingly, immutably, independently from the perceptive accident, and in relation with the Primary Form. Form exists as a quantity that participates in both the preceding dualities, that is to say, as belonging to one independent case of the physical space; in a portrait, for instance, the *head* exists as a generality common to all men; as a head it will have qualities of accidental form, its position in space, total roundness of the cranium, but in a portrait after making a head one must particularize and make of that head *one head,* and this individualization that will come over it will not depend upon the plastic accident but will be a determined ensemble of traits that would make a unique and personal facial cipher.

In the picture the accidental form carries with itself a mechanical taxation, its measure in relation to the other forms that accompany it, and the space that surrounds it; pure form does not carry in itself any relative dimension, therefore, for the picture; it will only be a starting point, a spiritual vista over the Universe, and this is the reason why it will live in the plastic ensemble, in the space created between the relative form and the super-physical dimension.

In plastic space, things have a super-physical dimension, which grows or diminishes in direct ratio to the importance that its existence has in the spirit of the painter: For example, the change of the real size of the objects among the primitives: the Holy Virgin is far larger than the gift carriers; Saint Francis is as tall as the church he supports, and the fortress besieged and conquered by the condottieri could pass easily between the legs of his horse.

Color, like form, exists in the plastic ensemble as an individual accident: like the *local color* of the painting of all times; it exists per se: pure color, color-impelling-force; and exists also as a result produced by the reactions which are the consequence of the action of the color and local form, the pure color and form and substance, like in the work of Grunewald, Seurat, and the Impressionists, that is to say, color-derived-force.

'Matter,' the substance, also lives as an *accident;* quality of painting; per se: as a substantial structure independent of the visual accident and its plastic consequences, and as derived force, giving the sensation of weight of lightness modifying the representative quantities on the visual space, increased or diminished, multiplied or divided for the expression of their greater or less stability, as in the paintings of Giotto, Cézanne, Greco, Zurbaran, Velázquez, and in Oriental art — and above all in the negro and Mexican sculpture.

The plastic ensemble thus understood, the painter starts from two opposed and indisputable principles: the existence of things in the real, visual, and physical space; and their existence in the real, super-physical, and spiritual space.

The controlled and logical action of their primary elements would make possible the coexistence in the same plastic ensemble of the most complex and the simplest expressions. The painter is able to create the causes which produce them, and to find the true space in which they can exist without losing their purity nor destroying that plastic ensemble, which understood in this manner, makes it possible for the expression of the most visible and tangible thing and the most inner feeling to be within the UNITY.

Diego M. Rivera[155]

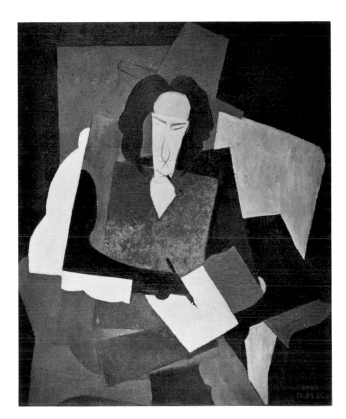

Figure No. 35
Diego Rivera, *Portrait of Ilya Ehrenburg*, 1915
Oil on canvas
The Meadows Museum, Southern Methodist
University, Dallas

Rivera applied his concept of a "personal facial cipher" in his most
successful Cubist works from this later period — his austere synthetic
portraits of his friends and loved ones. Beginning with his portraits of his two
close Russian writer friends, Ehrenburg (1915, Fig. 35) and Voloshin (1916,
Cat. 46); the elegant portraits of his wife, the *Woman in Green* (Cat. 54), the
Maternity, the *Portrait of Angeline Beloff* (Cat. 48); and those of his mistress,
the *Portrait of Marevna* and *Woman Seated in an Armchair* (Cat. 64), Rivera
superimposed the small group of indispensible features required to produce
the likeness of a figure on his reductive volumes and planes. Many of his
portrait subjects were drawn from the intimate circle of Russian émigré artist
friends who met regularly at the weekly salon of the Russian poetess Marie
Zetlin and her writer husband, Mikhail Zetlin (pseudonym "Amari"), one of the
owners of the Russian Vysotskky Tea Company. Rivera's small gouache portrait
of *Mme Zetlin* in her guestbook (Cat. 58), which included works of the artists
present at those gatherings, was a study for the larger *Portrait of a Woman*.
Also relating to the Zetlin's salon is the little metaphysical woodcut that Rivera
made for his Theosophist friend Voloshin. The occult and criptic signs of the
woodcut revolve around the mystic concepts that were the topic of discus-
sions at the Zetlin's apartment, discussions usually led by Voloshin or Rivera.[156]

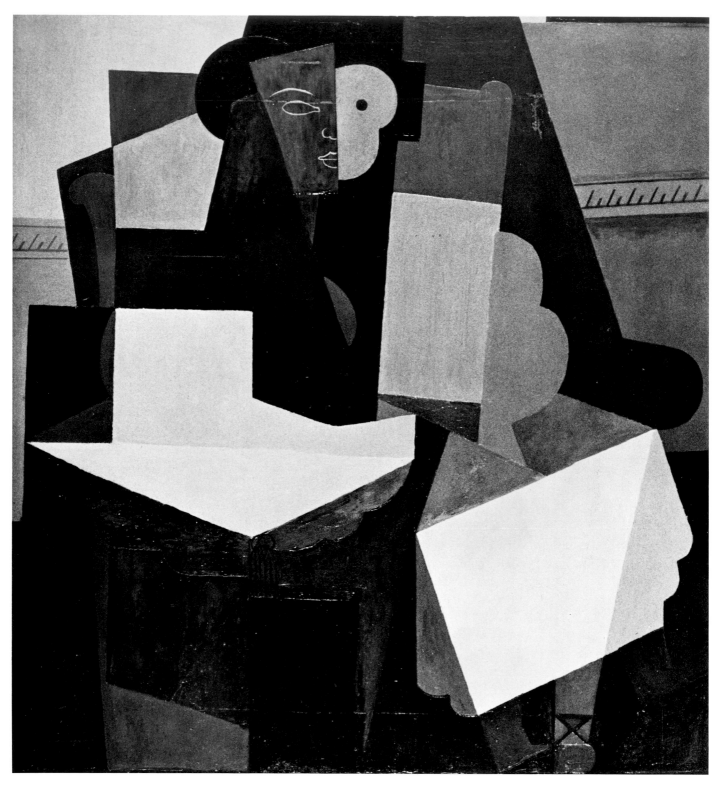

Retrato de Mme. Lhote, (Portrait of Mme. Lhote) 1917

Catalogue No. 66

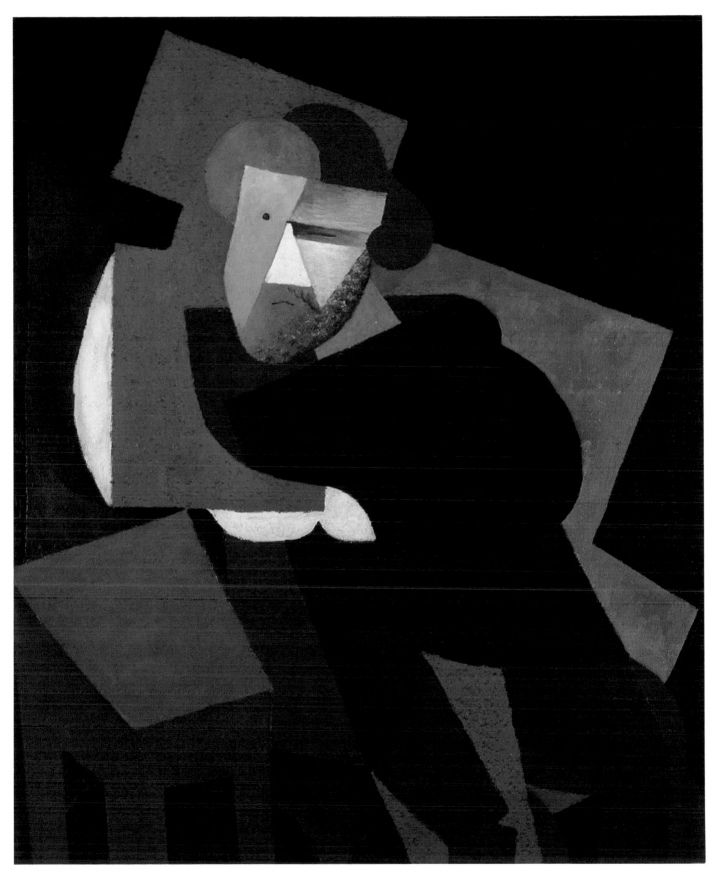

Retrato de Maximiliano Volochin, (Portrait of Maximilian Voloshin) 1916

Catalogue No. 46

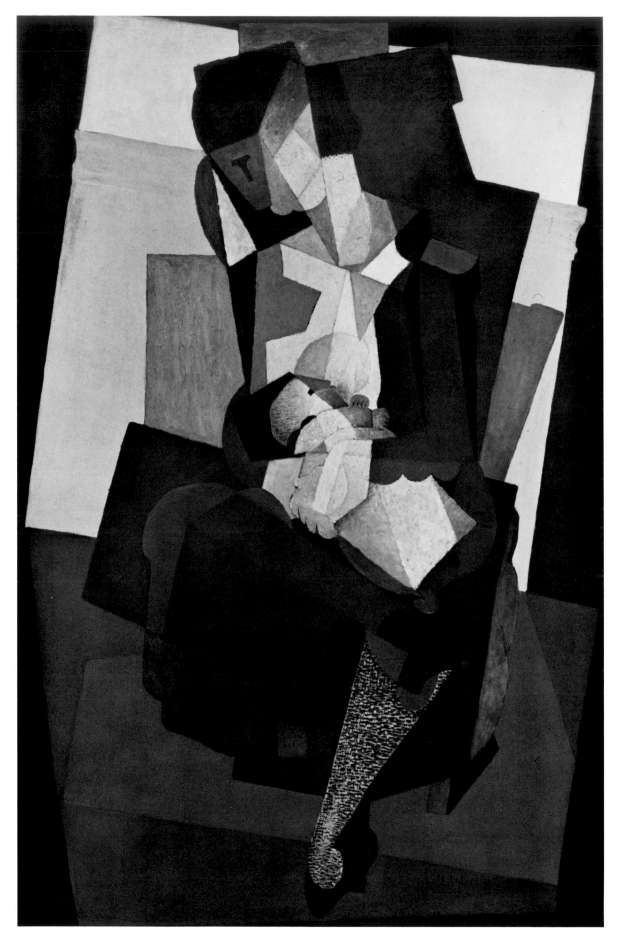

Angelina y El Niño Diego, Maternidad, (Angeline and Baby Diego, Maternity) 1916

Catalogue No. 55

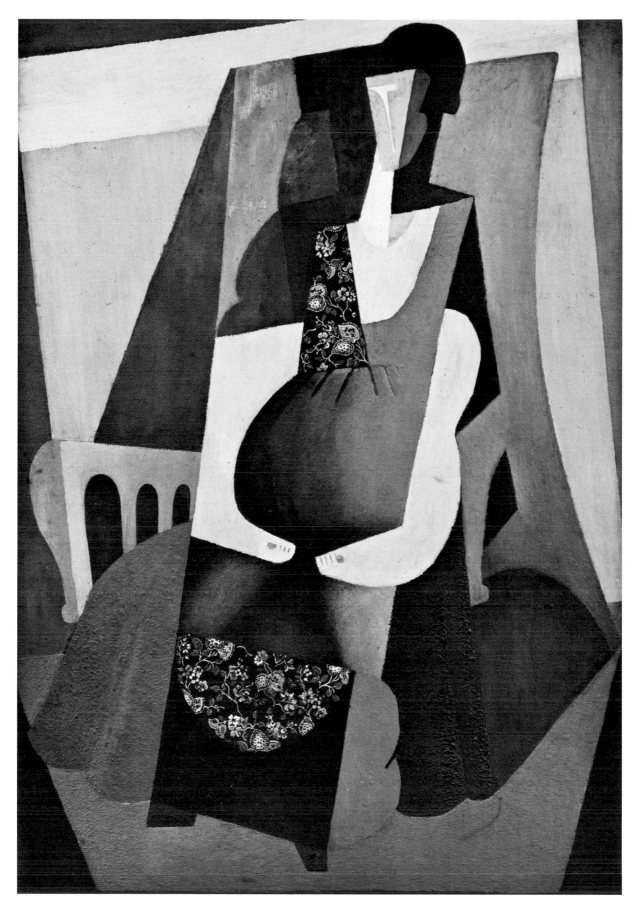

Mujer en verde, (Woman in Green) 1916

Catalogue No. 54

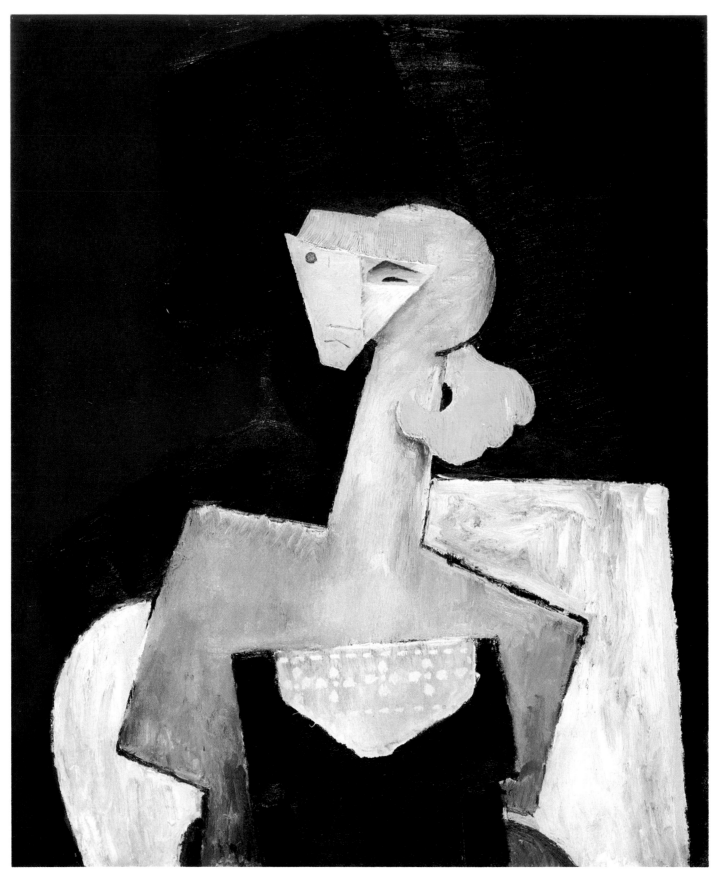

Retrato de Angelina Beloff, (Portrait of Angeline Beloff) 1916

Catalogue No. 48

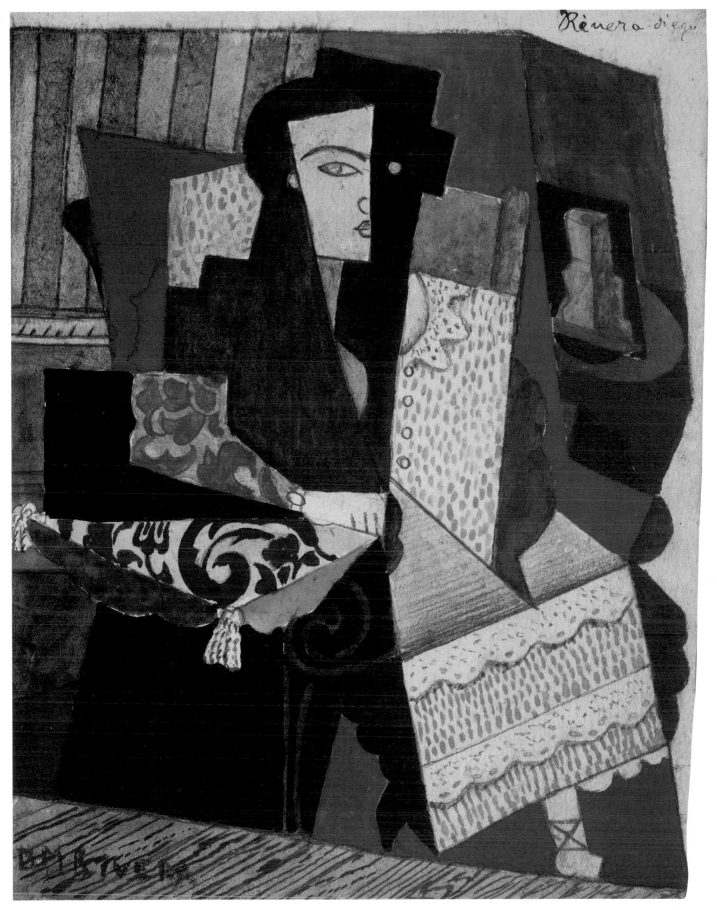

Portrait of a Woman (Mme. Zetlin), (Retrato de una mujer, Mme. Zetlin) 1916

Catalogue No. 58

Most of Rivera's Cubist works from 1916 and 1917 are dated by the artist in some cases to the month and day. They provide an unusual opportunity to see Rivera's experiments as he progressed and retreated from reality and the subject into higher spatial realms. In a highly individual theoretical fashion, Rivera strove to detach multiple colors and volumes from their objects and simultaneously combine their hypothetically abstract profiles and frontal surfaces into a super-physical plastic dimension. His stated aim was to evoke in the spectator a spiritual "totalizing image" or "Unity" of form, color, and matter as he (the artist) had arranged in the plastic ensemble of the painting.

One of Rivera's most abstract experiments from which he apparently soon retreated was his *Painter in Repose* (Cat. 56). Painted directly from the model, it was a portrait of his friend, the painter, Frank Burty Haviland. In a humorous but revealing anecdote, Rivera recalled that in spite of its abstraction and objections from his colleagues about its excessive depuration and austerity, the painter's little daughter upon seeing it immediately recognized it as a portrait of her father.[157] According to André Lhote, who worked alongside Rivera during this period on similar but less interesting portraiture, Rivera was striving for Platonic essences. He was using a pseudo-scientific method of stereometric modeling of colors and form which included "depicting objects by their absence,"[158] that is, by their silhouettes and shadows. Throughout his last years in Cubism, Rivera applied this conceptual unifying, metaphysical technique to his portraits and still lifes. In a still life such as *The Oranges* (Cat. 63), Rivera's conceptual separation of the color and texture of an object from its shape can be seen. The orange color is removed to the left side of the picture and recreated in a higher dimensional realm of the sense of pure color and pure geometrical forms with the source of its original locus, the bowl of oranges on the right, becoming only a silhouette. The colors of the other still life objects are also distilled and diffused to the side in order to express as though metaphorically the natural fusion of forms and their space. According to Lhote, this technique of the dissociation of form and color and "the predominance of the straight line over the tender curve was intended in our minds to incline the spectator toward a severe mediation."[159]

Rivera's attempts to represent the quantitative and qualitative appearances of architectonic bodies and their forms, reflections and shadows and refractions in space, was aided by scientific readings and by a mechanical device or "machine" he constructed in 1917. Through his earlier friendship with Gleizes and Metzinger, and now in wartime Paris with his close collaboration with the Classical Cubist painter, Gino Severini, Rivera had become an avid student of the popular scientific theories of the mathematician-physicist, Henri Poincaré, and his intuitive ideas about visual and tactile space. According to Rivera, he was in several ways already familiar with aspects of these ideas from his studies under Velasco and Rebull at the Mexican Academy of San Carlos.[160] Lhote, who frequented artists' studios and delighted in theoretical discussions, recalled Rivera's regular attendance at the Sunday gatherings at the home of Matisse during the war, where "the inquisitor, Juan Gris, whose purity was beyond doubt, spoke only of 'noumena' and the Italian, Severini, and the Mexican, Diego Rivera, swore only by Poincaré, Riemann and the Fourth Dimension."[161]

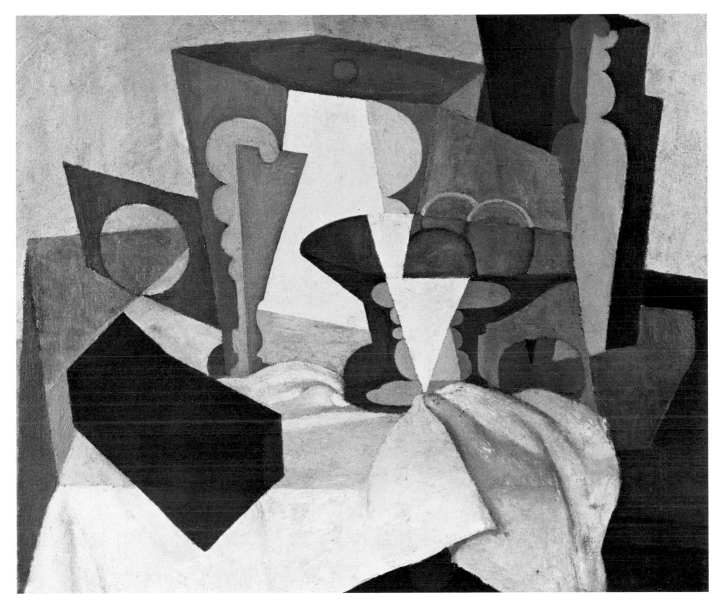

Les Oranges, (Oranges) 1917

An artist who worked closely alongside Rivera during the peak years of his Classical Cubist style was the former Futurist Gino Severini. Severini wrote a detailed article about their joint experiments which was published in the *Mercure de France* in 1917. Severini noted that to satisfy their curiosity about the possible scientific justification for their plastic experiments they looked into

> qualitative geometry (Analysis Situs) for the most evident demonstration of the fourth dimension. I knew beforehand, however, that geometry could do no more than strengthen convictions already arrived at in our group by common artistic intuition...

> Placing oneself at the point of view of the physical sciences, it is possible to create a new world in a space of four or of "n" dimensions.... As the painter Rivera, following Poincaré, justly observed, 'A being living in a world with varied refractions, instead of homogeneous ones, would be bound to conceive of a fourth dimension.'

> This milieu with distinctive refractions is realized in a picture if a multiplicity of pyramids replaces the single cone of Italian perspective. Such is the case with certain personal experiments made by Rivera, who sees in Poincaré's hypothesis a confirmation of some intuitions of Rembrandt, El Greco and Cézanne.[162]

Severini later elaborated:

> Rivera was extremely intelligent.... He had discovered, or reconstructed, a theory of perspective according to which the horizontal plane and the vertical plane underwent the same deformation, and the object was enriched by other dimensions beyond the three normal dimensions. He explained much of this theory to me, which to tell the truth was not very clear or convincing. But he ultimately perfected it and devised for it a fixed and mysterious instrument which he kept a secret and which he called "la chose" ("The Thing").[163]

André Salmon also recalled the "curious machine" Rivera had built to demonstrate his theories. Considering it to be the origin of "l'affaire Rivera," Salmon elaborated on its construction:

> Rivera claimed even to have found the secret of the Fourth Dimension.... He had built a curious machine, a sort of articulated plane, of gelatin, like the one paper engravers use to make their tracings. His French scientific vocabulary was modest. He called this apparatus "la chose."[164]

Figure No. 36
Albrecht, Dürer, *A Man Drawing a Recumbent Woman*, Woodcut from *Underweysung der messung*, Nürnberg, 1536

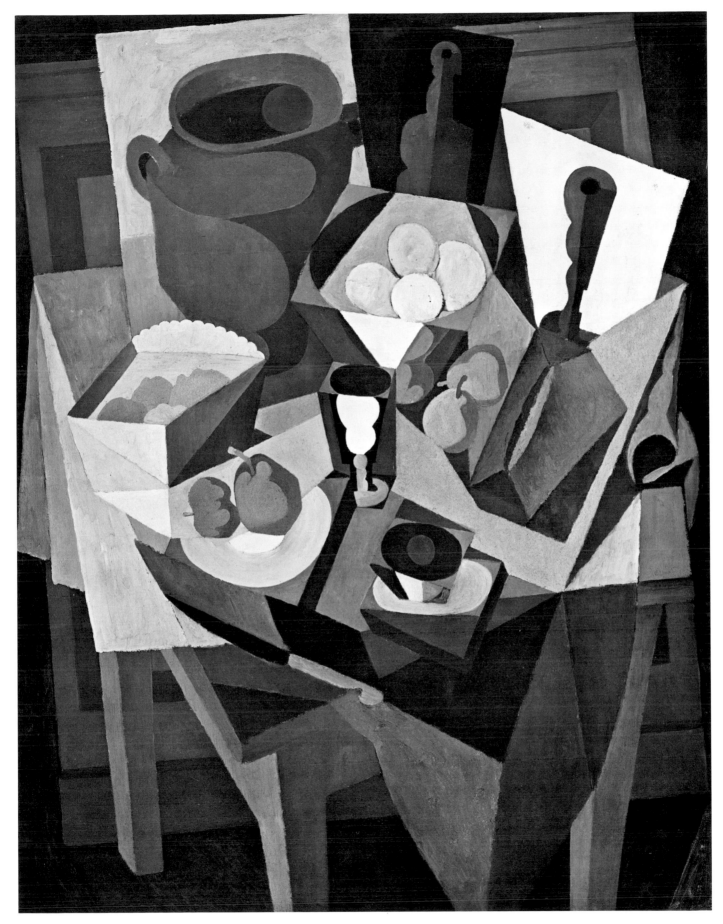

Still Life with Bread and Fruit, (Naturaleza muerta con pan y fruta) 1917

Catalogue No. 62

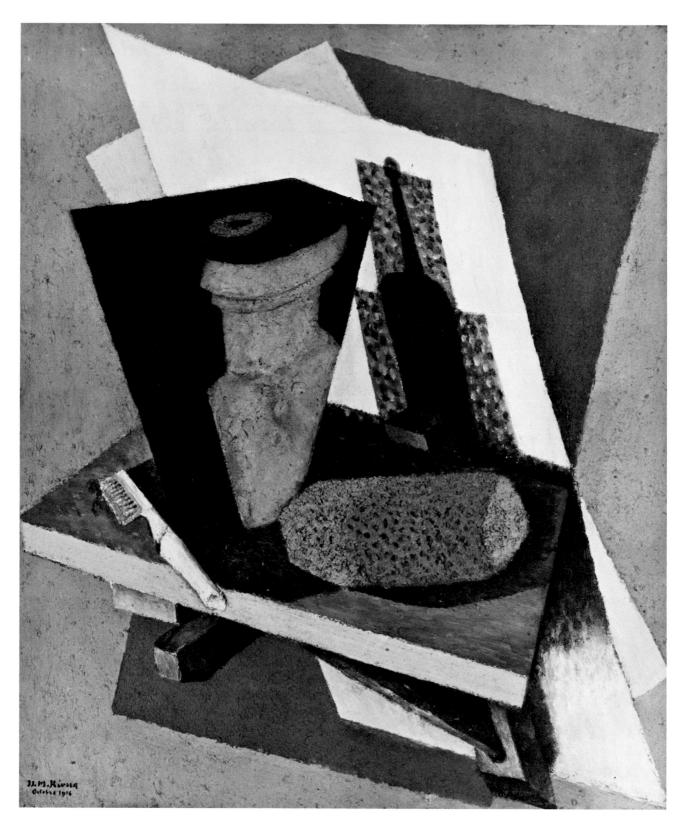

Still Life, (Naturaleza muerta) 1916

Catalogue No. 59

134

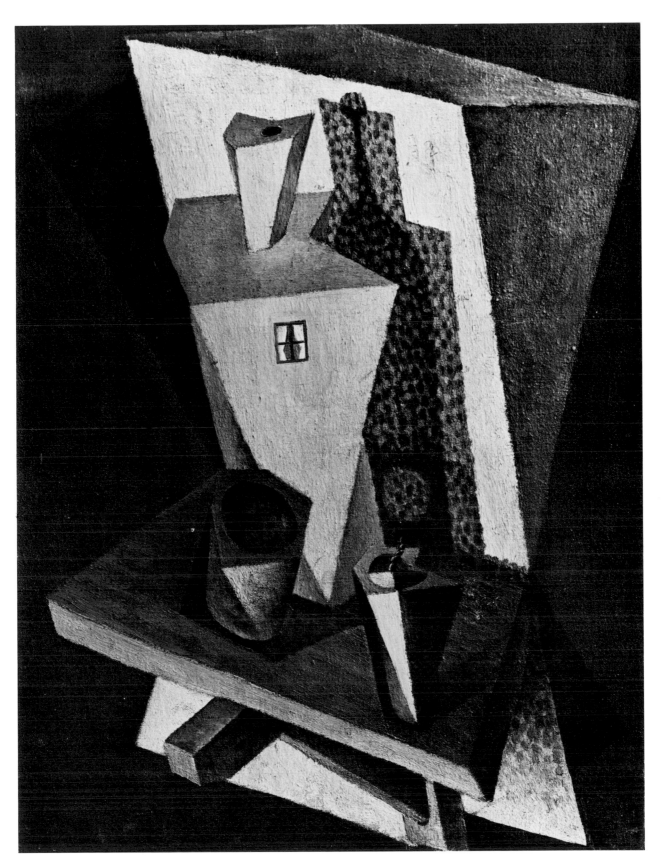

Composition: Still Life with Green House, (Composición: Naturaleza muerta con casa verde) 1917 Catalogue No. 60

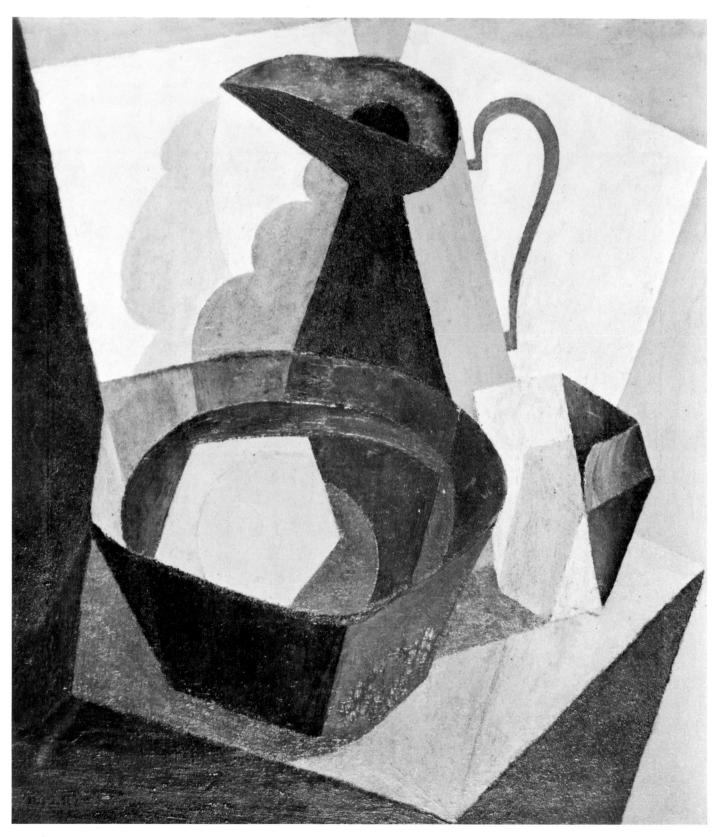

La Legía, (Implements for the Wash) 1917

Catalogue No. 61

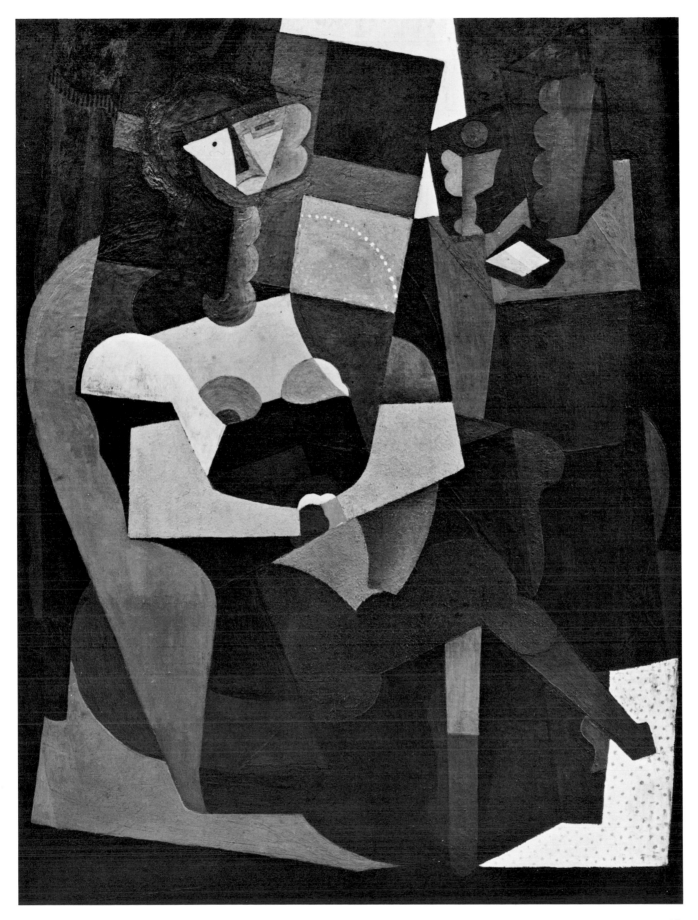

Mujer sentada en una butaca, (Woman in an Armchair) 1917

Catalogue No. 64

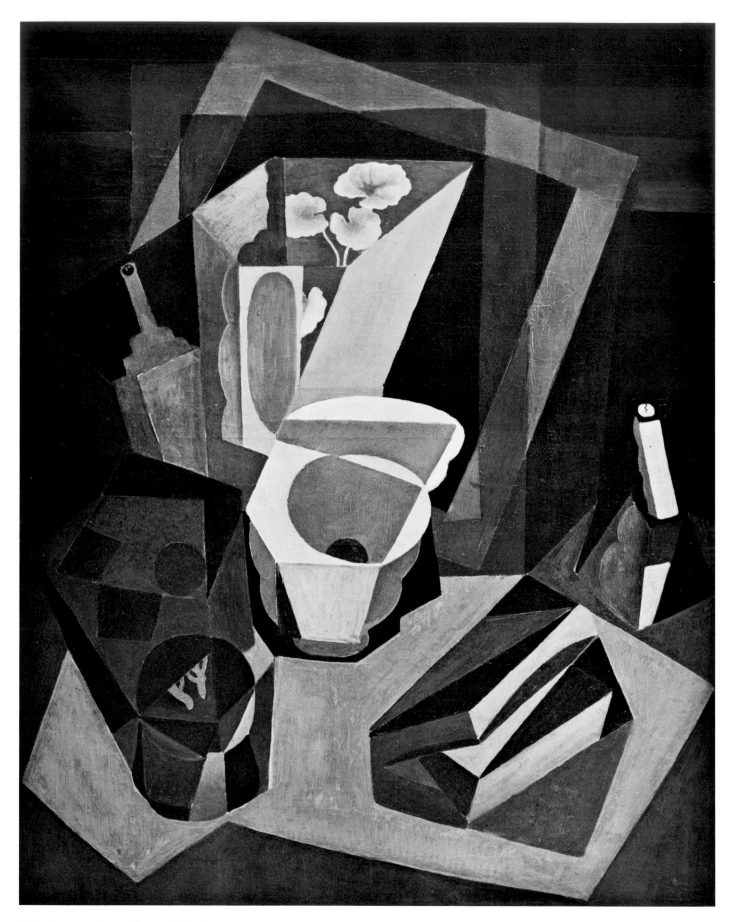

Naturaleza muerta con planta, (Still Life with Plant) 1917

Catalogue No. 65

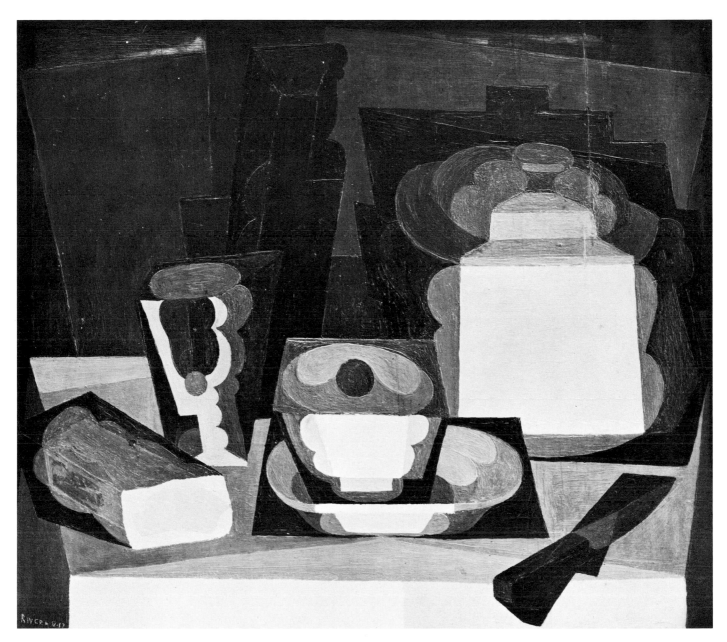

Naturaleza muerta – Nature morte au col, (Still Life – Still Life with Long-necked Bottle) 1917

Catalogue No. 67

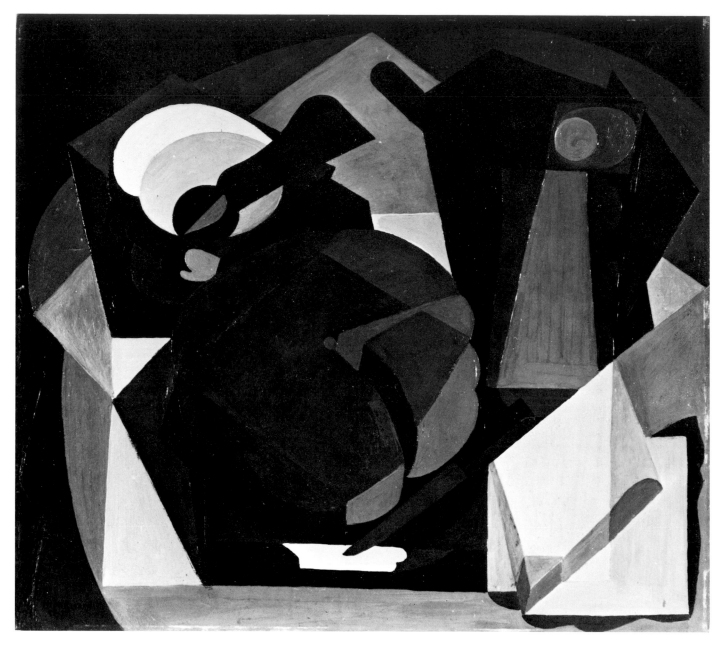

La Table Mince, (The Meager Table) 1917

Catalogue No. 68

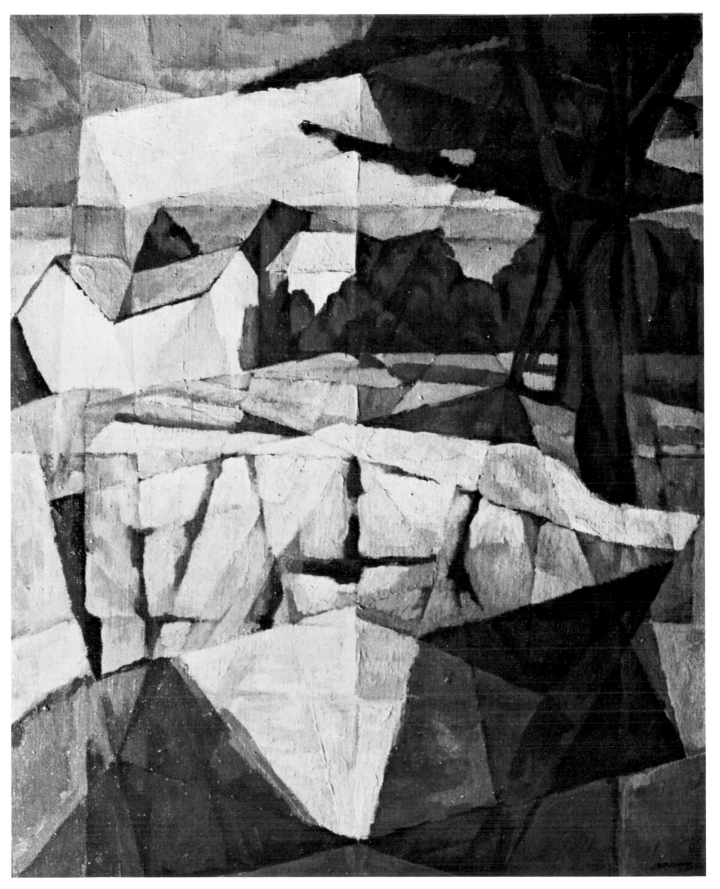

Paysage de Fontenay, (Paisaje de Fontenay) (Fontenay Landscape) 1917

Catalogue No. 69

Still Life with Cigarettes, (Naturaleza muerta con cigarrillos) 1917 Catalogue No. 70

 Paris, Still Life, (Naturaleza muerta, Paris) 1918 Catalogue No. 76

"La Chose," or "The Thing" may have been a free-standing transparent panel like Dürer's famous "drawing machines" (Fig. 36) constructed of framed glass panes which were sometimes gridded and accompanied by sight vanes. Rivera's "construction of mobile planes made of gelatine leaves" could then have been placed before the artist and his subject or model and with a calculated articulation of the transparent or translucent planes provided him with an experimental apparatus to work out an aesthetically pleasing and optically accurate scheme of varied refractions for his Cubist work. As we have seen, from his earliest years, Rivera was extremely fascinated by refractive optical properties. And when queried not long ago, Rivera's former mistress, Marevna, could only recall Rivera's "machine" as "some sort of kaleidoscope device."[165] In the absence of Rivera's notebooks a reconstruction of his "machine" will have to remain speculative. "But after all," as Severini conceded, "with whatever thing, even with 'la Chose,' the painter produced beautiful work, and Rivera did not lack a certain degree of talent."[166]

The results of Rivera's high-minded theorization and pseudo-scientific experimentation were applied in the most static, abstract, and classicizing works of his Cubist period, such as his *Maternity*, the *Painter in Repose*, the *Poet, Mme Zetlin, La Lessive* (Cat. 61), and his last Cubist still lifes of 1917. Rivera's *Maternity* (Cat. 55) painted shortly after the birth of his son in August 1916 (who died two years later) displays the intense complexity of Rivera's involvement with multi-colored refractions turned into volumetric geometry, and austere stabilizing and translucent planes combined with opaque surfaces. Severini's *Maternity (Woman and Child)* also of 1916 exemplifies the two artists' collaboration at the time. Although displaying a more delicate sense of balance than Rivera's, Severini's geometry had not penetrated the surface and the "super-physical dimension" to the degree that Rivera's had.

The style of the "Classical Cubists" with their predilection for "ideal Platonic forms (straight and circular forms derived from geometry) that ensured permanence, order, precision and perfection,"[167] had its visual source in the intellectuality of Gris's work and Picasso's intuitive creations. Its aesthetic articulation was provided by the Cubist dealer, Léonce Rosenberg. During the war, Rosenberg was Rivera's exclusive dealer, as well as that of Gris, Metzinger, Hayden, Lipchitz, Severini, and later Lhote, María Blanchard, and Zárraga. He grouped these artists under the banner of his "Galerie de l'Effort Moderne." Also during the war, in the absence of Apollinaire who was at the front, a young poet, Pierre Reverdy, became the most prominent Cubist critic and theoretician in Paris and a close collaborator of Léonce Rosenberg. As an eloquent Cubist theoretician, Reverdy took to pronouncing judgement on "certain artists" who fell short of his expectations that "Cubism is...an art of *creation* not of reproduction or interpretation."[168] In the first issue of his literary-artistic review, *Nord-Sud* (March 1917), Reverdy published the first attempt to seriously define the terms of a synthetic Cubist "Science" of art and aesthetics in his essay, "Sur le Cubisme." As the original manuscript of "Sur le Cubisme" implied, when Reverdy castigated painters of Cubist portraits, the artists he had in mind were specifically, Diego Rivera and André Lhote.

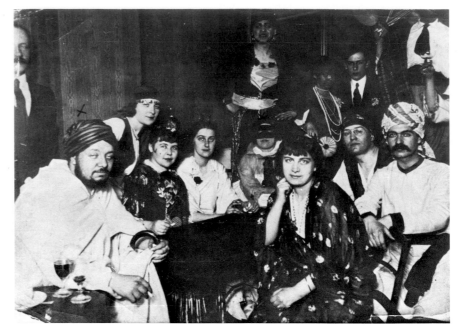

Figure No. 37
Diego Rivera and Angeline Beloff with friends at
an artists' costume party in Paris, c. 1914.
Rivera on the left wears a turban and holds his
walking-stick. Angeline Beloff in the rear center
wears a black mask and above her stands the
sculptor Miestchaninoff dressed as a gypsy.
Photograph courtesy of INBA

In the same month in which "Sur le Cubisme" appeared, Reverdy's
aesthetic position also took on an intensely personalized tone as a result of an
incident. This incident, or "artistic squabble"[169] as Juan Gris called it, was the
first element of what came to be known in Parisian avant-garde circles as
"l'affaire Rivera." The incident may have had serious implications for the
eventual dissolution of the original Classical Cubist circle resulting in the
formation of two militantly Cubist and Anti-Cubist camps in 1918.[170] It had all
the implications for Rivera's subsequent decision to break with Cubism and
change directions altogether.

According to an account of the event by Max Jacob, Léonce Rosenberg
organized a supper at the restaurant Lapérouse for the painters of his gallery
and several literary people including Pierre Reverdy and himself. After the
supper everyone went to finish the evening off at André Lhote's apartment in
Montparnasse (Fig. 37). Jacob related in a letter to the collector, Jacques
Doucet, of 22 March 1917:

> While we became livelier and livelier in the studio, Pierre arrogantly
> raised himself up on the Cubist pedestal: he treated his friends there
> with such little respect that Monsieur Ribera (sic) felt insulted and
> slapped him without regard for his oratory talent. The young and
> ardent theoretician of Cubism, in whose heart runs courageous blood,
> leaped upon his insulter and they both forgot about the present, those
> present, and precedences. Reverdy yanked Ribera's hair while
> screaming: the crowd of people there threw themselves on the
> combatants. The unfortunate Madame Lhote had tears in her eyes.[171]

Metzinger took the side of Rivera. Rivera held out his hand with apologies
on his lips, but, Jacob states, "the rancor of poets is enduring." Finally,
Reverdy was taken away and the Lhotes kept Rivera in their studio. There was
talk of a duel.

Jacob continues:

> Rosenberg is very mad at Reverdy. This is the most serious event of
> season: *It will be necessary to take definite sides* (The painters, only
> painters!). Reverdy's side, with Braque, Gris, and surely, Picasso, Ribera ͻ
> (sic) side will perhaps be Metzinger, Lhote, Maria Gouttieres (sic),
> Mariewna, the whole gang that usually meets at the Zeitlin's house...[172]

In a letter from Juan Gris to the critic Maurice Raynal, who was then at the
Front, Gris too related the incident:

144

Here there's discord in the air. Have you heard about the Reverdy-Rivera incident? During a discussion about painting at Lhote's, Rivera slapped Reverdy's face and so the latter went for him. I hear lots of china was broken and one pane of glass. Metzinger tried to intervene and get them to fight it out in a duel, that didn't work. I don't know whether we shall see much more such incidents.[173]

Several months later in another letter to Raynal, dated May 23, 1917, Gris described how things had progressed:

In No. 3 of Nord-Sud there's an article which has greatly annoyed me: 'Une nuit dans la plaine' ("A Night on the Plane") by Reverdy, a sort of fable in which, under the thinnest disguise, he insults Rivera and tries to make him ridiculous. It's silly revenge for the scene he had with him. I don't give a damn for Rivera, but I'm sorry that Reverdy does things like that. What's more, everyone is cross about it. [174]

The incident was undoubtedly a manifestation of the friction, personal and otherwise, which had begun to permeate Cubist Paris around 1917. It was also the origin of the eventual rift between the camp of Rivera, Lhote, André Favory, and Rosenberg's Cubist painters of "L'Effort Moderne" which was publicly proclaimed in a series of letters to the Parisian weekly, *Le Carnet de la Semaine*, between August and September of 1918. In a series of 1918 articles in *L'Europe Nouvelle*, André Salmon referred to the whole conflict as "l'affaire Rivera."

Rivera soon broke with his dealer and close collaborator of Reverdy, Léonce Rosenberg, over the question of stylistic freedom. As a result, the Mexican painter was ostracized by the group of artists that included Braque, Gris, Léger, Lipchitz, and soon even Severini and Lhote.

By 1917 Rivera had already undertaken a series of Ingresque portraits, whose point of departure was Picasso, as a possible alternative to Cubism.[175] However, Rivera's carefully controlled technique suggests not so much an imitation of Picasso's style as a more fundamental regression to his Academy days when he had been a pupil of the Mexican Nazarene and follower of Ingres, Santiago Rebull. In his Ingresque drawings, Rivera briefly digressed from a Cubist to a truly modern representational style, where complicated spatial constructions are disguised by overt realism. It was a prelude to a tendency he was to display consistently while working out the rudiments of a modernist-based Social Realist mural style. Rivera also turned patiently to an intensive study of the works of Cézanne, and to the "hidden geometry" in the works of Ingres, Renoir, and the Dutch Masters. His study of the "optical reformations" of Cézanne prompted him to experiment with curvilinear perspective as can be seen in one of his last works of 1917, the *Ferrocarril de Montparnasse*. By January of 1918, Rivera had rejected Cubism altogether and embarked upon a style bordering on pure *Cézannisme* that produced such imitative Cézannesque works as his *Landscape at Arcueil* (Cat. 73) and *Still Life* (1918). Such later French works by Rivera as his Piquey landscapes and series of aqueducts from Arcueil are almost indistinguishable from original late Cézannes with their compositions and subdued palette of ochres, green, pale blues, and deep umbers. Rivera's *Landscape at Arcueil* is clearly derivative from such works as Cézanne's *Bend in Road at Montgeroult*. Rivera's "realist reaction" against the prevalent wartime Cubism of the Parisian avant-garde was only reinforced by his meeting with the ardent champion of Cézanne, the physican and art historian, Elie Faure, at the end of the war. Rivera's *Portrait of Elie Faure* and the stunning *Mathematician* (Cat. 74) are masterful testimonies to how profoundly Rivera came to understand the formally constructionist aims of the artist he came to call "Father Cézanne."

Perhaps the clearest record we have of the conclusion to "l'affaire Rivera," and the artist's departure from Cubism is a review of a group exhibition in

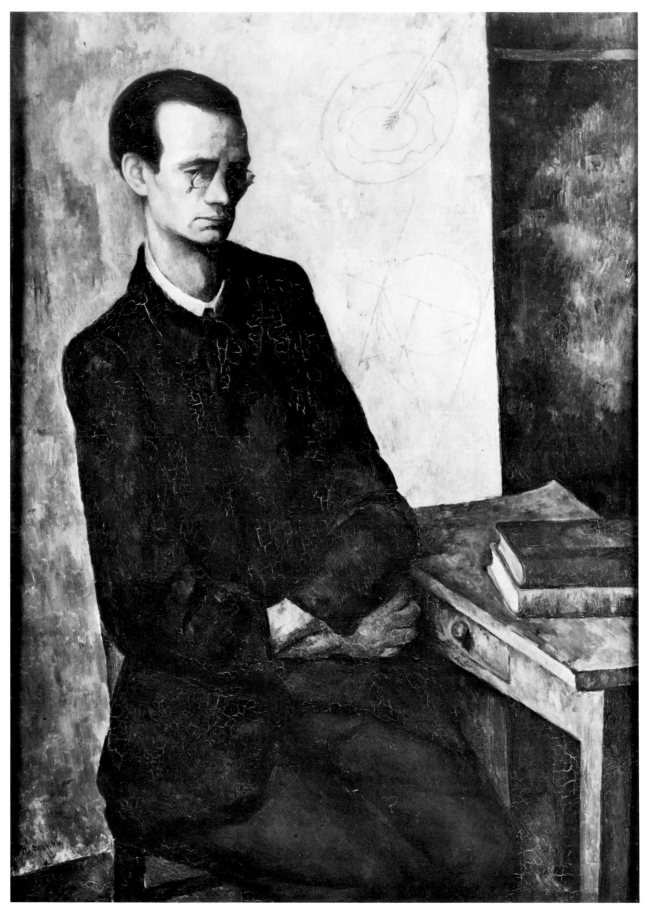

El Matemático, (The Mathematician) 1918

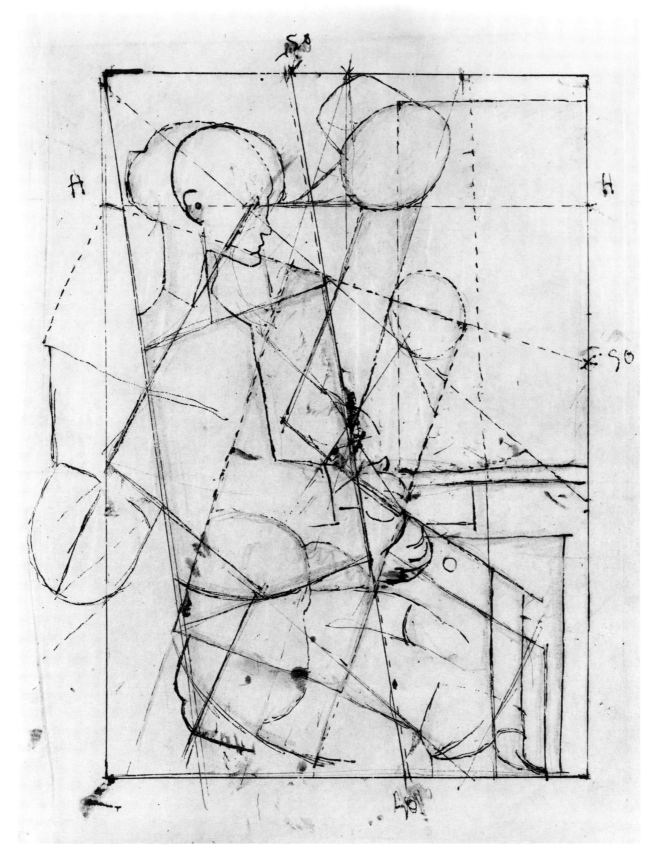

Dibujo de construcción. (Construction Drawing) 1918

Catalogue No. 75

Caserío, (Country Village) 1918

Paisaje de Arcueil, (Arcueil Landscape) 1918

Catalogue No. 73

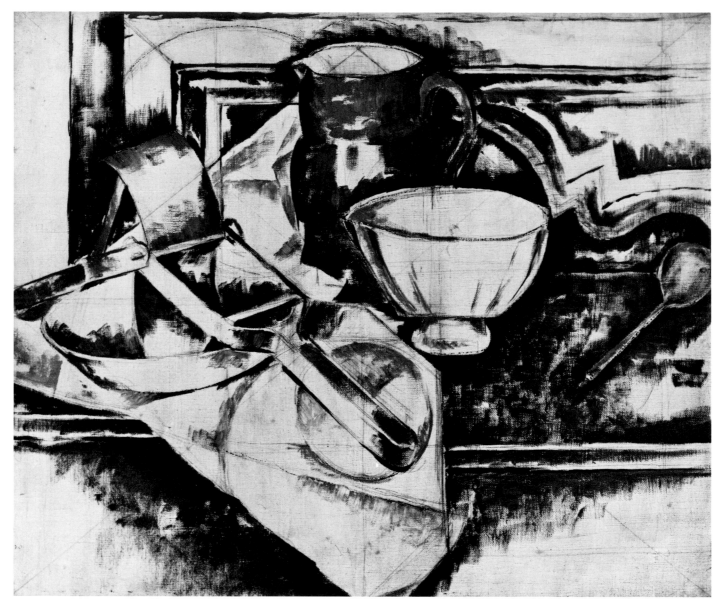

Naturaleza muerta, (Still Life – Unfinished) 1918

Catalogue No. 72

which Rivera participated at the end of 1918. It was written by Rivera's friend, the Danish sculptor Adam Fischer, for the Copenhagen artistic journal *Klingen.* In an article entitled "Modern Classical Art in Paris," Fischer wrote:

> At Blot's on Richepance street near the Madeleine, there is presently an exhibition of paintings which, if the efforts of the exhibitors are generalized, will be able to exert a great influence on the development of modern art.
>
> For the past half year a powerful press campaign has been carried on against a certain art dealer who is sitting on a large stock of Cubist art, and who, in order not to damage his business, has made use of a contract he had with a young painter to take his entire production in order to, by hiding his pictures, conceal that he was on the point of abandoning Cubism, or more correctly, that his Cubist endeavors led him on a trail resulting in the fact that his pictures could no longer be called 'Cubistic.'
>
> The painter is called Diego M. Rivera, and it is he and some other artists who have attached themselves to him, who exhibit at Blot's. And all those in Paris interested in art are discussing this.
>
> There are Pro-Cubists and Anti-Cubists...[176]

After describing the "evolution" of Rivera and the other exhibitors and their return to the original lessons of Cézanne, Fischer concluded:

> Cubism had for them become a dogma which was not to be touched. But just that, turning Cubism into a dogma, became its death sentence.
>
> Now, since Rivera has been released from his contract, he is on the point of executing the death sentence. Of his earlier pictures' Cubistic appearance nothing is left. The abstract structure of his pictures is concealed, one feels it, but one does not see it.
>
> In his portraits and still lifes (he) has tried to produce a slice of nature, to show an optical, correct picture while at the same time producing the true dimensions.
>
> Construction, which was lost, has been found again. The works which Diego M. Rivera, Eugène Corneau, Favory and André Lhote are exhibiting at Blot's are constructed.[177]

By the end of 1918, as Fischer observed in so many words, "Rivera had been released from his contract with Cubism — a dogma which was not to be touched." What Rivera had actually done was to finally release himself from the constraints of an alien notion of himself. He had never really operated well within the orthodoxy of Cubism, but nevertheless many of his works were equal in quality and theoretical aims to those of the orthodox Cubists. Some, such as his magisterial *Zapatista Landscape* and the *Woman at the Well,* excelled. Rivera worked in a Cubist style for five years. The Cubistic appearance of his earlier pictures was now gone, but for Rivera the consequences of Cubism per se were not. Perhaps the most meaningful definition of Cubism as it can be applied to the work of Rivera was provided by Juan Gris in 1925:

If what has been called 'Cubism' is only an appearance, then Cubism has disappeared; if it is an aesthetic, then it has been absorbed into painting.

Cubism is not a manner but an aesthetic, and even a state of mind; it is therefore inevitably connected with every manifestation of contemporary thought. It is possible to invent a technique or a manner independently, but one cannot invent the whole complexity of a state of mind.[178]

For Gris, Cubism was a complex "state of mind." For Rivera, Cubism became an acutely individualized and personalized state of mind that led him on a road to a monumental self-discovery from which he later never veered. In spite of all his subsequent inventions and tales about his wasted involvement with Cubism and his complaints of lost time, it was in Cubism, as Martín Luis Guzmán so astutely perceived in 1915, that Rivera had discovered the road back to his birthplace, Anáhuac.

Footnotes

[1]Armando Olivares, *Diego de Guanajuato* (Guanajuato: Universidad de Guanajuato, 1957), p. 10. All the translations in this essay are the author's unless otherwise indicated.

[2]All his biographers have claimed that Rivera was born on December 8, 1886, "the sumptuous feast day of María de la Concepción," and christened "Diego María de la Concepción Juan Nepomuceno Estanislao de la Rivera y Barrientos Acosta y Rodríguez." Very little factual information about Rivera's family or childhood is available. The practice of his many biographers and interviewers has been to accept uncritically the wildly differing versions of his early childhood and family origins for their anecdotal value, or to attach a stilted "caveat lector" to their prefaces. See Bertram D. Wolfe, *Diego Rivera, His Life and Times* (New York: Alfred A. Knopf, 1939), pp. 4-5, and *The Fabulous Life of Diego Rivera* (New York: Stein and Day, 1963), pp. 13-14, hereafter cited as *Diego Rivera* and *The Fabulous Life*. See also, Diego Rivera with Gladys March, *My Art, My Life* (New York: Citadel Press, 1960), p. 17, and Diego Rivera with Luis Suárez, *Confesiones de Diego Rivera* (Mexico City: Editorial Grijalbo, 1975), p. 13, hereafter cited as Rivera-March and Rivera-Suárez.

And although Rivera traditionally celebrated his birthday on December 8, he and his twin brother, Carlos María Rivera, who died one and one-half years later, were actually born on the 13th of December 1886. This is the birthdate given on the baptismal certificate registered in the Archivo de la Parroquia de Nuestra Señora de Guanajuato. The two boys were both christened in equally unspectacular fashion, simply "Je (José) Diego María Rivera" and Je (José) Carlos María Rivera."

Rivera's family history and ancestry have never been accurately documented and verified. The surviving members of the family recall only what Rivera recounted to his many biographers in his often contradictory accounts about his genealogy. In his most detailed and fantastic account of his ancestry given to Frances Flynn Paine in 1930 for the catalogue of his one-man exhibition at the Museum of Modern Art, New York, Rivera claimed that his paternal grandfather Don Anastasio de la Rivera had been born in St. Petersburg to a Russian mother who died at childbirth. His great-grandfather, a general of Spanish troops and allies of Napoleon fighting in Russia, was the Italian-born Marquise de la Navarro, "a direct descendant of the Sforzas." This paternal great-grandfather then took Don Anastasio back to Spain to raise him where he became a prominent military figure of the early 19th century. Don Anastasio de la Rivera reportedly later emigrated to Mexico, settled in Guanajuato and figured prominently in the wars of Liberal Reform at the side of Benito Juárez (New York City. MOMA, *Diego Rivera*, 1931, with a biographical note by Frances Flynn Paine, p. 9). See also Alredo Cardona Peña, "Danza de rostros," *Revista de Revistas,* Mexico City, December 8, 1957, p.41.

Wolfe, relying on his examination of Rivera's parental marriage license, could only ascertain that Rivera's grandfather (Don Anastasio de la Rivera) had been born in Spain and had emigrated to Mexico via Cuba, presumably at the beginning of the nineteenth century. In his new country of residence he married Mexican born Doña Inés de Acosta who was of Portuguese-Jewish descent. Rivera's maternal grandmother Doña Nemesia Rodríguez Valpuesta de Barrientos, was of Spanish-Indian extraction, born in Salamanca, Guanajuato and married to a Spanish telegraphist and mine operator Juan B. Barrientos who was originally from the Veracruzan port of Alvarado (in Wolfe, *Diego Rivera*, p.5). If Rivera's account of his paternal grandmother, Inés de Acosta's uncle being Benito de Acosta is true, Rivera is then the descendant of the eminent engineer and first Mexican aeronaut, Don Benito León Acosta, whose birthplace was also Guanajuato. See Diego Rivera and Loló de la Torriente, *Memoria y Razón de Diego Rivera,* I (Mexido City: Ed. Renacimiento, 1959), p. 89, hereafter referred to as Rivera-Torriente I.

[3]From unpublished "Notes on Cubism" dated April 8, 1932, taken by Wolfe from a discussion of Cubism with Rivera in Ernestine Evans' New York apartment. Typescript, Bertram D. Wolfe Papers, Hoover Institution on War, Revolution and Peace, Stanford University, 114-3.

[4]Diego Rivera, "From a Mexican Painter's Notebook," trans. Katherine Anne Porter, *Arts,* VII, No. 1 January 1925, p. 22.

[5]Rivera-Torriente II, p. 11 ("Because I was a pendejo!"). Santamaría's *Diccionario de mejicanismos* (1978) defines the adjective 'pendejo' as "Cowardly, pusillanimous, and euphemistically, stupid or dumb. A term that is seriously offensive and obscene and by all means improper for use by educated people."

[6]André Salmon, *L'Art vivant,* Paris, 1920, p. 157. Cf. Rivera-Suárez, p. 120.

[7]Guillaume Apollinaire, "Le 30e Salon des Indépendants," *Les Soirées de Paris,* No. 22, March 15, 1914, p. 188.

[8]For a detailed study of the artist's formative years and career up to 1921, see my Ph.D. dissertation (The University of Texas at Austin, 1984) entitled " 'Rivera Cubista': A Critical Study of the Early Career of Diego Rivera, 1898-1921," and my brief reappraisal of this period in "Diego Rivera: Los años de España, Francia y del cubismo — Una nueva perspectiva,"in *Diego Rivera,* ed. Manuel Reyero, Mexico City, 1983, pp. 13-40.

[9]Originally published in 1876. There are several references to Don Diego Rivera's activities as a student at the Colegio de la Purísima Concepción (now the Universidad de Guanajuato) in 1862, and his distinguished activity as a professor in Agustín Lanuza, *Historia del Colegio del Estado de Guanajuato*, Mexico City, 1924, pp. 228, 389, and 415.

[10]Rivera-Torriente I, pp. 105-108, and Rosales Hernán, *La niñez de personalidades mexicanas*, Mexico City, 1934, p. 134.

[11]In his famous ''Oración Cívica'' of September 16, 1867. While a medical student in Paris, Barreda became a convert to Comte's idea of social physics as the aspiration of uniting man with Nature and discovering the laws which regulate society. After his return to Mexico he was appointed the first director of the Escuela Nacional Preparatoria. His encyclopedic system of education was based on the most neutral and demonstrable of the physical sciences beginning with mathematics, to the exclusion of *all* metaphysical or ''spiritual'' concepts in Mexico's national educational curriculum. Barreda's Preparatoria produced the major minds of the Porfiriato and Mexico's early twentieth-century literary and artistic avant-garde. See Abelardo Villegas, *Positivismo y porfirismo*, Mexico City, p. 6, and the fundamental work on the subject, Leopoldo Zea, *El positivismo en México: Nacimiento, apogeo y decadencia* 2 vols., Mexico City, 1943-44.

[12]See Marevna Vorobëv, *Life in Two Worlds,* trans. Benet Nash, London, 1962, pp. 229-34; Ilya Ehrenburg, *People and Life, 1891-1921,* trans. A. Bostock and Y. Kapp, New York, 1962, p. 191; Elie Faure, ''Mon périple'' (1932) in *Oeuvres complètes III*, Paris, 1964, pp. 560-61; and Vladimir Kupchenko, ''Maksimilian Voloshin i Diego Rivera,'' *Latinskaia Amerika* (Moscow), No. 2, 1977, p. 184.

[13]The ''Porfiriato'' was the popular term applied to those years of the political and social dictatorship under the recurring presidencies of Don Porfirio Díaz between 1877 and 1911. During the Porfiriato, cosmopolitanism and a disdain for anything deriving from the popular indigenous classes, for example those illustrated in the prints and broadsides of José Guadalupe Posada, were the order of the day for the new elite families of an incipient Mexican bourgeoisie. *Afrancesamiento* (roughly ''Frenchification'') and a preoccupation with integrating Mexico with the best and most banal of contemporary Western European ''High'' culture also reigned.

[14]*El Mundo Ilustrado*, Mexico City, January 1, 1906, n. pag.

[15]Wolfe, *Fabulous Life,* pp. 39-40, and repeated with slight variation by all of Rivera's biographers.

[16]See Jean Charlot, ''Diego Rivera at the Academy of San Carlos,'' *College Art Journal*, X, Fall 1960, p. 10, and see note 41 below.

[17]Rivera recalled his curriculum at the Academy to his biographer, Loló de la Torriente (I, pp. 234 and 246) and also recalled attending specialized technical classes in the school of architecture which was housed in the Academy. These classes included ''mechanical'' and advanced geometry (p. 196). Rivera's recollection of his curriculum is verified by the published instructions for the ''Programas que regirán en la Escuela Nacional de Bellas Artes durante el año escolar de 1900.'' *Revista de la Instrucción Pública Mexicana,* IV, No. 3, March 1, 1900, p. 82 ff., and in the ''Bases para inscripciones en la Escuela Nacional de Bellas Artes,'' *Boletín de Instrucción Pública,* V, 1905, p. 371.

For a valuable discussion of the positivistic nature of this curriculum and that of other schools in Mexico City during the Porfiriato, including the private religious schools such as those Rivera attended, where textbooks were carefully controlled, see the fundamental study by Moisés Gonzáles Navarro, ''La instrucción pública,'' in *Historia moderna de México*, Mexico City, 1957, IV, pp. 529-692.

[18]Published in Mexico City: Imp. de Lara, 1867, p. 1.

[19]Published in 1866, it was prescribed as a required text along with the *Estética gráfica, la obra de Jules Pillet* (which might be any one of the many texts written by the prolific inspector of drawing and professor at the Ecole des Beaux-Arts, Jules Jean Désiré Pillet) in the official ''Programas que regirán, *op. cit,* p. 82.

[20]Rivera-Torriente I, pp. 194-95.

[21]Cf. William Innes Homer, *Seurat and the Science of Painting,* Cambridge, 1964, pp. 17-18.

[22]For the definitive study on the relationship between nineteenth-century developments in geometries of multiple dimensions, space differentiation, and Cubist theory, see Linda D. Henderson, *The Fourth Dimension and Non-Euclidean Geometry in Modern Art,* Princeton, 1983; and for Ernst Mach and Poincaré's differentiation between the space of geometry and the space of perception, or physiological space as Mach called it, see especially pp. 36-38. For Gleizes and Metzinger's interpretation of Poincaré's ideas about tactile and motor space in their book *Du Cubisme,* see pp. 81-85 in Henderson.

[23]''Diego Rivera's Art Exhibition at the Academy,'' *The Mexican Herald*, Mexico City, November 22, 1910, p. 12, and ''Diego Rivera, Exposición en San Carlos,'' *Revista Moderna de México,* XV, No. 5, January 1911, pp. 258-64.

[24]Jean Charlot, *Mexican Art and the Academy of San Carlos,* Austin, 1962, p. 138.

[25]Rivera-Torriente I, p. 205.

[26]Rivera-Torriente I, pp. 211-12.

[27]The polemical dialogue on Beauty between Socrates and Protarchus from Plato's *Philebus* has Socrates stating:

> ...By 'beauty of shape' I don't in this instance mean what most people would understand by it — I am not thinking of animals or certain pictures, but, so the thesis goes — a straight line or a circle and resultant planes and solids produced on a lathe or with ruler and square. Do you see the sort of thing I mean? On my view these things are not, as other things are, beautiful in a relative way, but are always beautiful in themselves, and yield their own special pleasures quite unlike those of scratching. I include colors, too, that have the same characteristic. Have you got my point, or not?

(Plato, *Philebus*, trans. J.C.B. Gosling, Oxford, 1975, p. 51, line 51-b-d.)

This quotation has been published in different translations in various avant-garde periodicals and pamphlets in Europe and America since the beginning of the century. In the October 1911 issue of *Camera Work* (No. 36, p. 68), Alfred Stieglitz reproduced an hermetic, abstract-like Cubist drawing by Picasso to illustrate Plato's reference to forms 'which are not beautiful for a particular purpose, but are by nature beautiful in themselves.' Marius de Zayas in "How, When, and Why Modern Art Came to New York" (Introduction and notes by Francis M. Naumann, *Arts Magazine,* April 1980, p. 102), stated that the quotation from Plato's *Philebus* was sent to Stieglitz during the Picasso exhibition at the "Photo-Secession" gallery in 1910 by a writer whose name he never learned. See also George Hamilton Heard. "John Covert: Early American Modern," *College Art Journal,* XII, No. 1, Fall 1952, pp. 37-41. Francis Picabia included the same extract from the *Philebus* in the preface for his "291" exhibition catalogue (March 1913), as noted in William A. Camfield, *Francis Picabia, His Art, Life and Times,* Princeton, 1979, pp. 48 and 51. It was also published by Amedée Ozenfant in his Parisian wartime journal *L'Elan,* No. 9, February 1916, where it was sure to be seen by Rivera. Rivera's dealer, Léonce Rosenberg, used it in his *Cubisme et tradition* (1920), where he sought to place Cubism within the Tradition and Order of all great Classical epochs of art. It was later taken up as a battle-cry by the proponents of the Purist art of Ozenfant and Le Corbusier and the Machine aesthetics of the 1920s. For a discussion of Plato's quote in this later context, see Reyner Banham, *Theory and Design in the First Machine Age,* New York, 1967, p. 205.

[28]Martín Luis Guzmán, "Diego Rivera y la filosofía del cubismo," in *Obras completas de Martín Luis Guzmán,* Mexico City, 1961, I, p. 85. Although the article is dated 1916 in the *Obras completas,* based on correspondence between Guzmán and Rivera dating from 1915, it was written in the fall of that year. (Correspondence in the possession of the late Sra. Ana West Vda. de Guzmán which she kindly permitted me to consult.)

[29]The famous axiom which has been so often conveniently misunderstood as a justification for "reducing the visual world to a few geometrical forms," or what could be conceived of as Phileban solids, has been definitively placed in its original context by the study of Theodore Reff, "Cézanne and Poussin," *Journal of the Warburg and Courtauld Institutes,* XXIII, 1960, pp. 150-174. See also, William Rubin, "Cézannisme and the beginning of Cubism," in *Cézanne, The Late Work,* ed., William Rubin, New York, 1977, p. 193.

[30]"Painting and Theory in the Final Decade," in *Cézanne, The Late Work, op. cit.* , p. 47.

[31]See "Conferencias en la Escuela de Bellas Artes," *El Imparcial,* Mexico City, April 26, 1904, p. 1, and "La Escuela de Bellas Artes: El nuevo plan de estudios...modelos europeos," *El Imparcial,* January 24, 1904, p. 3.

[32]Rivera-Torriente I, p. 219. The mystifying and "divine proportion" of the Golden Section is one in which the ratio of the divided line or part to the whole is figured so that the smaller part is to the larger part as the larger part is to the whole, and the two quantities of the Golden Section will always equal the whole. The ratio is expressed algebraically as $\dfrac{A}{B} = \dfrac{B}{A + B,}$

and numerically as 1 to 1.618...or .618...to 1. What should result and appear harmonious and pleasing to the eye in a picture constructed on the principle of the Golden Section is a perfectly proportioned unity in a diversity of parts. The mathematical properties of the Golden Section have fascinated artists and architects since antiquity. However, in many artists the sense of balance and of harmony is an innate psychological factor. Consequently, it is difficult to accurately determine if a work of art has been consciously constructed on a geometric and algebraic proportional system if the underlying design is not visible or if the artist does not explain the system used.

The extensive literature on the Golden Section is fairly well-covered in Charles Bouleau, *Charpentes: La géométrie secrète des peintres,* Paris, 1963, and Matila Ghyka, *Le Nombre d'Or,* Paris, 1931, 2 vols.

[33]I am indebted to the Ingres specialist, Professor Agnes Mongan, for confirming this point for me.

[34]On Pelegrín Clavé and Overbeck's Nazarene style and its dissemination at the Academy of San Carlos, see Justino Fernández, *Estética del arte mexicano,* Mexico City, 1972, pp. 388-89, and Charlot, *Mexican Art and the Academy, op. cit.,* p. 140. And for a discussion of Rebull's use of the "Sección de Oro" proportional system in his religious academic paintings, see Fernández, *El arte del siglo XIX en México,* Mexico City, 1967, pp. 76-80.

156

[35]Kupka was associated with the Puteaux Cubists and maintained a long-time interest in the Golden Section in his work. For an account of Kupka's Nazarene education at the Prague Academy, see Meda Mladek, "Central European Influences," in *Frantisek Kupka: A Retrospective*, eds. M. Mladek and M. Rowell, New York, 1975, p. 20.

[36]Rivera-Torriente II, pp. 37-40. Even many years later, when the architect and painter, Juan O'Gorman, wrote an analysis of Rivera's mural painting technique that included a description (not altogether clear) by Rivera of the proportional system he utilized in his work, O'Gorman concluded:

> The Mexican painter Diego Rivera profoundly knows and consistently uses a *completely personal and original system* of dynamic symmetry. His compositions, both mural and easel painting, are constructed with geometrical scaffoldings *invented by him* and based on harmonious proportions. (emphasis added)

In Juan O'Gorman, "Técnica empleada por Diego Rivera para pintar al fresco," *Diego Rivera, 50 años de su labor artística*, Mexico City, 1951, p. 284.

For a consideration of the mathematical and geometrical properties of the Golden Section and its utilization in the Cubist compositions of Juan Gris, see William A. Camfield, "Juan Gris and the Golden Section," *The Art Bulletin*, XLVII (March 1965), pp. 128-34, and Lucy Adelman and Michael Compton, "Mathematics in Early Abstract Art," in *Towards a New Art*, London, 1980, pp. 74-78.

[37]*Traités du paysage et de la figure*, Paris, 1958, p. 59.

[38]See José Juan Tablada, "En la Academia de San Carlos: La exposición Fabrés," *El Imparcial*, Mexico City, December 31, 1902, p. 1, and Tablada, "El 'Salón' de alumnos en Bellas Artes," *Revista Moderna de México*, III, No. 4, December 1904, pp. 207-11.

[39]Wolfe, *Diego Rivera*, p. 28.

[40]In *Revistas de Revistas*, Mexico City, August 30, 1925, pp. 24-25. Charlot arrived in Mexico City from France in 1921. Shortly thereafter, he took an interest in artistic quality of the curious popular prints (*calaveras* and *corridos*) being hawked on street corners and sought out their creators. His version of his "discovery" of Posada is provided in *Posada's Mexico*, ed. Ron Tyler, Washington, D.C., 1979, pp. 3-5. Cf. Jean Charlot, *The Mexican Mural Renaissance*, New Haven, 1963, p. 181.

[41]To his many biographers Rivera claimed to have been expelled from the Academy for his "revolutionary political ideas and discontent with academic training," incorrectly citing the year he left San Carlos as 1902. The degree to which Rivera's apocryphal mythology has fostered historical distortion is evidenced by the following passage, the basis for an entire book on the formative years of Diego Rivera:

> The year 1902 was an early and decisive turning point in Diego Rivera's career...In the same year a students' strike was organized and led by the already politically minded young Rivera to protest the re-election of President Díaz. As a result Rivera...was temporarily expelled from the school. He refused to return and determined instead to begin his first independent work as an artist.

(Florence Arquin, *Diego Rivera: The Shaping of an Artist*, Norman, 1971, p. 31.) The story and date are repeated with variations in Rivera-March, p. 16, Rivera-Torriente I, p. 209, and in Wolfe, *Diego Rivera*, pp. 32-33. Besides the official records of Rivera's activities at the Academy dating to December 1905 and cited in Charlot, *op. cit.*, see José Juan Tablada's remarks on the artist in "La exposición de pintura y escultura en la Academia de Bellas Artes," *El Imparcial*, November 20, 1906, p. 1.

[42]Rivera-Torriente I, pp. 201 and 265.

[43]In his important article on "Cézannisme and the Beginnings of Cubism," *op. cit.*, William Rubin traced the influence of Cézanne and the chronology of his rise in popularity among the future Cubist painters, Picasso, Braque, Léger, and Delaunay. Rubin's analysis of the process involved in the development of Cézanne's reputation and influence of his work for even these artists who were physically and geographically close to his works and notoriety preclude the possibility of an artist such as Rivera having received a similar exposure to Cézanne's works at such an early date in Mexico. Furthermore, a systematic review of Mexican contemporary art criticism produced no mention of Cézanne, much less reproductions of his works in Mexican periodicals until 1921 when Rivera returned and invoked his name in interviews.

[44]Cf. Jean-Marie Lavaud, "Une collaboration de Valle-Inclán au journal 'Nuevo Mundo' et l'exposition de 1912," *Bulletin Hispanique*, Bordeaux, LXXXI, Nos. 1-2, 1976, pp. 293-97.

[45]"Diego Rivera," *La Semana Ilustrada*, Mexico City, June 30, 1914, p. 1.

[46]Rivera-March p. 60.

[47]Jean-Paul Crespelle, *Montparnasse vivant*, Paris, 1962, p. 13, and *La vie quotidienne à Montparnasse à la grande époque, 1905-1930*, Paris, 1976, pp. 21-22.

[48]Guillaume Apollinaire, "Montparnasse," *Paris-Journal*, June 23, 1914, reproduced in *Apollinaire on Art*, ed., Leroy C. Breunig, trans., Susan Suleiman, New York, 1972, pp. 409-10.

[49]"Artista que va a Europa," *El Tiempo*, December 21, 1910, p. 3, and "Tuvo magnífico éxito la exposición de Diego Rivera," *El Imparcial*, December 21, 1910, p. 4, where the prices that Rivera's work sold for are discussed.

[50]Rivera-March, p. 91. With Rivera's papers closed it is impossible to determine if he indeed renewed his pension from the governor of Veracruz in 1911. None of the newspaper reports during his brief stay in Mexico are specific on this point. In the archives of the Mexican Embassy in Paris, where there are records for the disbursement of pension funds to various music and some art students from 1911 forward during this period, there is no record for the disbursement of a pension to Diego Rivera. With the dispersal of the Dehesa papers it is also difficult to establish this point. Rivera told his biographers conflicting stories about the renewal of his government pension after the Revolution began. In those accounts where he "barely escaped Mexico with his life as a revolutionary," the implications are that his previous Porfirian pension would obviously not have been renewed. In other accounts he claims to have remained in Mexico "fighting with Zapata's forces until Madero's triumph June 1911." He claimed, for example, to Wolfe that "The new government increased the number of scholarships for promising writers and artists and having, along with his father, espoused the Liberal cause, there was no difficulty in renewing his pension. By the end of 1911 he was back in Paris – this time to stay in Europe for a decade" (Diego Rivera, p. 65). The Mexican Embassy records, although sparse for the period during Madero's presidency, do not bear this out. It is my contention, in the absence of further documentation, that Rivera returned to Paris as a Porfirian artist in January 1911 with his pension from Dehesa renewed and a sum of money from the sale of his works. And that when Díaz resigned the Presidency in May of 1911, and Dehesa followed him in resigning from the governor's office of Veracruz in June, Rivera's pension ceased. He then relied on his savings to live until he established himself on the Parisian art market by 1913.

[51]For those authors who had taken note of the fact that Rivera had been in Paris earlier before and settled there only after a trip to Mexico in 1910, the dates for his return to the French capital range from July 1911 (Rivera, "Datos biográficos," El Arquitecto, March-April, 1926, p. 3) to September 1911 (Olivier Debroise, Diego de Montparnasse, Mexico City, 1979, p. 19 who states that Rivera returned to live at 26, rue du Départ — an address he did not occupy until the fall of 1912; and Rivera-March, pp. 96-98) and November 1911 (Crespo de la Serna, "Proceso de desarrollo de la pintura de Diego Rivera," Diego Rivera, 50 años, op. cit., p. 65). Rivera stated to Torriente that he departed Mexico in October 1911 (I, p. 348), and to Wolfe (Diego Rivera, p. 65), Hans Secker (Diego Rivera, Dresden, 1957, p. 41) and Suárez (p. 112) that he returned to Paris "at the end of 1911."

A systematic review of the major Mexico City dailies: El Imparcial, El Tiempo, and El País, for the entire year of 1911 produced no mention of Rivera or his activities either in Mexico or Europe, whereas other Mexican artists were frequently reported on.

[52]Rivera-Torriente I, pp. 351-54.

[53]"El Salón de Otoño, " Mundial Magazine, Paris, II, No. 7, November 1911, pp. 44-45. The literary journal, Mundial Magazine (1911-1914) was founded in May 1911. Its literary director was the famous Nicaraguan poet Rubén Darío, then living in Paris. During its brief existence it was a Spanish-language organ for the illustration and dissemination of Latin American culture to the public and to Latin American émigrés in France, as well as a disseminator of French culture to the South American public. Its lavishly llustrated numbers, which included reviews of all the Parisian art Salons and major exhibitions by Hispanic-American artists, were available in Mexico City and Guadalajara but are today extremely rare in Mexican libraries.

[54]Rivera is not listed in the catalogue of the 1911 Salon des Indépendants. For detailed accounts of the events leading up to the grouping of the artists in that Salon's "Room 41" and their later manifestation in the juried Salon d'Automne of 1911, see John Golding, Cubism, a History and Analysis, 1907-1914, New York, 1968, pp. 138-58, and Albert Gleizes, Souvenirs: Le Cubisme, 1908-1914, Lyon, pp. 15-31. On the influence of Picasso and Braque upon the Salon 'Cubistes' as well as the contemporary distinction between them and the 'Picassistes' see Virginia Spate, Orphism, Oxford, 1979, p. 17.

[55]Brendel, op. cit., p. 40.

[56]Ibid. Brendel does not identify the source, but the passage is from Metzinger's article "Cubisme et Tradition," Paris-Journal, August 16, 1911. For a discussion of the seminal importance of this article by Metzinger, see Lynn Gamwell, Cubist Criticism, Ann Arbor, 1980, p. 32.

[57]Cf. Spate, op. cit., p. 15.

[58]The Evening Post, New York, October 7, 1916, quoted in Marius de Zayas, op. cit. See also, the York Evening Mail, October 9, 1916 also quoted in De Zayas, pp. 119-120.

[59]Piet Mondrian (1872-1944) first arrived in Paris from his native Holland in January 1912. His first Parisian address was at 33, avenue du Maine, from where he submitted three paintings to the 1912 Salon des Indépendants. In May of that year he moved to the building of artists' studios and apartments at 26, rue du Départ, which would be Rivera's address from 1912 until 1919. On Mondrian's arrival in Paris and his various studios there, see the catalogue essay by Michel Seuphor for the exhibition Mondrian, Paris, Orangerie des Tuileries, January-March 1969.

[60]"Regresó de Europa el pintor Zárraga," El Imparcial, Mexico City, January 11, 1914, p. 5.

[61] In a letter from Samuel Halpert in Toledo to Robert Delaunay then in Portugal, dated February 6, 1916, Halpert discusses "the old house of the Riveras where they had once lived together with Angel Zárraga." Zárraga had just rented the house to him. The letter was in the possession of Mme Sonia Delaunay in 1979.

[62] "La obra del pintor mexicano Diego M. Rivera," *El Mundo Ilustrado*, Mexico City, May 17, 1914, n. pag.

[63] See note 61.

[64] *Exposition Angel Zárraga*, Chez MM. Bernheim-Jeune & Cie, Paris, March 8 – June 22, 1920, pp. 3-4.

[65] No. 19, November 1912, p. 640.

[66] José D. Frías, "Los pintores mexicanos en París," *Zig-Zag*, I, No. 17, August 5, 1920, p. 33.

[67] See Robert P. Welsh, "Mondrian," *Revue de l'art*, No. 5, 1969, p. 99, and Joop Joosten, "Mondrian: Between Cubism and Abstraction," in *Piet Mondrian, Centennial Exhibition*, New York, Guggenheim Museum, 1971, pp. 53-56.

[68] See "Notas de Instrucción: Comisionado en Europa," *El Imparcial*, Mexico City, May 18, 1912, p. 2.

[69] Rivera-Suárez, p. 115.

[70] "Diego Rivera y su ética y estética," *Cuadernos Americanos*, XLVII, No. 5, September-October 1949, p. 282.

[71] Arquin, *op. cit.*, pp. 64-5, and Justino Fernández, "Diego Rivera antes y después," *Anales del Instituto de Investigaciones Estéticas*, V, No. 18, 1949, p. 68.

[72] The origin of "Cubism" as a stylistic term dates from the critic Louis Vauxcelles' review of Braque's November 1908 exhibition at the Galerie Kahnweiler. Vauxcelles characterized Braque's L'Estaque paintings as being "reduced to geometrical schemes, to cubes." According to Apollinaire, Matisse, who was on the jury of the 1908 Salon d'Automne a few months earlier, had criticized Braque's entries as being composed of 'little cubes' and thereby first uttered the word which for better or for worse became the visual hallmark of the style in the public's mind. See Edward F. Fry, *Cubism*, New York, 1966, pp. 50-51; and for a revised view of the history of the word "Cubism," see Daniel Robbins, *Albert Gleizes*, exhibition catalogue, New York, Guggenheim Museum, 1964, p. 20.

[73] *Picasso, Fifty Years of his Art*, New York, 1946, p. 69.

[74] Rivera-March, pp. 65-66.

[75] Letter from Diego Rivera to the Danish painter, Georg Jacobsen, dated August 28, 1920, published in Grete Zahle, "Diego Rivera og hans forbindelse med to Danske kunstnere," Kunstmuseets *Aarsskrift* (Copenhagen, Statens Museum For Kunst), 1976, pp. 60-61. Cf. Franz Marc and the Blue Rider Group's similar and earlier appraisal of the relationship between Cézanne and El Greco, in Jonathan Brown's discussion of "El Greco, the Man and the Myths," *El Greco of Toledo*, Boston, 1982, p. 28.

[76] Paine, *op. cit.*, p. 22.

[77] María Elena Sodi de Pallares, *Teodoro A. Dehesa: Una época y un hombre*, Mexico City, 1959, p. 107. Sodi de Pallares had the good fortune to view Dehesa's collection of the early works Rivera had shipped from Europe in accordance with his pension before those works were dispersed. She was also able to read Rivera's European letters to Dehesa before those letters were lost. My search through all that is left of the Dehesa papers last year did not produce Rivera's letters. Sodi de Pallares passed away several years ago and her papers too have been dispersed.

[78] Guzmán, *op. cit.*, p. 84.

[79] *Ibid.*

[80] Enrique Gual, *Cien dibujos de Diego Rivera*, Mexico City, 1949, pl. 5.

[81] Daniel Robbins discusses this group of artists, who were first united in a phalanstery on the outskirts of Paris called the Abbaye de Créteil and later formed the "Artists of Passy" which included the Duchamp-Villon family. Professing radical social ideas on an epic scale, the salient feature of the work of these pre-war Cubists was a concern for epic subjects: landscapes with huge surging rhythms, broad geographical displacement of dynamic themes and evocative subjects, city-scapes, physical labor and collective experiences rooted in the land. There were few "Classical still lifes" in shallow space among their works ("From Symbolism to Cubism: The Abbaye de Créteil," *The Art Journal*, XXIII, No. 2, Winter 1963-64, pp. 111-116.).

[82] Rivera-March, pp. 104-05.

[83] Rivera-Suárez, p. 124.

[84] *IV^e Exposition du Groupe Libre*, Paris, Chez MM. Bernheim-Jeune & Cie., January 13-25, 1913, pp. 22-23.

[85] Camille Mauclair, "Préface," *Ibid.*, pp. 3-6 *et passim*.

[86] "Art – Le Groupe Libre," *Mercure de France*, February 1, 1913, p. 640.

[87] "Les Arts: 'Le Groupe Libre,' " *Gil Blas*, January 18, 1913, p. 5.

[88]Carlos González Peña, "Al margen de la semana: Un burro pintor," *El Universal Ilustrado*, Mexico City, May 24, 1918, p. 2.

[89]Best Maugard, *op. cit.*, p. 283.

[90]Rivera-Suárez, p. 115.

[91]Rivera-Torriente II, p. 10.

[92]Daniel Robbins, "The Formation and Maturity of Albert Gleizes," (Ph.D. dissertation, New York University), 1975, p. 107.

[93]Spate, *op. cit.*, p. 20.

[94]Mondrian's studio appears to have been one floor beneath and slightly to the right of Rivera's. This view and the same "X" shaped trusses of the track signal served as the motif for Mondrian's abstract *Composition en gris et jaune*, 1913. See R.P. Welsh, *op. cit.*

[95]"Calendario: Murió Diego," *Excélsior*, Mexico City, November 30, 1957, p. 6.

[96]Guzmán, *op. cit.*, p. 84.

[97]As quoted in Spate, *op. cit.*, p. 205.

[98]Rivera-Suárez, p. 115.

[99]"Atl," "Le Salon des Indépendants," *L'Action d'art*, Paris, April 1, 1913, p.3.

[100]Ilya Ehrenburg, *People and Life, 1891-1921*, trans. Anna Bostock and Yvonne Kapp, New York, 1962, p. 196.

[101]Zárraga mentions these two works in his Mexican interview in *El Imparcial*, January 11, 1914, p. 5.

[102]The catalogue for the *XIᵉ Exposition du Salon D'Automne de 1913*, lists the following entry:

> Rivera (Diego), né au Mexique. Mexicain. — 26, rue du Départ
> #1788 — Composition (peinture à la cire).
> #1789 — La jeune fille aux artichauts.
> #1790 — La jeune fille à l'éventail.

Rivera's isolated use of the encaustic technique for this work was probably the result of Atl's (Gerardo Murillo) influence. Throughout the year Atl worked in an encaustic technique in his studio on the outskirts of Paris in preparation for his one-man exhibition. See Atl's catalogue preface to his exhibition "Les Montagnes du Mexique,"Galerie Joubert et Richebourg, Paris, May 1-15, 1914.

[103]See Jonathan Brown, "El Greco and Toledo," in *op. cit.*, p. 135.

[104]Raynal, "Conception et Vision," *Gil Blas*, August 29, 1912, p. 4, and Olivier-Hourcade, "La tendance de la peinture contemporaine," *Revue de France des pays francais*, February 1912, pp. 35-41. Gamwell, *op. cit.*, pp. 46-47, discusses the significance of these two articles for a definition of Cubism as an "art of conception."

[105]In the most recent major Cubist exhibition, the Tate Gallery's "The Essential Cubism," the exhibition's organizers Douglas Cooper and Gary Tinterow admit in their catalogue essay that in the final analysis, they are

> led to the inescapable conclusion that it [Cubism] cannot be defined as a style any more than it can be identified by its subject matter. Nor was it the expression in pictorial terms of any particular philosophy.

("Introduction," p. 14, London, The Tate Gallery, April 27-July 10, 1983.) Predictably, Rivera is not included in their selection of "true Cubism," and is mentioned in the catalogue only as "a figure at that time on the fringe of Cubism" (p. 402).

[106]See Robbins, *op. cit.*

[107]Pedro Henríquez Ureña and Alfonso Reyes, *Epistolario Intimo* (1906-1946), Santo Domingo, 1981, I, pp. 154-55. Reyes' father, General Bernardo Reyes, a possible contender for the Mexican presidency had recently been murdered (February 1913) in the terrible violence of Huerta's coup d' état against Madero that came to be known as the "Ten Tragic Days." Huerta's administration sent his son Alfonso to Europe to serve as the Second Secretary of the Mexican Legation in Paris.

[108]"Les Arts: Sujets de conversation," *Gil Blas*, October 14, 1913, p. 4.

[109]*Les Indépendants, 1884-1920*, Paris, 1920, p. 164.

[110]See "Presentación de una obra de Diego Rivera recién descubierta por técnicos del C.N.C.O.A. del I.N.B.A.," Mexico City, 1977.

[111]For a discussion of "Cubo-Futurism" see Jean-Claude Marcadé, "K. S. Malevich: From Black Quadrilateral (1913)...," in the exhibition catalogue, *The Avant-Garde in Russia 1910-1930, New Perspectives*, Los Angeles County Museum of Art, 1980, pp. 20-23; and Charlotte Douglas, "Cubisme francais, cubo-futurisme russe," *Cahiers du Musée National d'Art Moderne*, Paris, 72, October-December 1979, pp. 184-93.

[112]On Bergson and "Cubo-Futurisme" see Charlotte Douglas, "The New Russian Art and Italian Futurism," *Art Journal*, XXIV, No. 3, Spring 1975, p. 235.

[113]Ulrico Brendel, "El Salon de Otoño," *Mundial Magazine,* Paris, VI, No. 3, January 1914, p. 223.

[114]André Salmon, "Le Salon d'Automne, 1913," *Montjoie!,* Nos. 11-12, November-December 1913, p. 6.

[115]See Spate, *op. cit.,* p. 10; and for Rivera's description see Rivera-Torriente I, pp. 341-42.

[116]Personal conversation with the author, Paris, 1979.

[117]It illustrates "Les Danses sud-américaines," by Jean-Paul D'Aile in *Montjoie!,* January-February 1914, p. 8

[118]García Calderón, *op. cit.*

[119]See Arthur Craven, *J'étais cigare,* Paris, 1971, p. 143.

[120]See *Helios,* Paris, No. 1, November 1913; and on Russian avant-garde Neo-Primitivism, see *Russian Art of the Avant-Garde: Theory and Criticism 1902-1934,* ed. John E. Bowlt, New York, 1976, pp. xxvi-xxvii.

[121]Wolfe, *Diego Rivera,* p. 92.

[122]Rivera-Torriente II, p. 43.

[123]*Ibid.*

[124]See Judith K. Zilczer, "The Noble Buyer: John Quinn, Patron of the Avant-Garde," ex. cat. Hirshhorn Museum and Sculpture Garden, Smithsonian Institution, 1978, cat. no. 63, and p. 181.

[125]Rivera-March, pp. 104-05.

[126]*Paris-Journal,* May 7, 1914; English translation in *Apollinaire on Art: Essays and Reviews 1902-1918,* ed. LeRoy C. Breunig, New York, 1972, pp. 376-77.

[127]García Calderón, *op. cit.*

[128]The catalogue is in the Archives of Alfonso Reyes, the Capilla Alfonsina, Mexico City, "Carpeta Rivera, 1914-57."

[129]Henríquez Ureña and Reyes, *op. cit.,* p. 226.

[130]Edward F. Fry, *op. cit.,* p. 134, and see also Douglas Cooper, *The Cubist Epoch,* Oxford, 1970, p. 155.

[131]See Donald E. Gordon, *Modern Art Exhibitions 1900-1916,* Munich, 1914, 2 vols. for a record of Rivera's participation in European exhibitions.

[132]Alfonso Reyes, "Historia documental de mis libros," *Revista de la Universidad de México,* IX, No. 7, March 1955, p. 16.

[133]Quoted in Irene Patai, *Encounters. The Life of Jacques Lipchitz,* New York, 1964, p. 142.

[134]Henríquez Ureña and Reyes, *op. cit.,* vol. II, pp. 89-93.

[135]*Ibid.*

[136]In the catalogue preface to the exhibition "Los Pintores Integros," Salón 'Arte Moderno,' Madrid, March 1915, p. 6.

[137]Reyes, *op. cit.* An unidentified clipping of Acevedo's article is in one of Reyes' scrapbooks in the Capilla Alfonsina.

[138]José Francés, "De Bellas Artes: Los Pintores, 'Integros,' " *El Mundo Gráfico,* V, No. 157, March 17, 1915, n. pag.

[139]*Ibid.*

[140]"Riverismo," in *Ismos,* Buenos Aires, 1943, p. 358.

[141]*Ibid,* pp. 353-54. Translation from Wolfe, *Diego Rivera,* p. 98.

[142]See Crespelle, *La vie quotidienne à Montparnasse,* p. 102.

[143]Guzmán, *op. cit.,* p. 86.

[144]Letter dated February 2, 1916 to Martín Luis Guzmán in New York. Collection of the Guzmán Estate.

[145]Max Jacob, "La Vie Artistique," *"291",* No. 12, February 1916, n. pag.

[146]Rivera-March, p. 114.

[147]Guzmán, *op. cit.,* p. 86. For a discussion of the changes that Picasso's *Man Leaning on a Table* underwent, see Pierre Daix. *Picasso, The Cubist Years 1907-1916,* London and Boston, 1979, Cat. no. 889.

[148]Marevna Vorobëv, *Life with the Painters of La Ruche,* trans. Natalia Heseltine, London, 1972, p. 95.

[149]Cocteau, *La Difficulté d'Etre,* Monaco, 1953, pp. 217-18.

[150]Guzmán, *op. cit.,* p. 86.

[151]Rivera to Guzmán, dated February 2, 1916. Estate of Sra. Ana West de Guzmán.

[152]The *New York Evening Mail,* October 9, 1916, quoted by de Zayas *op. cit.,* p. 119.

[153]Frederick W. Eddy, "Diego Rivera," *New York World,* October 3, 1916, quoted by de Zayas, *op. cit.,* p. 120.

[154]*Ibid.*

[155]The letter was translated and reproduced in de Zayas, *op. cit.*, p. 119. It is reproduced here with the kind permission of Sr. Rodrigo de Zayas.

[156]For a discussion of the Zetlins and their Salon, see Marevna Vorobëv, *Life in Two Worlds*, pp. 150-56, and Ehrenburg, *op. cit.*, pp. 127-29; and for Voloshin's mysticism see Kupchenko, *op. cit.*

[157]Rivera-Suárez, p. 123.

[158]Lhote quoted in Anatole Jakovsky, *André Lhote*, Paris, 1947, n. pag. (facing plate 17).

[159]*Ibid.*

[160]Rivera-Torriente II, p. 35, and cf., Rivera-Torriente I, pp. 194-95, and 212-19.

[161]Lhote quoted in Jakovsky, *op. cit.*, n. pag. (facing plate 16).

[162]Gino Severini, "La Peinture d'avant-garde," *Mercure de France*, CXXI, June 1, 1917, pp. 462-63.

[163]Gino Severini, *Tutta la vita di un pittore*, Milan, 1946, p. 270.

[164]Letter from André Salmon to Bertram D. Wolfe, November , 1937, quoted in Wolfe, *Diego Rivera*, p. 116.

[165]Conversation with the author February 1980 in Ealing (London). Cf. Debroise, *op. cit.*, p. 77.

[166]Severini, *Tutta la vita*, p. 270.

[167]For a discussion of "Classical Cubism" and its manifestations during the war years of 1916-17 in Paris, see Christopher Green, "Cubism Classicized: A New View of Modern Life," in the exh. cat. *Léger and Purist Paris*, London, The Tate Gallery, pp. 32-4; and Green, *Léger and the Avant-Garde*, London, 1976, pp. 120-32.

[168]Pierre Reverdy, "On Cubism," in Fry, *op. cit.*, p. 145. See also Pierre Reverdy, *Nord-Sud, Self-defense et autre écrits sur l'art et poésie: 1917-1926*, ed. Etienne-Alain Hubert, Paris, 1975, p. 245.

[169]Gris to Maurice Raynal dated March 24, 1917, in *Letters of Juan Gris*, ed. Douglas Cooper, London, 1956, p. 46.

[170]Cf. Malcolm Gee, "The Avant-garde, Order and the Art Market, 1916-23, *Art History*, Vol. 2, No. 1, March 1979, pp. 95-106, and Etienne Alain-Hubert, "Pierre Reverdy et le cubisme en mars 1917," *Revue de l'art*, 43, 1979, pp. 59-66.

[171]In Max Jacob, *Correspondance*, ed. Francois Garnier, Paris, 1955, Vol. I, p. 145.

[172]*Ibid.*, p. 146.

[173]Gris, *op. cit.*, p. 46.

[174]*Ibid,*, p. 49.

[175]See my "Jean Cocteau: An Unpublished Portrait by Diego Rivera," *The Library Chronicle* (Humanities Research Center, The University of Texas at Austin), No. 12, 1979, pp. 10-20.

[176]"Moderne Klassik Kunst i Paris," *Klingen*, Copenhagen, Vol. II, No. 3, 1919, n. pag.

[177]*Ibid.*

[178]In a reply to a questionnaire "Chez les Cubistes," published by the *Bulletin de la Vie Artistique*, January 1, 1925, pp. 15-17, and reproduced in Daniel-Henry Kahnweiler, *Juan Gris, His Life and Work*, trans. Douglas Cooper, London, 1947, p. 159.

Documentation

Selected Bibliography

Given the vast general bibliography on Rivera, this bibliography is limited to sources where significant reference is made to Rivera's Cubist years either by himself or by others. In most cases these sources have been cited in the catalogue essay. For a fairly complete bibliography covering the artist's post-1921 career see the exhibition catalogues: Mexico City, Museo Nacional de Artes Plásticas, *Diego Rivera, 50 años de su labor artística*, 1951; updated by Mexico City, Palacio de Bellas Artes, *Exposición nacional de homenaje a Diego Rivera con motivo del XX aniversario de su fallecimiento*, 1977-1978; and the bibliography compiled by Olivier Debroise, "Diego Rivera, bibliografía (1950-diciembre 1977)," in *Artes Visuales*, No. 16 (Winter 1977), pp. 20-21.

I. Autobiographies and Writings by Rivera

Untitled "declaration" written by Rivera to Marius de Zayas in 1916. Translated by de Zayas and reproduced in de Zayas, Marius. "How, When, and Why Modern Art Came to New York." Introduction by Francis Naumann. *Arts Magazine*, LIV (April 1980), p. 119.

"From a Mexican Painter's Notebook." Trans. Katherine Anne Porter. *Arts*, VII, No. 1 (January 1925), pp. 21-23.

"Datos biográficos," *El Arquitecto*, Mexico City, II, No. 8 (March-April 1926), p. 3.

Das Werk des Malers Diego Rivera. Autobiographical introduction by the artist. Berlin: Neuer Deutscher Verlag, 1928.

"La pintura mexicana," *Excélsior*, March 18, 1942, pp. 1-2, & 8.

Memoria y razón de Diego Rivera. An autobiography dictated to Loló de la Torriente. 2 vols. Mexico City: Ed. Renacimiento, 1959.

My Art, My Life. Dictated to Gladys March. New York: Citadel Press, 1960.

Confesiones de Diego Rivera. Dictated to Luis Suárez. Mexico City: Ed. Era, 1962.

II. References to Rivera's Cubist Years in Paris
A. Books and Exhibition Catalogues

Apollinaire on Art: Essays and Reviews 1902-1918. Trans. Susan Suleiman. Ed. Leroy C. Breunig. New York: Viking Press, 1972.

Arquin, Florence. *Diego Rivera: The Shaping of an Artist 1889-1921*. Norman: University of Oklahoma Press, 1971.

Cabanne, Pierre. *L'Epopée du Cubisme*. Paris: La Table Ronde, 1963.

Cardona Peña, Alfredo. *El Monstruo en su laberinto*. Conversations with Diego Rivera, 1949-1950. Mexico City: Costa Amic, 1965.

Charlot, Jean. *Mexican Art and the Academy of San Carlos 1785-1915*. Austin: University of Texas Press, 1962.

—————. *Mexican Mural Renaissance 1920-1925*. New Haven and London: Yale University Press, 1963.

Cocteau, Jean. *La difficulté d'être*. Monaco: Ed. du Rocher, 1947.

Coquiot, Gustave. *Les Indépendants 1884-1920*. Paris: Librairie Ollendorff, 1920.

Cooper, Douglas, ed. and trans. *Letters of Juan Gris, 1913-1927*. Collected by Daniel-Henry Kahnweiler. London: Privately printed, 1956.

Cravan, Arthur. *J'étais cigare* (*Maintenant* followed by *Fragments* and a *Letter*). Preface by José Pierre. Paris: Eric Losfeld, 1971.

Debroise, Olivier. *Diego de Montparnasse*. Mexico City: Fondo de Cultura Económica, 1979.

Ehrenburg, Ilya. *People and Life, 1891-1921*. Trans. A. Bostock and Y. Kapp. New York: Alfred A. Knopf, 1962.

Evans, Ernestine. *The Frescoes of Diego Rivera*. New York: Harcourt, Brace & Co., 1929.

Faure, Elie. *Oeuvres complètes*. 3 vols. Paris: J.J. Pauvert, 1964.

Favela, Ramón. "'Rivera Cubista': A Critical study of the Early Career of Diego Rivera, 1898-1921." Ph.D. dissertation, The University of Texas at Austin, 1984.

Flores Arauz, María Cristina. "La obra cubista de Diego Rivera." Tesis profesional en Historia, Universidad Nacional Autónoma de México, 1965.

Gee, Malcolm. *Dealers, Critics, and Collectors of Modern Painting: Aspects of the Parisian Art Market between 1910 and 1930*. New York and London: Garland, 1981.

George, Waldemar. *Oscar Miestchaninoff*. Paris: Arts et Métiers Graphiques, 1966.

Gómez de la Serna, Ramón. *Ismos*. Buenos Aires: Ed. Poseidon, 1943.

Gual, Enrique. *Cien dibujos de Diego Rivera*. Mexico City: Ediciones de Arte, 1949.

Gordon, Donald E. *Modern Art Exhibitions 1900-1916*. 2 vols. Munich: Prestel-Verlag, 1974.

Henderson, Linda D. *The Fourth Dimension and Non-Euclidean Geometry in Modern Art*. Princeton: Princeton University Press, 1983.

Henríquez Ureña, Pedro, and Alfonso Reyes. *Epistolario íntimo (1906-1946)*. 2 vols. Santo Domingo: Universidad Nacional Pedro Henríquez Ureña, 1981.

Jacob, Max. *Correspondance*. Ed. Francois Garnier. 2 vols. Paris: Ed. de Paris, 1955.

Jakovsky, Anatole. *André Lhote*. Paris: Librairie Floury, 1947.

Madrid. Salón "Arte Moderno." *Los Pintores Integros*, ex. cat. by Ramón Gómez de la Serna, 1915.

Mexico City. Instituto Nacional de Bellas Artes (I.N.B.A.). *Colección Marte R. Gómez: Obras de Diego Rivera, 1886-1957*, 1973.

Mexico City. I.N.B.A. *Presentación de una obra de Diego Rivera recién descubierta por técnicos del Centro Nacional de Conservación de Obras Artísticas del I.N.B.A.*, 1977.

Mexico City. Museo Nacional de Artes Plásticas. *Diego Rivera: 50 años de su labor artística. Exposición de homenaje nacional*. Coordinated by Fernando Gamboa. I.N.B.A., 1951.

Mexico City. Palacio de Bellas Artes. *Exposición nacional de homenaje a Diego Rivera con motivo del XX aniversario de su fallecimiento*. Coordinated by Lenin Molina. I.N.B.A., 1977-1978.

Mexico City. Museo Rufino Tamayo. *Diego Rivera*. Coordinated by Dolores Olmedo, 1983.

Mittler, Max, ed. *Diego Rivera: Wort und Bekenntnis*. Zurich: Verlag der Arche, 1965.

Montenegro, Roberto. *Planos en el tiempo*. Mexico City: Imp. Arana, 1962.

New York. The Museum of Modern Art. *Diego Rivera*, by Frances Flynn Paine. Notes by Jere Abbott, 1931-1932.

Olivares, Armando. *Diego de Guanajuato*. Guanajuato: Universidad de Guanajuato, 1957.

Ozenfant, Amédée. *Mémoires (1886-1962)*. Paris: Seghers, 1968.

Paris. Galerie Bernheim-Jeune. *IVᵉ exposition du 'Groupe Libre.'* Preface by Camille Mauclair, 1913.

Paris. Galerie B. Weill. *Exposition particulière de peintures, aquarelles et dessins par M. Diego H. Riviera* (sic) with a preface by "B." (Berthe Weill), 1914.

Paris. Galerie Eugène Blot. *Exposition de peinture. . . de Eugène Corneau, André Favory, Gabriel Fournier, André Lhote et Diego Rivera; sculptures de Paul Cornet et Adam Fischer*, preface by Louis Vauxcelles, 1918.

Patai, Irene. *Encounters: The Life of Jacques Lipchitz*. New York: Funk & Wagnalls, 1964.

Patout, Paulette. *Alfonso Reyes et la France*. Paris: Klincksieck, 1978.

Pierre, José. *Le Cubisme*. Lausanne: Ed. Rencontre, 1966.

Reverdy, Pierre. *Nord-Sud, Self-defence et autres écrits sur l'art et la poésie: 1917-1926*. Ed. Etienne Alain Hubert. Paris: Flammarion, 1975.

Reyero, Manuel, ed. *Diego Rivera*. Mexico City: Fundación Cultural Televisa, 1983.

Riverside, Calif. The Art Gallery, University of California, Riverside. *The Cubist Circle*, 1971.

Salmon, André. *L'art vivant*. Paris: Ed. G. Crés et Cie, 1920.

——————. *Montparnasse*. Paris: A. Bonne, 1950.

San Francisco. California Palace of the Legion of Honor. *Diego Rivera*. Preface by Katherine Field Caldwell, 1930.

Secker, Hans F. *Diego Rivera*. Dresden: Verlag der Kunst, 1957.

Severini, Gino. *Tutta la vita di un pittore*. Milan: Garzanti, 1946.

——————. *Tempo de "L'Effort Moderne"; La vita di un pittore*, vol. 2. Ed. Piero Pacini. Florence: Enrico Vallecchi, 1968.

——————. *Dal cubismo al classicismo*. Ed. Piero Pacini. Florence: Marchie & Bertolli, 1972.

Siqueiros, David Alfaro. *Me llamaban el coronelazo*. Mexico City: Ed. Grijalbo, 1977.

Sodi de Pallares, María Elena. *Tedoro A. Dehesa: Una época y un hombre.* Mexico City: Ed. Citlaltepetl, 1959.

Taracena, Berta. *Diego Rivera: Pintura de caballete y dibujos.* Mexico City: Fondo de la Plástica Méxicana, 1979.

Vorobёv, Marevna. *Life in Two Worlds.* Trans. Benet Nash. New York: Abelard-Schuman, 1962.

_____. *Life with the Painters of La Ruche.* Trans. Natalia Heseltine. London: Constable and Co., 1972.

Weill, Berthe. *Pan! dans l'Oeil!*. . . Paris: Librairie Lipchitz, 1933.

Wolfe, Bertram D. *Diego Rivera, His Life and Times.* New York: Alfred A. Knopf, 1939.

_____. *The Fabulous Life of Diego Rivera.* New York: Stein & Day, 1963.

Zilczer, Judith K. *The Noble Buyer: John Quinn, Patron of the Avant-Garde.* Exhibition catalogue. Hirshborn Museum and Sculpture Garden, Washington, D.C., 1978.

B. Articles

Apollinaire, Guillaume. "Le Salon des Indépendants," *L'Intransigeant,* March 2, 1914.

_____. "Le 30e Salon des Indépendants," *Les Soirées de Paris,* No. 22 (March 15, 1914), p. 188.

_____. "Les Arts: A la galerie B. Weill, Diego A. Rivera . . .," *Soirées* de Paris, No. 24 (May 15, 1914), p. 250.

"Les Arts: Sujets de conversation." *Gil Blas,* Paris, October 14, 1913, p. 4.

"The Aztecs and Señor Rivera," *American Art News,* October 14, 1916, p. 3.

Atl. "Le Salon des Indépendants," *L'Action d'art,* Paris, No. 4 (April 1, 1913), pp. 3-4.

Barrera, Carlos. "Murió Diego," *Excélsior,* November 30, 1957, p. 6.

Barrios, Roberto. "Diego Rivera," *La Semana Ilustrada,* Mexico City, June 30, 1914, p. 1.

_____. "Diego Rivera, pintor." *El Universal,* Mexico City, July 21, 1921. Reprinted in *El Universal Ilustrado,* July 28, 1921, pp. 22-23.

Best Maugard, Adolfo. "Diego Rivera. Su ética y estética." *Cuadernos Americanos,* XLVII, No. 5 (September-October 1949), pp. 282-89.

Brendel, Ulrico. "El Salon de Otoño." *Mundial Magazine,* Paris, II, No. 7 (November 1911), pp. 44-46.

_____. "El Salón de Otoño." *Mundial Magazine,* II, No. 19 (November 1912), pp. 623-34.

_____. "El Salón de Otoño en París." *Mundial Magazine,* VI, No. 33 (January 1914), pp. 215-225.

Charlot, Jean. "Diego Rivera at the Academy of San Carlos." *College Art Journal,* X, No. 1 (Fall 1950), pp. 10-17.

_____. "Diego Rivera in Italy." *Magazine of Art,* XLVI, No. 1 (January 1953), pp. 3-10.

"Chronique mensuelle: Société Manes." *Les Soirées de Paris,* No. 22 (March 15, 1914), p. 131.

Crespo de la Serna, Jorge Juan. "El Proceso de desarrollo de la pintura de Diego Rivera." In Mexico City. *Diego Rivera: 50 años* (See Exhibition Catalogues), pp. 61-75.

Darío, Rubén. "Cabezas: Angel Zárraga (con dibujos de Diego María Ribera [sic]." *Mundial Magazine,* II, No. 19 (November 1912), pp. 640-41.

Debroise, Olivier. "Diego Rivera y la representación del espacio." *Artes Visuales,* No. 16 (Winter 1977), Suppl. pp. I-XVI.

"Los desaguisados del cubismo." *El Universal Ilustrado,* May 24, 1918, n. pag.

["Diego Rivera"]. *New York Evening Mail,* October 9, 1916.

["Diego Rivera"]. *New York Evening Post,* October 7, 1916.

Eddy, Frederick W. "Paintings by Diego Rivera." *New York World,* October 3, 1916.

Favela, Ramón. "Jean Cocteau: An Unpublished Portrait by Diego Rivera." *The Library Chronicle* (Humanities Research Center, The University of Texas at Austin, No. 12 (1979), pp. 10-20.

Fernández, Justino. "Diego Rivera. Antes y después." *Anales del Instituto de Investigaciones Estéticas,* Universidad Nacional Autónoma de México, V, No. 18 (1949), pp. 63-82.

Fischer, Adam. "Moderne klassisk Kunst i Paris." *Klingen,* Copenhagen, II, No. 3, (1919), n. pag.

Francés, José. "De Bellas Artes: Los pintores 'Integros.'" *El Mundo Gráfico,* Madrid, V, No. 157 (March 17, 1915), n. pag.

Frías, José D. "Los pintores mexicanos en París." *Zig-Zag,* Mexico City, I, No. 17 (August 5, 1920), pp. 32 34.

_____. "El fabuloso pintor Diego María Ribera [sic]." *Revista de Revistas,* Mexico City, November 27, 1921, p. 11.

García Calderón, Francisco. "La obra del pintor mexicano Diego M. Rivera." *El Mundo Ilustrado*, Mexico City, May 17, 1914, n. pag.

Gee, Malcolm. "The Avant-Garde, Order and the Art Market, 1916-23." *Art History*, II, No. 1 (March 1979), pp. 95-106.

Gómez de la Serna, Ramón. "Riverismo." *Sur*, Buenos Aires, I, No. 2 (October 1931), pp. 59-85.

Gónzalez Peña, Carlos. "Al margen de la semana: Un burro pintor." *El Universal Ilustrado*, May 24, 1918, p. 2.

Green, Christopher. "Cubism Classicized: A New View of Modern Life." In *Léger and Purist Paris*. Ex. cat., The Tate Gallery, London, 1971, pp. 32-37.

Guzmán, Martín Luis. "Diego Rivera y la filosofía del cubismo (Written in 1915)." In *Obras completas de Martín Luis Guzmán*. 2 vols. Mexico City: Compañía General de Ediciones, 1961.

Hubert, Etienne-Alain. "Pierre Reverdy et le cubisme en mars 1917." *Revue de l'art*, No. 43 (1979), pp. 59-66.

Jacob, Max. "La vie artistique." *291*, New York, No. 12 (February 1916), n. pag.

Kahn Gustave. "Art: `Le Groupe Libre.'" *Mercure de France*, Paris, February 1, 1913, pp. 639-40.

_____ . "MM. Diego Rivera, André Lhote, *et al*." *Mercure de France*, Paris, December 1, 1918. pp. 518-19.

Kupchenko, Vladimir. "Maksimilian Voloshin i Diego Rivera." *Latinskaia Amerika*, Moscow, No. 2 (1977), pp. 182-86.

Ottmann, Henry. "A-propos sur le Salon d'Automne." *L'Art Décoratif*, Paris, XXXI (January 1914), pp. 3-64.

"Pinturrichio" (Louis Vauxcelles). "Carnet des ateliers: Au pays du Cube." *Carnet de la Semaine*, Paris, October 6 - October 27, 1918.

Reverdy, Pierre. "Une nuit dans la plaine." *Nord-Sud*, No. 3 (May 15, 1917), pp. 27-33.

Reyes, Alfonso. "Historia documental de mis libros: De las 'Conferencias del Centenario' a los 'Cartones de Madrid.'" *Revista de la Universidad de México*, IX, No. 7 (March 1955), pp. 1-16.

Rodríguez, Antonio. "Panorama de las artes: Diego Rivera a través de su magna exposición, II." *Suplemento dominical de El Nacional*, Mexico City, August 21, 1949, pp. 7 and 14.

Salmon, André. "Le Salon d'Automne, 1913." *Montjoie!*, Paris, Nos. 11-12 (November-December 1913), pp. 1-9.

_____ . "La furia Polonaise." *Gil Blas*, Paris, June 12, 1914, p. 1.

_____ . "La semaine artistique – Selon Cézanne (Galerie Blot)." *L'Europe Nouvelle*, IV, No. 43 (November 2, 1918), pp. 2069-70.

_____ . "La semaine artistique – Exposition André Lhote, Oser et choisir." *L'Europe Nouvelle*, IV, No. 48 (December 7, 1918), pp. 2309-10.

"The Season of Art Exhibitions Now Opening: Paintings by Diego Rivera." *New York Times*, October 8, 1916, Sec. IV, p. 17.

Severini, Gino. "La peinture d'avant-garde." *Mercure de France*, Paris, CXXI (June 1, 1917), pp. 451-68.

Siqueiros, David Alfaro. "Diego M. Rivera, pintor de América." *El Universal Ilustrado*, Mexico City, July 7, 1921, pp. 20-21.

Tablada, José Juan. "Desde París: El Salón de Otoño." *Revista de Revistas*, Mexico City, December 10, 1911, pp. 1 and 19.

_____ . "Mexican Painting of To-Day." *International Studio*, LXXVI, No. 308 (January 1923), pp. 267-76.

_____ . "Diego Rivera – Mexican Painter." *The Arts*, IV, No. 4 (October 1923), pp. 221-33.

"Triunfo de los pintores mexicanos." *Revista de Revistas*, Mexico City, August 1, 1920, p. 24.

Vauxcelles, Louis. "Les Arts: Expositions diverses – 'Le Groupe Libre.'" *Gil Blas*, Paris, January 18, 1913, p. 5.

_____ . "Salon d'Automne." *Helios*, Paris, No. 2 (December 1913), pp. 6-13.

_____ . "Les Arts – Cubisme." *Le Pays*, July 30, 1917, n. pag.

Wright, Willard Huntington. "Modern Art: Four Exhibitions of the New Style of Painting." *International Studio*, LX (January 1917), p. xcvii.

Zahle, Grete. "Diego Rivera og hans forbindlese med to danske kunstnere." *Kunstmuseets Arsskrift* (Statens Museum for Kunst, Copenhagen), 1976, pp. 46-62.

Zayas, Marius de. "How, When, and Why Modern Art came to New York." Introduction by Francis Naumann. *Arts Magazine*, LIV (April 1980), pp. 96-126.

III. General Works Cited

Adelman, Lucy, and Michael Compton. "Mathematics in Early Abstract Art." In *Towards a New Art: Essays on the Background to Abstract Art*. London; The Tate Gallery, 1980, pp. 64-69.

Banham, Reyner. *Theory and Design in the First Machine Age*. 2nd ed. New York: Praeger Publishers, 1967.

Barr, Alfred. *Picasso: Fifty Years of His Art*. New York: The Museum of Modern Art, 1946.

Bowlt, John E., ed. and trans. *Russian Art of the Avant-Garde: Theory and Criticism 1902-1934*. New York: Viking Press, 1976.

Brown, Jonathan. "El Greco, the Man and the Myths." In *El Greco of Toledo*. Ex. cat., The Toledo Museum of Art, 1982, pp. 15-33.

_____ . "El Greco and Toledo." In *El Greco of Toledo*. Ex. cat., The Toledo Museum of Art, 1982, pp. 75-147.

Camfield, William A. "Juan Gris and the Golden Section." *The Art Bulletin*, XLVII (March 1965), pp. 128-34.

Campoy, Antonio Manuel. *María Blanchard*. Madrid: Ed. Gavar, 1981.

Cooper, Douglas. *The Cubist Epoch*. Ex. cat., The Metropolitan Museum of Art, New York, 1971. Oxford and New York: Phaidon, 1971.

Cooper, Douglas, and Gary Tinterow. *The Essential Cubism*. Ex. cat., The Tate Gallery, London, 1983.

Crespelle, Jean-Paul. *Montparnasse vivant*. Paris: Librairie Hachette, 1962.

_____ . *La vie quotidienne à Montparnasse à la Grande Epoque 1905-1930*. Paris: Librairie Hachette, 1976.

Daix, Pierre, and Joan Rosselet. *Picasso: The Cubist Years 1907-1916: A Catalogue Raisonné of the Paintings and Related Works*. Trans. Dorothy S. Blair. Boston: New York Graphic Society, 1979.

Fernández, Justino. *El arte del siglo XIX en México*. 2nd ed. Mexico City: Universidad Nacional Autónoma de México, 1967.

_____ . *Estética del arte mexicano*. Mexico City: Universidad Nacional Autónoma de México, 1972.

Fry, Edward F., ed. *Cubism*. New York: McGraw Hill, 1966.

Gamwell, Lynn. *Cubist Criticism*. Ann Arbor: UMI Research Press, 1980.

Gleizes, Albert. *Souvenirs: Le Cubisme 1908-1914*. Cahiers Albert Gleizes, I. Lyon: Association des Amis d'Albert Gleizes, 1957.

Gleizes, Albert, and Jean Metzinger. *Du Cubisme*. Paris: Eugène Figuière, 1912.

Golding, John. *Cubism: A History and an Analysis: 1902-1914*. 2nd rev. ed. New York: Harper & Row, 1968.

Douglas, Charlotte. "The New Russian Art and Italian Futurism." *Art Journal*, XXXIV, No. 3 (Spring 1975), pp. 229-39.

_____ . "Cubisme francais, cubo-futurisme russe." *Cahiers du Musée National d'Art Moderne*, Centre Georges Pompidou, 79/2 (October-December 1979), pp. 184-93.

Gris, Juan. "Réponse à l'enquête 'Chez les cubistes.'" *Bulletin de la Vie Artistique*, Paris, VI, No. 1 (January 1, 1925), pp. 15-17.

Homer, William Innes. *Seurat and the Science of Painting*. Cambridge, Mass.: The M.I.T. Press, 1964.

Joosten, Joop. "Mondrian: Between Cubism and Abstraction." In *Piet Mondrian, Centennial Exhibition*. Ex. cat., The Solomon R. Guggenheim Museum, New York, 1971, pp. 53-66.

Kahnweiler, Daniel Henry. *The Rise of Cubism*. Trans. by Henry Aronson. New York: Wittenborn, 1949.

_____ . *Juan Gris, His Life and Work*. Trans. by Douglas Cooper. Rev. ed. London: Thames and Hudson, 1969.

Lhote, André. *Traités du paysage et de la figure*. Rev. ed. Paris: Ed. Bernard Grasset, 1958.

Lavaud, Jean-Marie. "Une collaboration de Valle-Inclán au journal 'Nuevo Mundo' et l'exposition de 1912." *Bulletin Hispanique* (Bordeaux), LXXI, Nos. 1-2 (January-June 1969), pp. 286-311.

Luna Arroyo, Antonio. *Rescate de Angel Zárraga*. Mexico City: Printed by the author, 1969.

Marcadé, Jean Claude. "K.S. Malevich: From Black Quadrilateral (1913)" In *The Avant-Garde in Russia 1910-1930, New Perspectives*. Ex. cat., The Los Angeles County Museum of Art, 1980, pp. 20-23.

Mladek, Meda. "Central European Influences." In *Frantisek Kupka: A Retrospective*. Ex. cat., The Solomon R. Guggenheim Museum, New York, 1975, pp. 13-37.

O'Gorman, Juan. "Técnica empleada por Diego Rivera para pintar al fresco." In *Diego Rivera, 50 años de su labor artística*. Ex. cat., Museo Nacional de Artes Plásticas, Mexico City, 1951, pp. 275-84.

Reff, Theodore. "Cézanne and Poussin." *Journal of the Warburg and Courtauld Institutes*, XXIII (1960), pp. 150-74.

_____. "Painting and Theory in the Final Decade." In *Cézanne: The Late Work*. Ex. cat., The Museum of Modern Art, New York, 1977, pp. 13-54.

"Regresó de Europa el pintor Zárraga." *El Imparcial*, Mexico City, January 11, 1914, p. 5.

Robbins, Daniel. "From Symbolism to Cubism: The Abbaye de Créteil." *Art Journal*, XXIII (Winter 1963-64), pp. 111-16.

_____. *Albert Gleizes 1881-1953: A Retrospective Exhibition*. Ex. cat., The Solomon R. Guggenheim Museum, New York, 1964.

_____. "The Formation and Maturity of Albert Gleizes." Ph.D. dissertation, New York University, 1975.

Rubin, William. "Cézannisme and the Beginnings of Cubism." In *Cézanne: The Late Work*. Ex. cat., The Museum of Modern Art, New York, 1977, pp. 151-202.

Seuphor, Michel. *Mondrian*. Ex. cat., Oreangerie des Tuileries, Paris, 1969.

Spate, Virginia. *Orphism: The Evolution of Non-Figurative Painting, 1910-1914*. Oxford: Clarendon Press, 1979.

Tyler, Ron. "Posada's Mexico." In *Posada's Mexico*. Ex. cat., ed. Ron Tyler, The Library of Congress, Washington, D.C., 1979, pp. 3-27.

Vauxcelles, Louis. Preface to *Exposition Angel Zárraga*. Ex. cat. Chez Bernheim-Jeune & Cie., Paris, 1920, pp. 1-6.

Villegas, Abelardo. *Positivismo y porfirismo*. Mexico City: Sep Setentas, 1972.

Welsh, Robert P. "Mondrian." *Revue de l'art*, Paris, No. 5 (1969), pp. 99-101.

Zea, Leopoldo. *El positivismo en México: Nacimiento, apogeo y decadencia*. 2 vols. Mexico City: El Colegio de México, 1944.

IV. Archival Sources

Adam Fischer Archives. The Royal Danish Library, Copenhagen, Denmark. Correspondence between Diego Rivera and Angeline Beloff and Adam Fischer and his wife Ellen Fischer.

Album of Family Photographs of Rivera, formerly in the Collection of Marte R. Gómez. *Museo "Casa Diego Rivera,"* Guanajuato, Guanajuato. Courtesy of I.N.B.A.

Archives and Registers of the Mexican Embassy in Paris for the period between 1900-1921.

Alfred Stieglitz Archives. Yale Collection of American Literature. Yale University, New Haven, Connecticut. Correspondence between Stieglitz and Marius de Zayas regarding works by Diego Rivera and the Modern Gallery

Bertram D. Wolfe Papers. Archives, Hoover Institution on War, Revolution and Peace. Stanford University, Stanford, California. Contains all the files and notes that Wolfe utilized in the preparation of his two biographies of Diego Rivera.

Correspondence between Diego Rivera and Martín Luis Guzmán, belonging to the late Sra. Ana West Vda. de Guzmán, Mexico City.

The *Capilla Alfonsina*, Mexico City. Contains correspondence between Diego Rivera and Alfonso Reyes during their years in Paris and Spain; also, a Scrapbook of clippings and photographs dating from 1914-1921, and materials relating to Angel Zárraga and Jesús Acevedo in Europe. Courtesy of Sra. Alicia Reyes.

Fonds Vauxcelles. A voluminous collection of mss., press clippings, correspondence, and exhibition catalogues belonging to the art critic Louis Vauxcelles, now in the *Bibliothèque d'Art et d'Archéologie Jacques Doucet*, Paris.

Fonds Robert et Sonia Delaunay. Bibliothèque Nationale, Paris. Correspondence from Foreign artists, including Rivera and numerous Spanish and Portuguese artists during 1914-1920.

Photographic Archive of the *Ancienne Collection Léonce Rosenberg. Service Photographique de la Caisse Nationale des Monuments Historiques*, Paris.

Collection Jacques Doucet, Bibliothèque Sainte-Geneviève, Paris. Correspondence of André Salmon and Jean Cocteau relating to Diego Rivera.

Cubist Related Exhibitions in Which Rivera Participated

Société des Artistes Indépendants. *Salon de 1910.* Paris, March 18 – May 1, 1910.

Société du Salon d'Automne. *Salon de 1911.* Paris, October 1 – November 8, 1911.

Salon des Indépendants, Paris, March 20 - May 16, 1912.

Salon d'Automne, Paris, October 1 - November 8, 1912.

Galerie Bernheim-Jeune & Cie. *IVe Exposition du 'Groupe Libre.'* Paris, January 13 1913. Catalogue preface by Camille Mauclair.

Kgl. Kunstausstellungs gebäude. *Secession: Fruhjahr-Ausstellung.* Munich, March 13 – May 31, 1913.

Salon des Indépendants. Paris, March 19 – May 18, 1913.

Wien, Opernring 19. Internationale Schwarz-Weiss-Ausstellung. Vienna, November – December 1913.

Salon d'Automne. Paris, November 15, 1913 – January 1914.

S.V.U. Mánes. Moderni Umeni, XXXXV. Vystava (Modern Art, 45th Exhibition). Prague, February – March 1914. Catalogue preface by Alexandre Mercereau.

Galerie B. Weill. *Exposition Particulière de Peintures, Aquarelles et Dessins par M. Diego H. Riviera* (sic). Paris, April 21 – May 6, 1914. Catalogue preface by "B." (Berthe Weill)

Galerie Georges Giroux. *Artistes Indépendants.* Brussels, May 16 – June 7, 1914.

De Onafhankelijken. *3de Internationale Jury-Vrije Tentoonstelling.* Amsterdam, May – June 1914.

Salón de Exposición 'Arte Moderno.' *Los Pintores Integros.* Madrid, March 5 – 15, 1915. Catalogue preface by Ramón Gómez de la Serna.

Modern Gallery. *Paintings by Cézanne, Van Gogh, Picasso, Picabia, Braque, and Rivera.* New York, February 12 – March 4, 1916.

Modern Gallery. *Paintings by Cézanne, Van Gogh, Picasso, Picabia, and Rivera.* New York, April 29 – June 10, 1916.

Modern Gallery. *Exhibition of Paintings by Diego M. Rivera and Mexican Pre-Conquest Art.* New York, October 1 – 21, 1916.

Society of Independent Artists. *First Annual Exhibition.* New York, April 10 – May 6, 1917.

Galerie Eugène Blot. *Exposition de Peinture, Aquarelles et Dessins de Eugene Corneau, André Favory, Gabriel Fournier, André Lhote et Diego Rivera; Sculptures de Paul Cornet et Adam Fischer.* Paris, October 28 – November 19, 1918.

Galerie Dalmau. *Exposició d'art francés d'avantguarda.* Barcelona, October 26 – November 15, 1920. Catalogue preface by Maurice Raynal.

Catalogue of Works in the Exhibition

Titles and dates of the catalogue entries correspond to the author's research in the preparation of a forthcoming catalogue raisonné of the European works of Diego Rivera. Where two titles are provided for a single entry, the first title is the one assigned by the lender; the second, in parenthesis, is the one assigned by the author. The source for the variant title appears in abbreviated form in parenthesis beneath the entry. It refers to the full documentary source listed in the bibliography for the original title of the work. All titles are given in English and Spanish, and on occasion a third language due either to the lender or Rivera indicating some titles in French.

Dimensions of each object are given first in inches, height preceding width preceding depth. These are followed by metric measurements in centimeters.

Catalogue No. 13 - Page 60
El viaducto - El sol rompiendo la bruma, 1913
(The Viaduct - Sun Breaking through the Fog)
oil on canvas
38⅜ x 31⅛ (97.5 x 79.0 cm.)
Señora Dolores Olmedo

(El viaducto - Paysage de Meudon)
(The Viaduct - Landscape of Meudon)
(Catalogue of Diego Rivera one-man exhibition, Paris,
Galerie Berthe Weill, 1914, No. 8)

Catalogue No. 14 - Page 46
Arbol, 1913
(Tree)
watercolor on paper
13¼ x 10¼ (33.8 x 26.0 cm.)
Instituto Nacional de Bellas Artes, Museo Casa Diego
Rivera, Guanajuato

Catalogue No. 15 - Page 7
Paisaje con postes de telégrafo, 1913
(Landscape with Telegraph Poles)
pencil on paper
10¼ x 13¼ (26.0 x 33.8 cm.)
Instituto Nacional de Bellas Artes, Museo Casa Diego
Rivera, Guanajuato

Catalogue No. 16 - Page 13
Naturaleza muerta con tetera, 1913
(Still Life with Teapot)
pencil on paper
10⅛ x 13¾ (25.8 x 35.0 cm.)
Instituto Nacional de Bellas Artes, Museo Casa Diego
Rivera, Guanajuato

Catalogue No. 17 - Page 4
El Puente de San Martín, Toledo, 1913
(St. Martin's Bridge, Toledo)
oil on canvas
35¾ x 43¼ (91.0 x 110.0 cm.)
Arquitecto Don Jesús González Vaquero

Catalogue No. 18 - Page 65
La mujer del pozo, 1913
(Woman at the Well)
oil on canvas
57⅛ x 49¼ (145.0 x 125.0 cm.)
Instituto Nacional de Bellas Artes, Museo Nacional de Arte
(verso of *Paisaje Zapatista*, Catalogue No. 40)

Catalogue No. 19 - Page 72
Still Life with Stringed Instrument, 1913
(Naturaleza muerta con balalaika)
oil on canvas
23⅝ x 14¾ (60.0 x 37.5 cm.)
Bergen Billedgalleri, Norway

Catalogue No. 20 - Page 26
Naturaleza muerta española, 1914
(Spanish Still Life)
pencil on paper
16½ x 9⅞ (41.8 x 25.0 cm.)
Instituto Nacional de Bellas Artes, Museo Casa Diego
Rivera, Guanajuato

Catalogue No. 21 - Page 66
Mujer sentada, 1914
(Seated Woman)
watercolor and pencil on paper
11 x 13 (28.0 x 33.0 cm.)
Señor Fernando Gamboa

Catalogue No. 22 - Page 64
Two Women, 1914
(Dos mujeres)
oil on canvas
78 x 63 (198.12 x 160.02 cm.)
The Arkansas Arts Center Foundation: Gift of Abby
Rockefeller Mauze, New York, 1955.

Catalogue No. 23 - Page 25
Naturaleza muerta con botella, 1914
(Still Life with Carafe)
collage and gouache on paper
14 x 7½ (35.5 x 19.0 cm.)
Propiedad del Gobierno del Estado de Veracruz

Catalogue No. 24 - Page 71
El joven de la estilográfica, 1914
(Young Man with a Stylograph)
oil on canvas
31¾ x 25⅝ (81.0 x 65.0 cm.)
Señora Dolores Olmedo
*(Young Man with a Stylograph - Portrait of Best
Maugard)*
(Joven de la estilográfica - Retrato de Best Maugard)
(Rivera-March, p. 105.)

Catalogue No. 25 - Page 75
El Grande de España, (El Caballero), 1914
(Grandee of Spain)
oil on canvas
76⅜ x 51 (194.0 x 129.5 cm.)
Museo de Monterrey
(El Caballero)
(The Cavalier)
(Washington, D.C., Hirshhorn Museum and Sculpture
Garden, "The Noble Buyer: John Quinn," no. 64.)

Catalogue No. 26 - Page 67
Jacques Lipchitz (Portrait of a Young Man), 1914
(Jacques Lipchitz (Retrato de Joven))
oil on canvas
25⅝ x 21⅝ (65.0 x 55.0 cm.)
Museum of Modern Art, New York; Gift of T. Gatesby Jones
(Joven con suéter gris - Retrato de Jacques Lipchitz)
*(Young Man in a Grey Sweater - Portrait of
Jacques Lipchitz)*
(Catalogue of 1914 Salon des Indépendants, No. 2869)

Catalogue No. 27 - Page 78
Cabeza de marino, 1914
(Sailor's Head), First Version
pencil on paper
17 x 10⅜ (43.0 x 26.5 cm.)
Instituto Nacional de Bellas Artes, Museo Casa Diego
Rivera, Guanajuato

Catalogue No. 28 - Page 79
Cabeza de marino, 1914
(Sailor's Head), Second Version
pencil on paper
16⅞ x 10¼ (42.8 x 26.0 cm.)
Instituto Nacional de Bellas Artes, Museo Casa Diego
Rivera, Guanajuato

Catalogue No. 29 - Page 77
Fusilero marino - Marino almorzando, 1914
(Sailor at Lunch)
oil on canvas
44⅞ x 27½ (114.0 x 70.0 cm.)
Instituto Nacional de Bellas Artes, Museo Casa Diego
Rivera, Guanajuato

Catalogue No. 30 - Page 88
Paisaje, 1914
(Landscape [of Mallorca])
watercolor and pencil on paper
20 x 12¾ (50.8 x 32.5 cm.)
Instituto Nacional de Bellas Artes, Museo Casa Diego
Rivera, Guanajuato

Catalogue No. 31 - Page 90
La Plaza de Toros, 1915
(The Bullfight Ring)
oil on canvas
18¾ x 27½ (47.5 x 70.0 cm.)
Capilla Alfonsina's Collection

Catalogue No. 32 - Page 95
Retrato de Ramón Gómez de la Serna, 1915
(Portrait of Ramón Gómez de la Serna)
oil on canvas
43 x 35½ (109.0 x 90.0 cm.)
Private Collection
(not shown in Mexico City)

Catalogue No. 33 - Page 96
El Rastro, 1915
(The "Rastro")
oil on canvas
10⅝ x 15 (27.0 x 38.0 cm.)
Señora Dolores Olmedo

Catalogue No. 34 - Page 27
La Grande Reconstruction, 1915
(La gran reconstrucción)
(The Great Reconstruction)
oil on cardboard
10⅛ x 12⅝ (25.7 x 32.1 cm.)
Private Collection
(shown in Phoenix and Mexico City)

Catalogue No. 35 - Page 101
El Arquitecto, 1915
(The Architect)
oil on canvas
56⅝ x 44⅞ (144.0 x 114.0 cm.)
Instituto Nacional de Bellas Artes, Museo Alvar y Carmen
T. de Carrillo Gil

Catalogue No. 36 - Page 102
La Terrasse du café, 1915
(La terraza del café)
(The Café Terrace)
oil on canvas
23¾ x 19½ (60.5 x 49.4 cm.)
The Metropolitan Museum of Art, The Alfred Steiglitz
Collection, 1949.

Catalogue No. 37 - Page 28
Still Life, 1915
(Naturaleza muerta)
oil on canvas
21¼ x 24 (54.0 x 61.0 cm.)
Rijksmuseum Kröller-Müller, Otterlo, Netherlands

Catalogue No. 38 - Page 103
Still Life with Bread Knife, 1915
(Naturaleza muerta con cuchillo)
oil on canvas
19⅝ x 23½ (49.9 x 59.7 cm.)
Columbus Museum of Art
(not shown in Mexico City)

Catalogue No. 39 - Frontispiece, Page 100
Still Life with Gray Bowl, 1915
(Naturaleza muerta con tazón gris)
oil on canvas
31¼ x 25¼ (79.4 x 63.8 cm.)
Lyndon Baines Johnson Library and Museum, Austin, Texas

Catalogue No. 40 - Page xii, Page 106
Paisaje Zapatista - El guerrillero, 1915
(Zapatista Landscape - The Guerrilla)
oil on canvas
57⅛ x 49¼ (145.0 x 125.0 cm.)
Instituto Nacional de Bellas Artes, Museo Nacional de Arte
(recto of *La mujer del pozo,* 1913, Catalogue No. 18)

Catalogue No. 41 - Page 112
Bodegón con taza, 1915
(Still Life with Cup)
tempera on paper
8⅝ x 8⅝ (22.0 x 22.0 cm.)
Propiedad del Gobierno del Estado de Veracruz

Catalogue No. 42 - Page 113
Naturaleza muerta - Bodegón con vaso y botella, 1915
(Still Life with Bottle and Vase)
tempera on paper
9 x 13½ (23.0 x 34.5 cm.)
Propiedad del Gobierno del Estado de Veracruz

Catalogue No. 43 - Page 82
La Bouteille d'Anis, 1915
(The Bottle of Anis)
oil on canvas
25½ x 27½ (64.8 x 69.9 cm.)
Private Collection, Los Angeles, U.S.A.
(not shown in Mexico City)

Catalogue No. 44 - Page 84
Retrato de "Berthe Kritosser," 1915
(Portrait of "Berthe Kritosser")
pencil on paper
18⅞ x 13 (48.0 x 33.0 cm.)
Instituto Nacional de Bellas Artes, Museo Casa Diego
Rivera, Guanajuato

Catalogue No. 45 - Page 83
Nature morte aux citrons, 1916
(Naturaleza muerta con limones)
(Still Life with Lemons)
oil on canvas
23⅝ x 28¾ (60.0 x 73.0 cm.)
Joan and Jaime Constantiner

Catalogue No. 46 - Page 125
Retrato de Maximiliano Volochine, 1916
(Portrait of Maximilian Voloshin)
oil on canvas
43¼ x 35½ (110.0 x 90.2 cm.)
Instituto Nacional de Bellas Artes, Museo Nacional de Arte

Catalogue No. 47 - Page 85
"Berthe Kritosser," 1916
(Portrait of Berthe Kritosser)
oil on canvas
41⅜ x 31½ (105.0 x 80.0 cm.)
Instituto Nacional de Bellas Artes, Museo Casa Diego
Rivera, Guanajuato

Catalogue No. 48 - Page 128
Retrato de Angelina Beloff, 1916
(Portrait of Angeline Beloff)
oil on canvas
31⅝ x 25½ (80.5 x 64.8 cm.)
Private Collection, U.S.A.

Catalogue No. 49 - Page 114
Still Life with Vase of Flowers, 1916
(Naturaleza muerta con flores)
oil on canvas
32⅛ x 25⅞ (81.6 x 65.7 cm.)
The Metropolitan Museum of Art, Gift of Raymonde Paul in
memory of her brother, C. Michael Paul, 1982.

Catalogue No. 50 - Page 115
Still Life with Lemons, 1916
(Naturaleza muerta con limones)
oil on canvas
31 x 25 (78.7 x 63.5 cm.)
Private Collection, Los Angeles, U.S.A.
(not shown in Mexico City)

Catalogue No. 51 - Page 116
Naturaleza muerta con utensilios, 1916
(Still Life with Utensils)
oil on canvas
28 x 21¼ (71.0 x 54.0 cm.)
Señora Dolores Olmedo

Catalogue No. 52 - Page 118
Naturaleza muerta, 1916
(Still Life)
oil on canvas
11¼ x 15⅛ (28.5 x 38.4 cm.)
Private Collection
(not shown in Mexico City)

Catalogue No. 53 - Page 117
Composición con busto, 1916
(Composition with Bust)
oil on canvas
28⅞ x 21½ (73.2 x 54.6 cm.)
Señora Dolores Olmedo

Catalogue No. 54 - Page 127
Mujer en verde, 1916
(Woman in Green)
oil on canvas
50¾ x 35 (129.0 x 89.0 cm.)
Instituto Nacional de Bellas Artes, Museo Alvar y Carmen T.
de Carrillo Gil

Catalogue No. 55 - Page 126
Angelina y El Niño Diego, Maternidad, 1916
(Angeline and Baby Diego, Maternity)
oil on canvas
51¼ x 31½ (130.0 x 80.0 cm.)
Instituto Nacional de Bellas Artes, Museo Alvar y Carmen T.
de Carrillo Gil

Catalogue No. 56 - Page 120
El pintor en reposo, 1916
(The Painter in Repose)
oil on canvas
51¼ x 38 (130.0 x 96.0 cm.)
Instituto Nacional de Bellas Artes, Museo Alvar y Carmen T.
de Carrillo Gil

Catalogue No. 57 - Page 119
El poste de telégrafo, 1916
(The Telegraph Pole)
oil on canvas
39⅜ x 33½ (100.0 x 85.0 cm.)
Señora Dolores Olmedo

Catalogue No. 58 - Page 129
Portrait of a Woman (Mme. Zetlin), 1916
(Retrato de una mujer, Mme. Zetlin)
gouache on paper
Page 3 of Mme. Zetlin's Livre d'Or (Guest Book)
6¼ x 5¼ (16.0 x 13.0 cm.)
Mr. and Mrs. Ferrand-Eynard

Catalogue No. 59 - Page 134
Still Life, 1916
(Naturaleza muerta)
oil on canvas with built-up relief effects
21⅛ x 18⅛ (54.8 x 46.0 cm.)
The St. Louis Art Museum: Gift of Morton D. May

Catalogue No. 60 - Page 135
Composition: Still Life with Green House, 1917
(Composición: Naturaleza muerta con casa verde)
oil on canvas
24 x 18⅛ (61.0 x 46.0 cm.)
The Stedelijk Museum, Amsterdam

Catalogue No. 61 - Page 136
La Legia, (La Lessive), 1917
(Implements for the Wash)
oil on canvas
31½ x 27½ (80.0 x 70.0 cm.)
Señora Dolores Olmedo

Catalogue No. 62 - Page 133
Still Life with Bread and Fruit, 1917
(Naturaleza muerta con pan y fruta)
oil on canvas
45¾ x 35 (115.0 x 89.0 cm.)
Los Angeles County Museum of Art: Gift of Morton D. May

Catalogue No. 63 - Page 131
Les Oranges, 1917
(Las naranjas)
(Oranges)
oil on canvas
21¼ x 25¼ (54.0 x 64.0 cm.)
Fundación Amigos de Bellas Artes, Caracas, Venezuela

Catalogue No. 64 - Page 137
Mujer sentada en una butaca, 1917
(Woman in an Armchair)
oil on canvas
51¼ x 38¼ (130.0 x 97.0 cm.)
Instituto Nacional de Bellas Artes, Museo Alvar y Carmen T. de Carrillo Gil

Catalogue No. 65 - Page 138
Naturaleza muerta con planta, 1917
(Still Life with Plant)
oil on canvas
36¼ x 28¾ (92.0 x 73.0 cm.)
Señora Dolores Olmedo

Catalogue No. 66 - Page 124
Retrato de Mme. Lhote, 1917
(Portrait of Mme. Lhote)
oil on panel
47½ x 43¾ (121.0 x 111.0 cm.)
Private Collection

Catalogue No. 67 - Page 139
Naturaleza muerta - Nature morte au col, 1917
(Still Life - Still Life with Long-necked Bottle)
oil on board
21⅝ x 24¾ (55.0 x 63.0 cm.)
Señora Dolores Olmedo

Catalogue No. 68 - Page 140
La Table Mince, 1917
(The Meager Table)
oil on fiberboard
19⅞ x 23¾ (50.5 x 60.5)
The Stedelijk Museum, Amsterdam

Catalogue No. 69 - Page 141
Paysage de Fontenay, 1917
(Paisaje de Fontenay)
(Fontenay Landscape)
oil on canvas
28¾ x 23¾ (73.0 x 60.3 cm.)
Private Collection
(not shown in Mexico City)

Catalogue No. 70 - Page 142
Still Life with Cigarettes, 1917
(Naturaleza muerta con cigarrillos)
pencil on paper
9⅞ x 13¾ (25.0 x 35.0 cm.)
Phoenix Art Museum: Gift of Mr. and Mrs. Orme Lewis

Catalogue No. 71 - Page 17
Portrait of Chirokof, 1917
(Retrato de Chirokof)
pencil on paper
12 x 9⅜ (30.6 x 23.8 cm.)
Worcester Art Museum, Massachusetts

Catalogue No. 72 - Page 150
Naturaleza muerta, 1918
(Still Life - Unfinished)
oil on canvas
17¾ x 21¼ (45.0 x 54.0 cm.)
Propiedad del Gobierno del Estado de Veracruz

Catalogue No. 73 - Page 149
Paisaje de Arcueil, 1918
(Arcueil Landscape)
oil on canvas
25¼ x 31½ (64.0 x 80.0 cm.)
Propiedad del Gobierno del Estado de Veracruz

Catalogue No. 74 - Page 146
El Matemático, 1918
(The Mathematician)
oil on canvas
46 x 33½ (117.0 x 85.0 cm.)
Señora Dolores Olmedo

Catalogue No. 75 - Page 147
Konstruktionsskitse, 1918
(Dibujo de construcción)
(Construction Drawing)
pencil on parchment
9⅞ x 7 (25.0 x 18.0 cm.)
Egil Nordahl Rolfsen and Kirsten Revold

Catalogue No. 76 - Page 142
Paris, Still Life, 1918
(Naturaleza muerta, Paris)
pencil on paper
9½ x 12⅜ (24.0 x 31.3 cm.)
The Art Institute of Chicago: Gift of Walter S. Brewster

Catalogue No. 77 - Page 148
Caserío, 1918
(Country Village)
watercolor on paper
20⅞ x 14¾ (53.0 x 37.5 cm.)
Private Collection

Credits
Catalogue and essay by Ramón Favela
Exhibition organized by James K. Ballinger
Catalogue design by by Theron Hardes
Typography by Southwest Typographers
Color Separations by American Color Corporation
Lithography by Prisma Graphic Corporation